characteristic
característica
kenmerkend
特點
ャタリスティック
특징의

Simply Material

To reveal the increasing essentialness of material
with a compilation of brilliant ideas, and craftsmanship

SimplySeries™
SimplyMaterial

First published and distributed by
viction:workshop ltd.

viction:ary™

Unit C, 7th Floor, Seabright Plaza, 9-23 Shell Street,
North Point, Hong Kong
URL: www.victionary.com
Email: we@victionary.com

Edited and produced by viction:workshop ltd.

Concepts & art direction by Victor Cheung
Book design by Cherie Yip @ viction:workshop ltd.

ISBN 978-988-98228-7-3

Printed and bound in China

content
contenido
inhoud
目錄
コンテンツ
목차

004	Preface
009	Geometric
071	Organic
145	Decorative
201	Illusive
265	Contributors
372	Acknowledgements

preface
prefacio
voorwoord
前言
はしがき
서론

Life is full of marvelous things, and material has caught a great deal of attention nowadays. From designers who need to choose whatever to create new things, to professionals getting new equipment to improve the quality of their work, or even a student who buys a shiny pen to show it off to other student; material has become an essential element to play with. 'Simply Material', as the first of the 'Simply' series, has hunted down incredible work from different designers, but all with a specific personality. Numerous printed pages are trapped together within this book, and it shows the meaning of the materials into the field where design is in the same context as culture, society and economy. Not to worry, they all have been well fed, properly exercised, and gently loved.

Has anyone wondered about what if a nightstand is made out of towels, or a sofa that is made of cotton-balls? 'Simply Material' could be considered as a space where designers came to flirt with the basic traditional boundaries through their work. Such as David Tunbridge's 'Nananu,' it is a chair where its construction look delicate yet very attractive. Now, just picture a simple form of a chair or sofa, but with untreated wood, and its shape is similar to a shell. How would anyone have the courage to sit in one of these? Some might ask. "There must be something very special about the wood. Merely by being put here it has been changed," says Trubridge. On the other hand, some designers' attitude is about the involvement in the process, and most importantly the idea and the performance of the piece. Another perfect example of the 'Geometric' section of the book is the Empress chair that Julian Mayor made in 2003. The interesting point of his creation is that the chair itself has an exact butt-shaped of a person, but the whole thing is made out of wooden sticks. "I want to experiment with how artificial something needs to be before it is perceived as real," Julian says. "I always think: how would a computer see that? My work is often based on sampling an experience and recreating it artificially." Geometric is the alluring subject that inspires designers to cross the boarder, or discard the traditions into their work from wherever their minds took them. People are surrounded by geometry everyday, it is the base element of objects, buildings or even space. So it was only a matter of time that someone would eventually come up with something using Geometry.

Meaning and effect, these two concepts on all levels are produced by the relationship between the object and the materials, which are made of with its surroundings. Contemporary works of design decipher their meaning through the use of materials. Much valuable information can be gained about the intention and the mind of the designer by investigating the contextual significance of materials at hand, and the fabrication or technique of the piece.

Illusive is defined to be a misapprehension by book, but the courage where a person dares to dream and trying to make it come true by reality. In the 'Illusive' section, designers whom created extraordinary pieces which are truly mind-blowing. The purpose here is not to fool anyone, well, maybe just a little bit. But the main idea is to open one's mind to beyond what is usual. With the digital age and the constant change everyday, nothing is what it seems before anymore. Some of the objects from this section can make a person smile, like the pieces designed by John Brauer from Essey ApS, the collection contained a series of somewhat similar to the bed-side-tables. The characteristic of these stands is like a simple magic trick; at first it seems like an ordinary table, then "Tah-Dah!" Where is the pillar that supposes to be supporting the table? Once the product can make a shift in a person's mood, then the true achievement has been made to a designer.

Over the years of art history, materials and substances of art have been chosen for longevity rather than meaning. Matter - bronze, ceramic, and stone all had traditionally been viewed as a separate category. It was and still is the way of cataloguing a collection rather than as the meaning of interpreting the work. Since the beginning of the Dada movement in Europe, material has become important for its own contextual significance. The first few lessons in an art class would always be to teach people how to choose the right materials or possible materials to work on. In 1934, Walter Benjamin pointed out in his lecture "Author as Producer", which was the meaning of introducing real things into Dada art-works. Finally, the "adequacy of material", proclaimed by the founders of the Bauhaus and later expressed by Marshall McLuhan in "The Medium is the Message". It has become enormously influential to a generation of artists and designers. "The only justification for me is not the object itself but its message. If it acts in some way as an agent for change, if maybe it causes a few thoughts and reflections then it has a value," says David Trubridge.

Contemporary designers introduced changes throughout history in choices of materials in their work. It is quite popular these days that designers would choose the most unimaginable materials to work with. For example, Estudio Campana has broken the rules on decoration on household furniture. Decorating is not only to make a certain space look nice, but also to feel comfortable. Just imagine, sitting down and covered in the most adorable stuffed animals like dolphins. This might be considered as the source of a smile at the end of a hard-working day. Flipping through the 'Decorative' section, Campana's idea is vividly spoken within the pages. It is as simply as a person putting on clothes, or wrapping a gift before giving it to someone, and stamping the logo on a product

– Decorate. Decorating is the action of a person expressing their mind on other things, like the lights on a Christmas tree, putting posters on a bedroom wall, and so on. The key here is to be able to relate to its audience and reach to a level where they understand exactly what the decoration means.

Usually a different choice of material is made on certain objects can be a breakthrough point for an artist. The reason is because the new material of choice represents the new found respect for certain things in life. For example, a telephone that is made from pure gold, it represents the luxury of being wealthy; an environmental-friendly bottle represents the idea of saving the earth.

Speaking of the earth. The third rock is full of elements such as trees, rocks, and cells and so on. People once thought that atom was the smallest component, until someone split it in half, and look what happened! So why can't pen look like a bone, or why can't a lamp look like an eye, and why can't designers create art that relate to every single person on earth? In the 'Organic' section, the 'Creepers' from FutureFactories has done just that. "I imagined this design slowly spreading across the room sending out 'feelers' for the next attachment." said Lionel Theodore Dean, the artist. Now with his imaginations and incredible craftmanship, a peach-pink cherry blossom that lit up at night is no longer a dream for some people.

It takes only the brave ones to create a masterpiece that would literally take people's breath away. Nobody can deny the fact that life is a beautiful thing, and to show others of one's own point of view of life through art is better than simply speaking of it. This is the way to present the idea of all objects have their own life stories originated from its own designer from different cultures. Designed pieces are like people; they lead their own lives and receive traces of material imminent degradation over a period of time. 'Simply Material' invite everyone to view these fantastic objects from designers' rich culture, and to create their own stories. Last but not the least, the series will soon introduce Simply Pattern and Simply Packaging that are considered to be the other two main focuses in the field.

geometric
geométrica
geometrisch
幾何
ジオメトリック
기하학적인

Geometry is one of the most important studies of mankind. The wisdom of geometry gives various arrangements between simple rectilinear and complex curvilinear forms. The work in 'Geometric' shows us the relationship between points, lines, and shapes; and how the subtle nature of materials turns to geometric products.

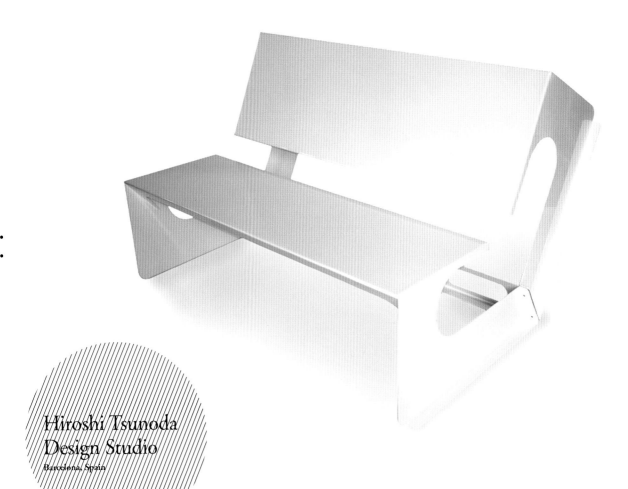

Hiroshi Tsunoda
Design Studio
Barcelona, Spain

Title
* K Bench ** K Chair

Type of Work
Furniture

Material
Aluminium

Dimension / Size
* 1020 x 980 x 770 mm
** 510 x 980 x 770 mm

Client
HTDS (Hiroshi Tsunoda Design Studio)

Year Produced
2005

Designer
Hiroshi Tsunoda

Description
Big yet elegant and attractive. K chair is made out of one whole sheet of laser cut aluminum. It consists of two exact pieces, joined together. It's painted with a shiny finish outside and matte finish inside.

*

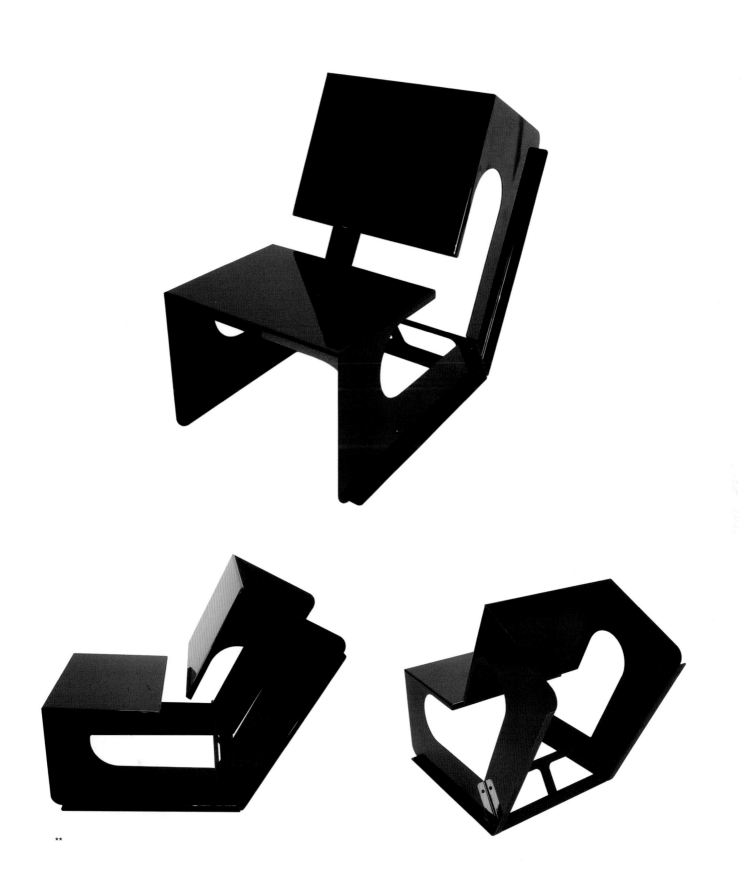

**

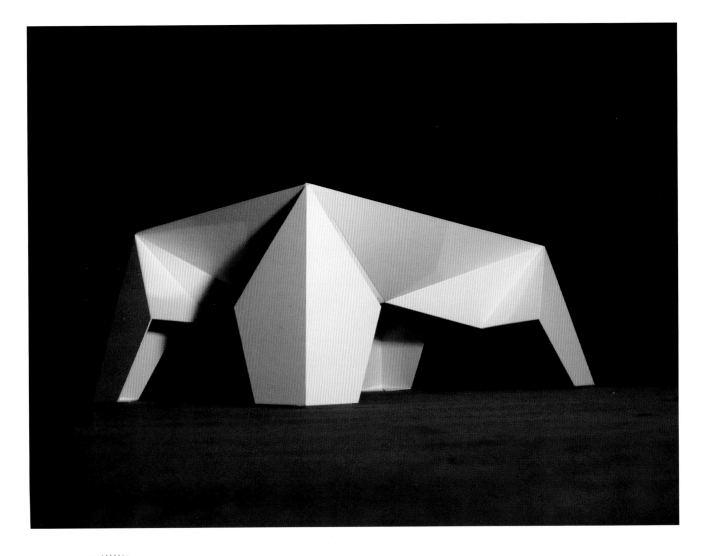

Buro
Vormkrijgers
Eindhoven, The Netherlands

Title
Sputnik

Type of Work
Coffee table

Material
Powdercoated aluminium

Dimension / Size
H 1000 x W 600 x L 400 mm

Client
Cultivate

Year Produced
2005

Designer
Sander Mulder, Dave Keune

Photographer
Niels van Veen

Description
Inspired by Origami techniques from the past and modern CNC milling techniques from today. Folded by hand from one sheet of aluminum, without any additional constructional elements or welds. This coffee table displays furniture design in its purest form. The honest lines serve both aesthetics as function, and this tables sturdiness will surprise time and time again.

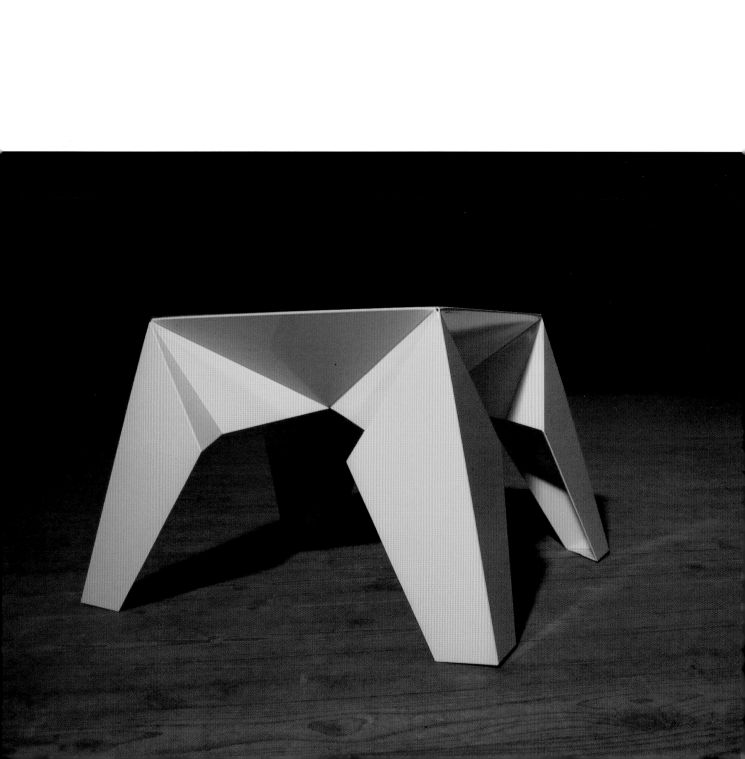

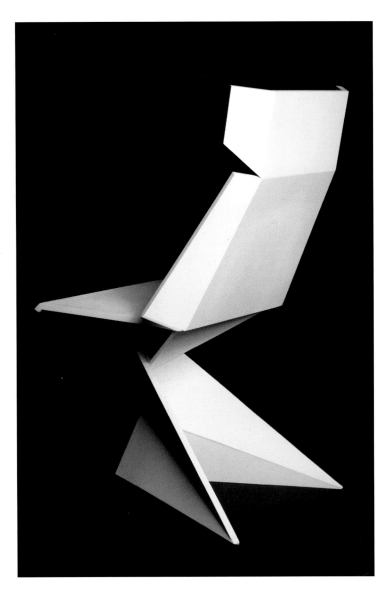

FORM US WITH LOVE
Kalmar, Sweden

Title
Aluminium Origami Chair

Type of Work
Furniture

Material
Aluminium

Dimension / Size
H 70 x L 45 x W 50 cm

Client
Various design shops

Year Produced
2006

Designer
FORM US WITH LOVE

Description
Seating furniture with inspiration from the graphic expression in origami (the Japanses art of folding paper). An idea to work conciously with light and shadows resulted in a sculpturally beautiful chair with architechtonic appearence. First chair was designed in 2004 and made of lacquered birch plywood in one example. After massive popular demand, the chair is now made out of aluminium and produced in a limited edition.

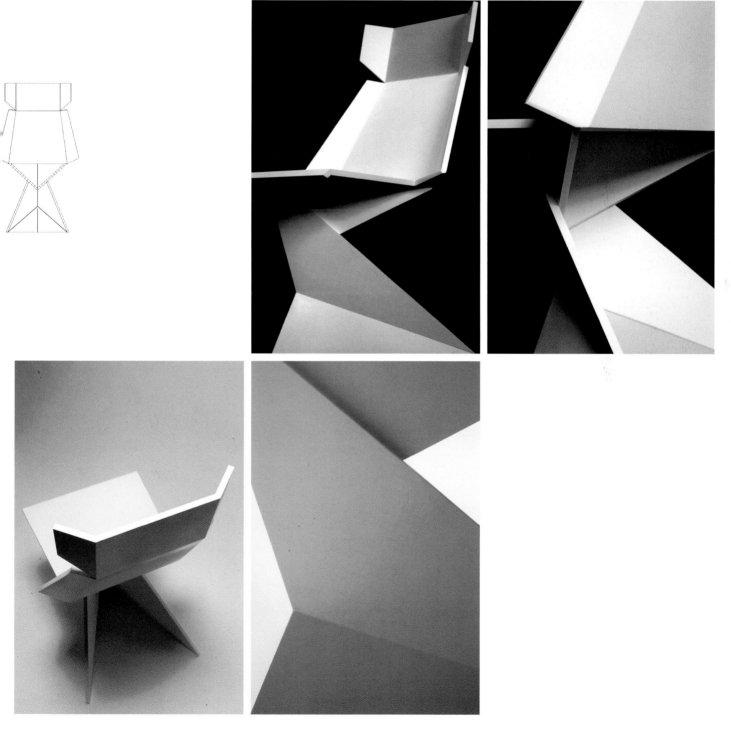

Ronen
Kadushin
Berlin, Germany

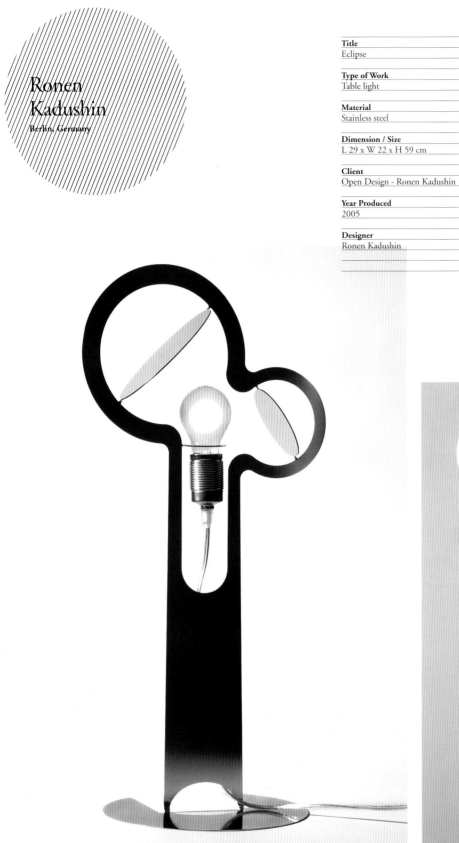

Title	**Photographer**
Eclipse	Chanan Strauss
Type of Work	**Description**
Table light	Part of the Open Design method first collection. A single piece of laser cut sheet steel, hand bent to form a 'Bare bone' lighting object. Additional electric components are standard and common.
Material	
Stainless steel	
Dimension / Size	Electric specs: 25W / 220v lamp
L 29 x W 22 x H 59 cm	
Client	
Open Design - Ronen Kadushin	
Year Produced	
2005	
Designer	
Ronen Kadushin	

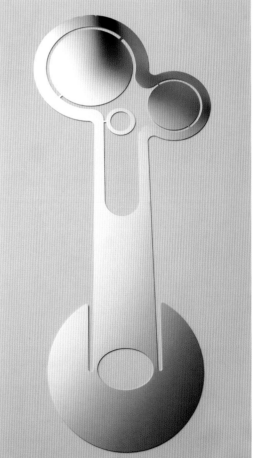

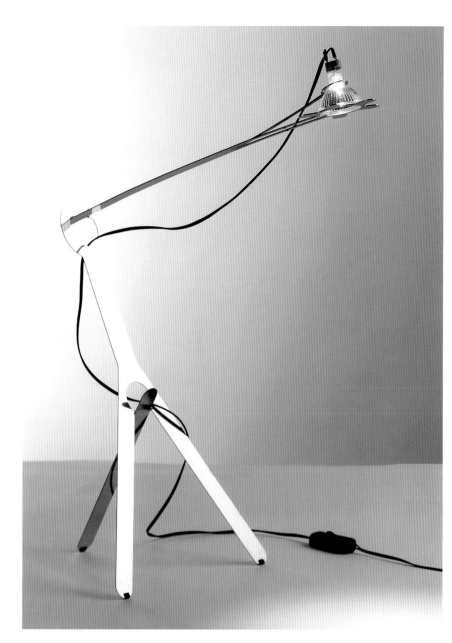

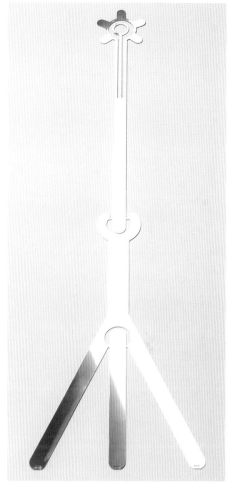

Ronen
Kadushin
Berlin, Germany

Title
Man holding flower

Type of Work
Table light

Material
Stainless steel

Dimension / Size
Approx. L 42 x W 24 x H 52 cm

Client
Open Design - Ronen Kadushin

Year Produced
2004

Designer
Ronen Kadushin

Photographer
Baruch Natah

Description
Part of the Open Design method first collection. A single piece of laser cut sheet steel, hand bent to form a 'Bare bone' lighting object. Additional electric components are standard and common.

Electric specs: 35W / 12v halogen lamp

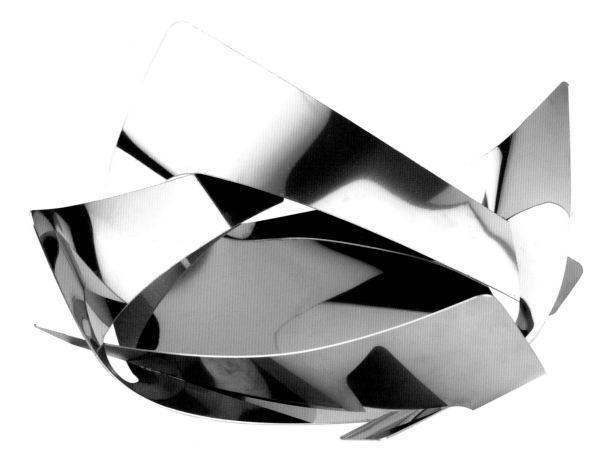

Ronen Kadushin
Berlin, Germany

Title
Square Dance

Type of Work
Fruit bowl

Material
Stainless steel

Dimension / Size
L 32 x W 32 x H 14 cm

Client
Open Design - Ronen Kadushin

Year Produced
2004

Designer
Ronen Kadushin

Photographer
Baruch Natah

Description
Part of the Open Design method first collection. Laser cut then hand bent, forcing the cutout of sheet steel to form a 3-dimensional object.

Ronen Kadushin
Berlin, Germany

Title	**Photographer**
Flat Knot	Baruch Natah
Type of Work	**Description**
Fruit bowl	Part of the Open Design method first collection. Laser cut then hand bent, forcing the cutout of sheet steel to form a 3-dimensional object.
Material	
Stainless steel	
Dimension / Size	
L 46 x W 21 x H 18 cm	
Client	
Open Design - Ronen Kadushin	
Year Produced	
2004	
Designer	
Ronen Kadushin	

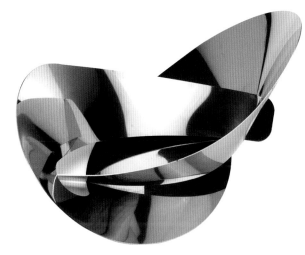

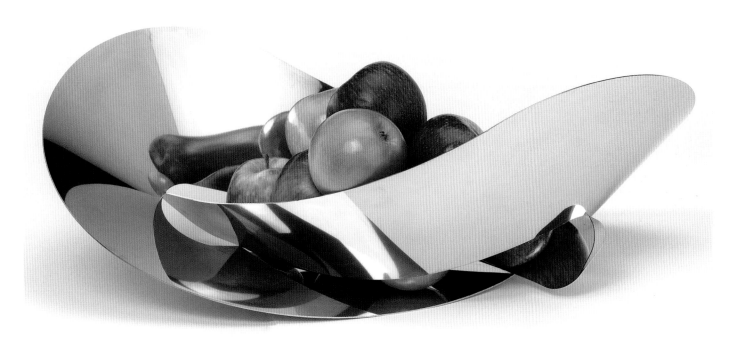

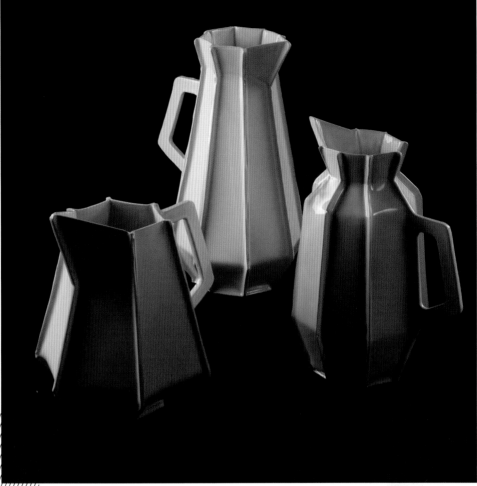

*

BOEK
(PIET HEIN EEK)
Geldrop, The Netherlands

Title
* Ceramic jugs ** Silver jugs

Type of Work
Household product

Material
** Brass silver plated

Dimension / Size
3 sizes: 22 x 28 x 27 cm, 20 x 27 x 34 cm,
18 x 23 x 30 cm

Client
-

Year Produced
2005

Designer
Piet Hein Eek

Description
Inspired by the work of his children – flat-
tening ceramics with a pasta roller. Eek had
the idea of developing ceramic designs using
flat sheets of the material as opposed to
casting a series of identical objects from
moulds. He used ceramic sheets in a similar
way to how he manipulates sheet metal.
Choosing to turn a two-dimensional material
into a three dimensional form by folding it.

To put these jugs together, sheet metal
components were made onto which the ce-
ramic sheets were moulded, and the separate
arts were collectively assembled, clamped
together at the seams and left to dry. At
this stage, the entire structures are soft and
therefore at risk of collapsing and the seams
are vulnerable to becoming unstuck.

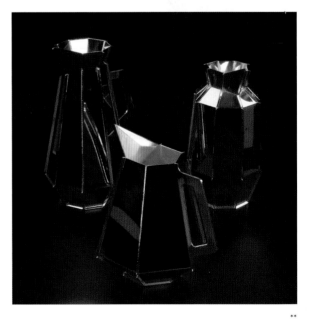

**

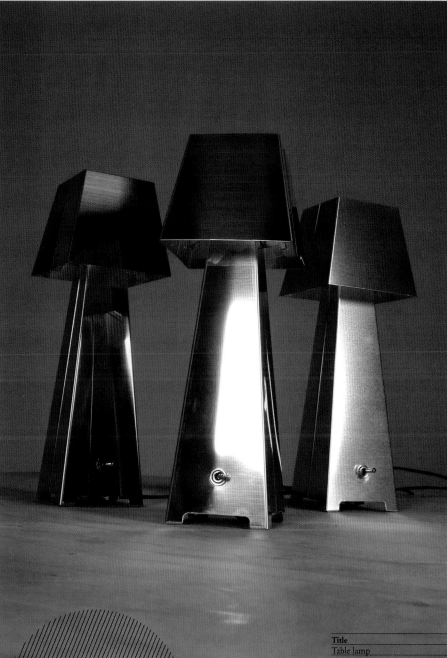

BOEK
(PIET HEIN EEK)
Geldrop, The Netherlands

Title
Table lamp

Type of Work
Lamp

Material
Brass, Copper, Aluminium

Dimension / Size
38 x 13.5 x 13.5 cm

Client
-

Year Produced
2005

Designer
Piet Hein Eek

Description
It is just a tablelamp.

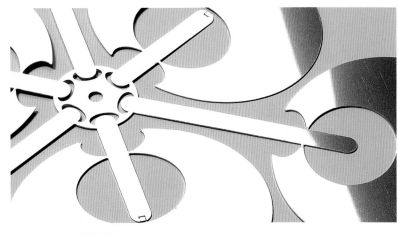

Ronen
Kadushin
Berlin, Germany

Title
Ananda

Type of Work
Table light

Material
Stainless steel

Dimension / Size
L 29 x W 29 x H 25 cm

Client
Open Design - Ronen Kadushin

Year Produced
2004

Designer
Ronen Kadushin

Photographer
Baruch Natah

Description
Part of the Open Design method first collection. A single piece of laser cut sheet steel, hand bent to form a 'Bare bone' lighting object. Additional electric components are standard and common.

Electric specs: 35W / 220v lamp

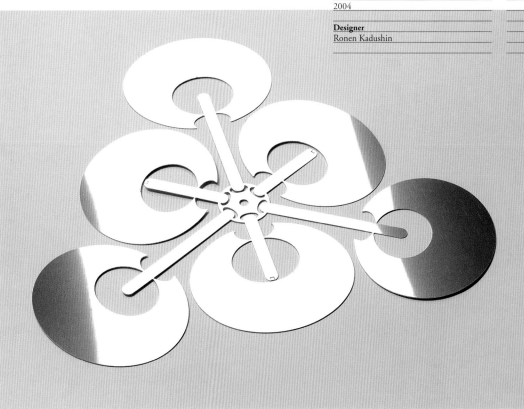

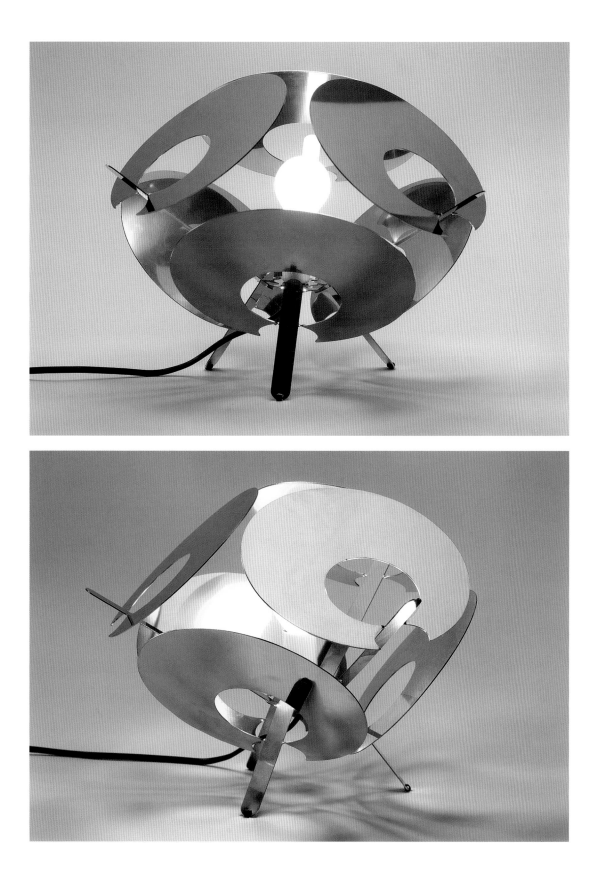

BY:AMT Inc
New York, USA

Title
Diamond Ring (part of the Bling_Blink Series)

Type of Work
Jewellry

Material
Acrylic, Silver, Gold, Platinum

Dimension / Size
US sizes: 5, 6, 7, 8, 9

Client
BY:AMT Inc

Year Produced
2003

Designer
Alissia Melka-Teichroew

Description
The Tiffany-setting diamond engagement ring: a classic design, symbol of marital bliss, emblem of our status-obsessed culture. BY: AMT's jewelry line puts a playful spin on this icon. The Tiffany ring's silhouette and basic shape remains intact, but rendered in many different materials, colours, and widths.

The laser-cut acrylic version of the ring comes in a rainbow of hues: ruby, fluo pink, smoke, black, and clear. The colours can be taken at face value—adding a bright accent to an outfit— but they can also add a layer of meaning to the ring. BY:AMT also offers sterling silver, 14-karat gold, and platinum versions of the ring.

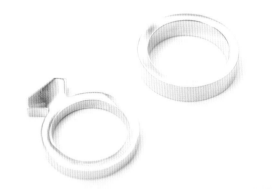

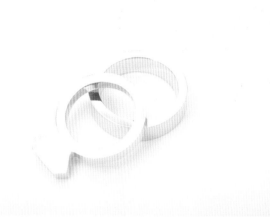

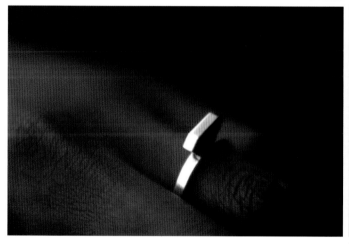

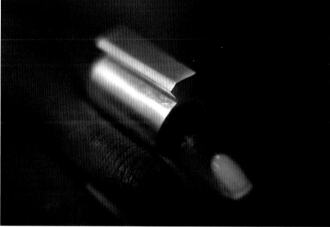

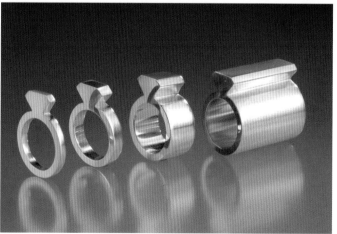

BY:AMT Inc
New York, USA

Title
* Big Bubble Bracelet ** Pearl Ring
*** Pearl Bracelet

Type of Work
Jewelry

Material
Laser cut acrylic

Dimension / Size
* S, M, L, Approx. D 100 x (T) 4 mm
** Vary, Approx. T 30 x W 20 x (T) 4 mm
*** S, M, L, Approx. D 97 x (T) 4 mm

Client
BY:AMT Inc

Year Produced
* 2006 , ** 2003

Designer
Alissia Melka-Teichroew

Description
Diamonds may be a girl's best friend, but
pearls are so chic. Make like Coco Chanel
and accessorize with AMT's pearl-shaped
acrylic rings, bracelets, and necklaces. The
collection comes in a palette of hot shades:
black, clear, ivory, ruby, or hot pink. For
maximum impact, stack rings and bracelets
of different colours.

Remarks:
T = Tall
(T) = Thick

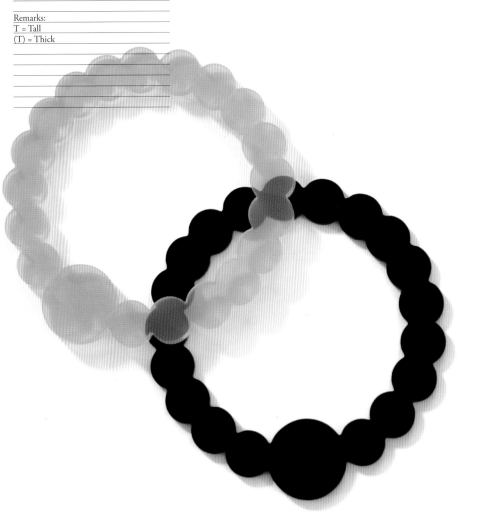

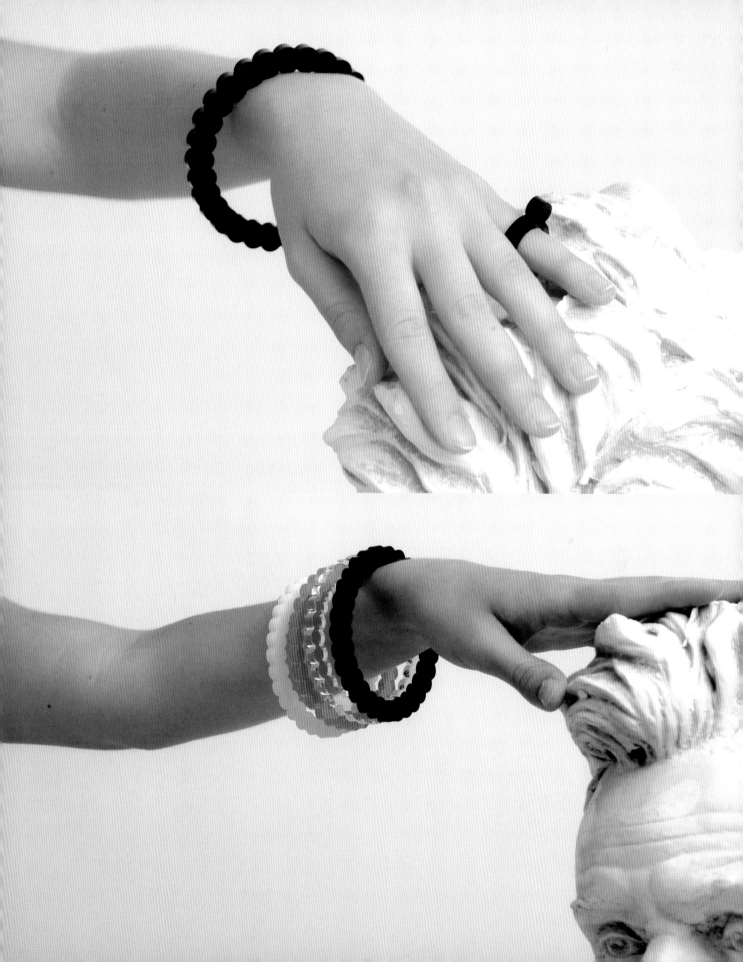

Julian Mayor
London, UK

Title
General Dynamic

Type of Work
Chair

Material
Glassfibre

Dimension / Size
700 x 700 x 700 mm

Client
-

Year Produced
2004

Designer
Julian Mayor

Description
Like the development stage on a computer, the designer wanted this chair to look like a three-dimensional sketch. Like much of his work, it requires that people visually invest in the form to finish it off. The form gives clues, but it needs the viewers eye to complete the surfaces.

General Dynamic is a limited edition.

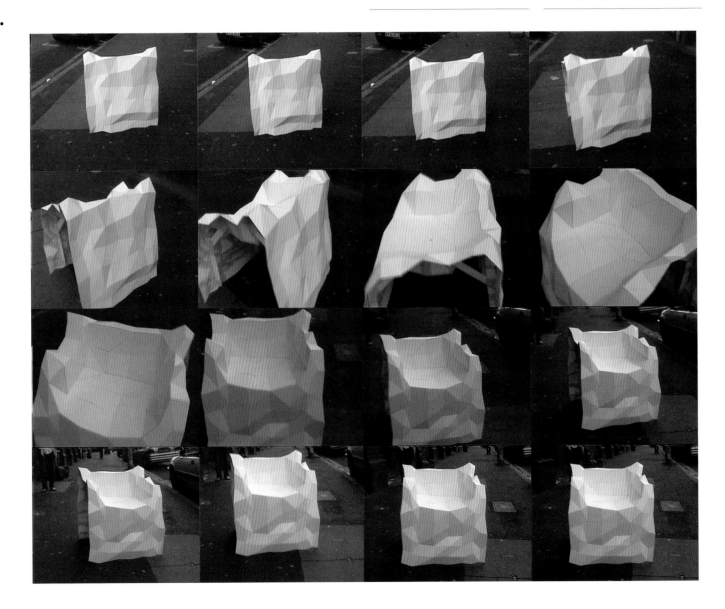

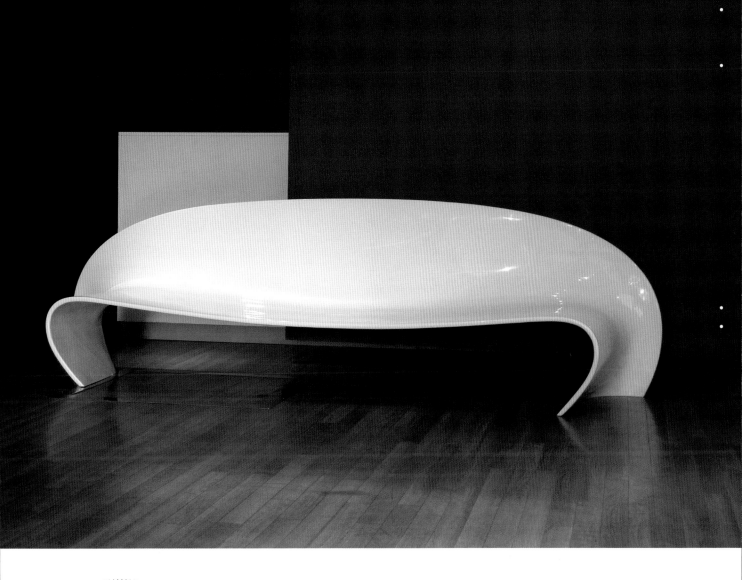

ASSA
ASHUACH
STUDIO
London, UK

Title
Upica Sofa

Type of Work
Furniture

Material
GRP reinforced U-pica mat, Gel finished

Dimension / Size
300 x 80 x 70 cm sitting at 55 cm

Client
ASSA ASHUACH STUDIO

Year Produced
2004 – 2005

Designer
Assa Ashuach

Description
The Upica sofa design focuses on the tight relationship between the physical and the visual structure. This object was carefully designed to create structural strength while keeping the essential sculptural elements. The result is a thin and light structure, different from each angle you look at it.

Limited edition of 40 by Assa Ashuach studio

Sand & Birch
Design
Latina, Italy

Title
Diamond Sofa

Type of Work
Furniture

Material
Aluminium, Swarovski crystal

Dimension / Size
Sofa: H 90
Lamp: H 190, x L 150 x W 100 cm

Client
-

Year Produced
2006

Designer
Andrea Fino, Samanta Snidaro

Description
The Diamond Sofa is entirely realised in mirror-like aluminium. On the wide stripe 160 crystals of Swarovsky will be disposed creating images. The lamp on its side is a fluorescent or a led one.

The Diamond sofa has been thought not only for sitting, but also as an object of very provocative design. It has been studied for entering houses and, at the same time, for inspiring pure luxury.

Sand & Birch is bringing forward a project in which the objects lose their proper primitive functions and acquire other meanings. In this way, the Diamond sofa becomes an expression of predominantly aesthetical value: from just a sofa it becomes a jewel.

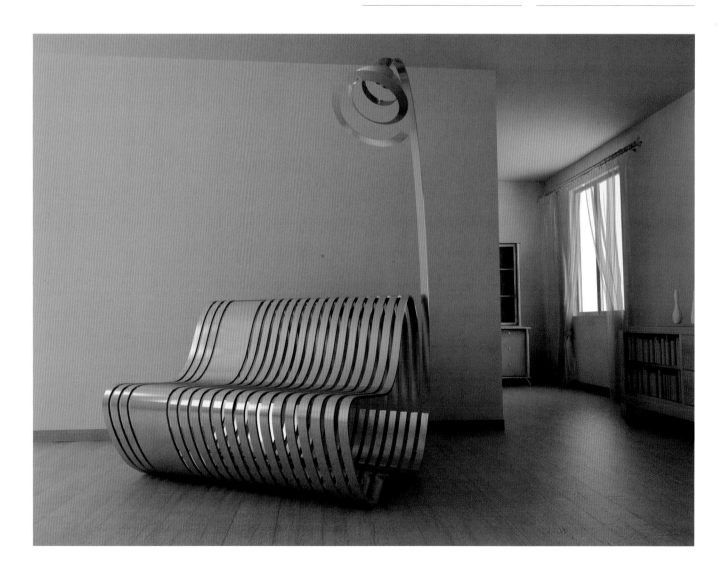

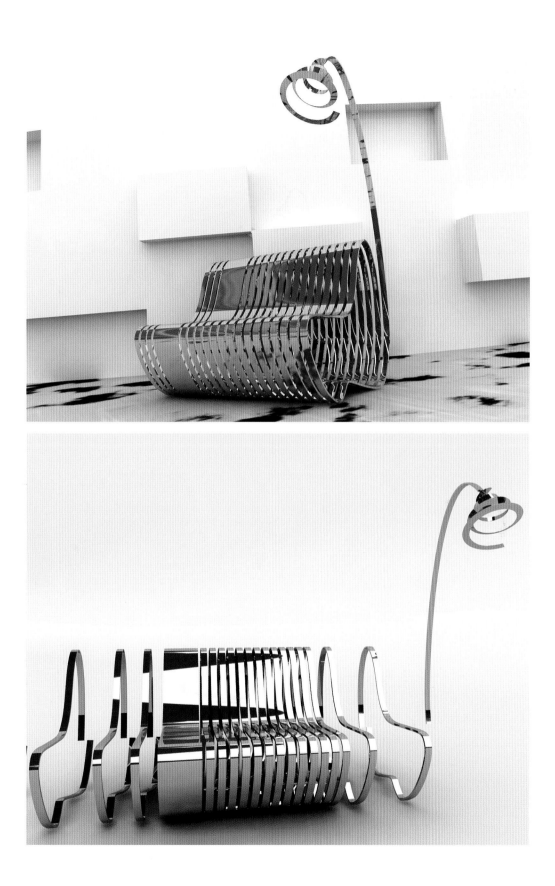

FEEK
Antwerpen, Belgium

Title
The 'Orca' line

Type of Work
Coated furniture

Material
Polyurethane foam, FEEK Polyurethane
'Rock Face' coating

Dimension / Size
1120 x 1120 x 650 mm

Client
FEEK

Year Produced
2004 – 2006

Designer
Frederik van Heereveld

Description
It is made out of 2-dimensional cut polyether foam covered with a 'Mellow Face' or 'Rock Face' coating. This combination of materials produces some very special features: elastic, water resistant; easy to clean and is extremely comfortable. This makes the FEEK units simple and practical, as well as modern and cosy, while also being both original and innovative. The strength of this combination really lies in the coating, as well as in this 'entirely new art of upholstery' as Frederik van Heereveld explains. 'This furniture embodies our entire philosophy. It concerns a new material which is flexible and easy to work with but can also be mass produced.

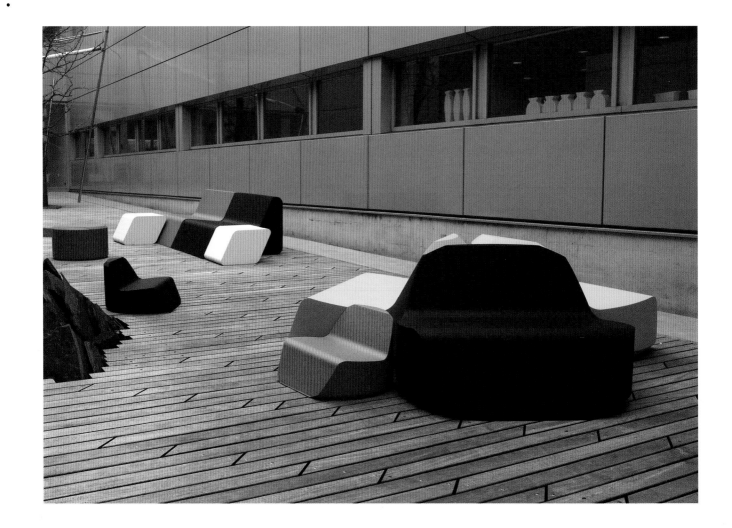

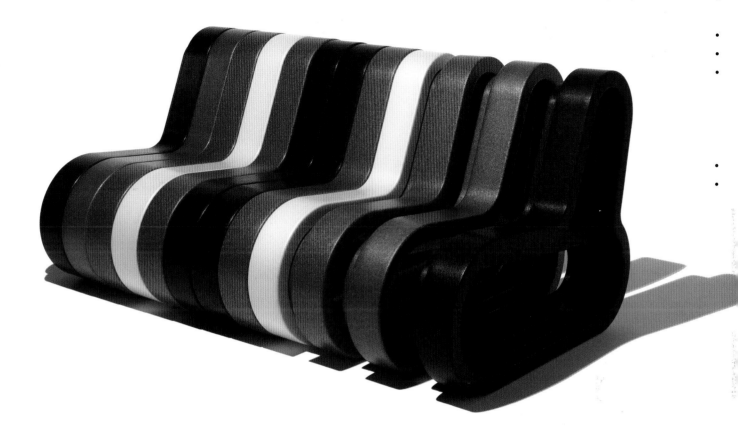

FEEK
Antwerpen, Belgium

Title
The Q-Couch

Type of Work
Que-able furniture

Material
EPP (Expanded polypropylene/ARPRO)

Dimension / Size
950 x 800 x 120 mm

Client
FEEK

Year Produced
2006

Designer
Frederik van Heereveld

Description
One FEEK's last realisations is the unparalleled Q-couch. This couch has been made completely in EPP (Expanded PolyPropylene), the perfect material for FEEK's philosophy. Flexible, futuristic and functional. Still only used in lightweight car-parts or packaging, it is the ideal crossover with design furniture, a completely new approach in the furniture sector. The Q-couch goes even further than that. So as not to curtail the creativity of consumers or architects this couch can be 'Q-ued' in all lengths, shapes and colours in any way you want. It is a creative answer to the contemporary atmosphere of eclecticism and individuality of the ever demanding consumer.

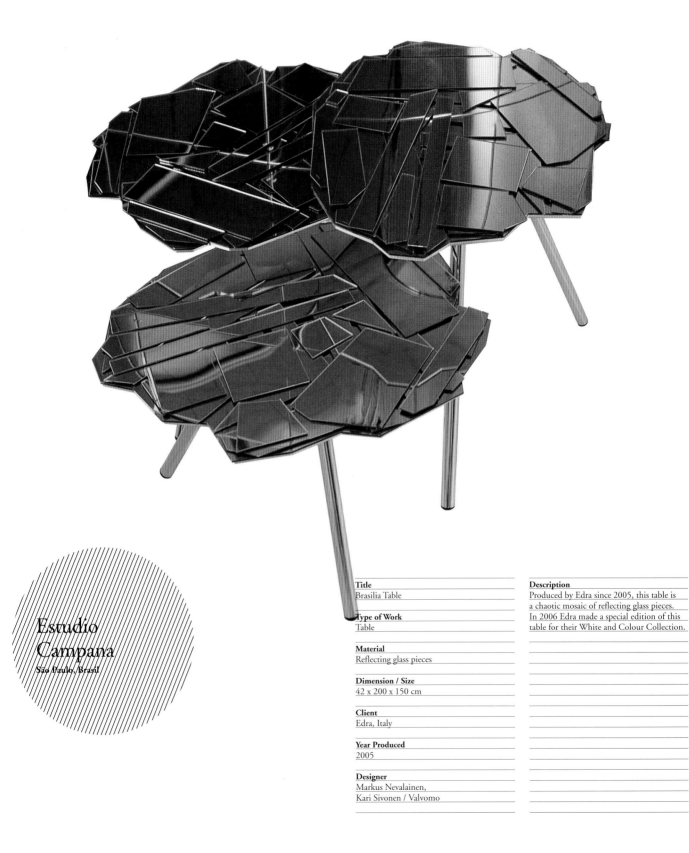

Estudio Campana
São Paulo, Brasil

Title
Brasilia Table

Type of Work
Table

Material
Reflecting glass pieces

Dimension / Size
42 x 200 x 150 cm

Client
Edra, Italy

Year Produced
2005

Designer
Markus Nevalainen,
Kari Sivonen / Valvomo

Description
Produced by Edra since 2005, this table is
a chaotic mosaic of reflecting glass pieces.
In 2006 Edra made a special edition of this
table for their White and Colour Collection.

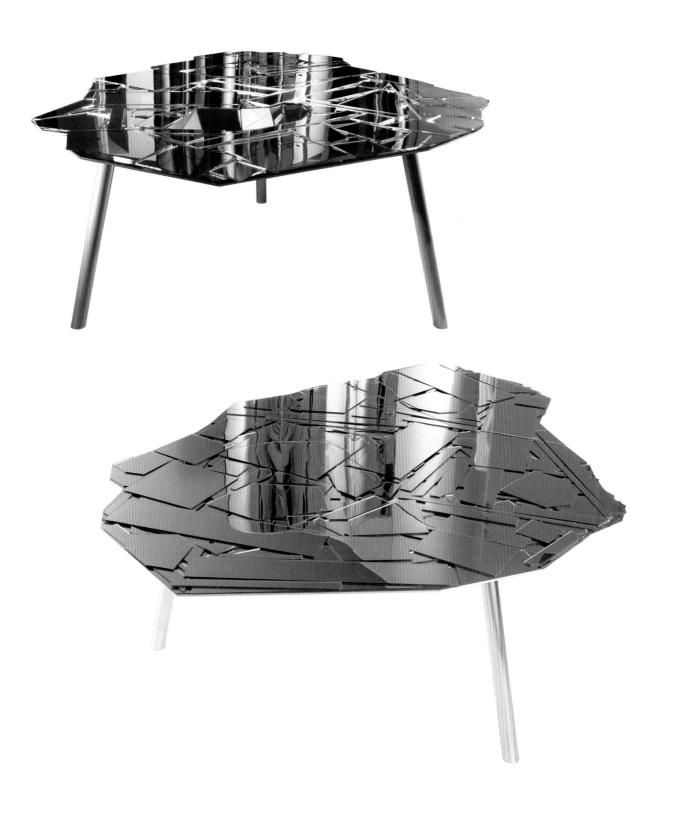

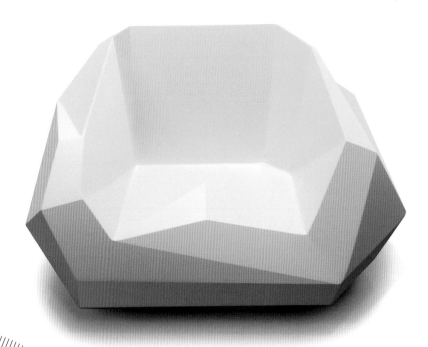

Studio
Rainer Mutsch
Vienna, Austria

Title
Fragments

Type of Work
Furniture

Material
PU (polyurethan) on Polystyrole-core, MDF

Dimension / Size
4.8 x 5.5 m

Client
Swarovski

Year Produced
2005

Designer
Rainer Mutsch

Description
'Bling-bling' now exists in a version you can lounge on. Vienna, Austria based designer Rainer Mutsch presents Fragments, an installation commissioned by crystal connoisseurs Swarovski along with The Crystalweb°, an interactive museum and site dedicated to crystals. Fragments is composed of mdf and plastic and is described by the designer as a 'heavily eroded group of furniture.'

Fragments is Rainer Mutsch's abstract re-interpretation of Wenzel Hablik's (1881 – 1934) historical 'Salon of Itzehoe.' The seating installation was made for an exhibition for Austria's Swarovski/TheCrystalweb° in Vienna.

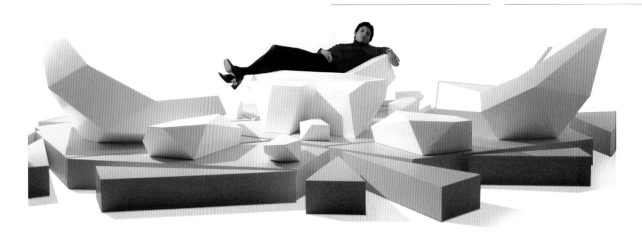

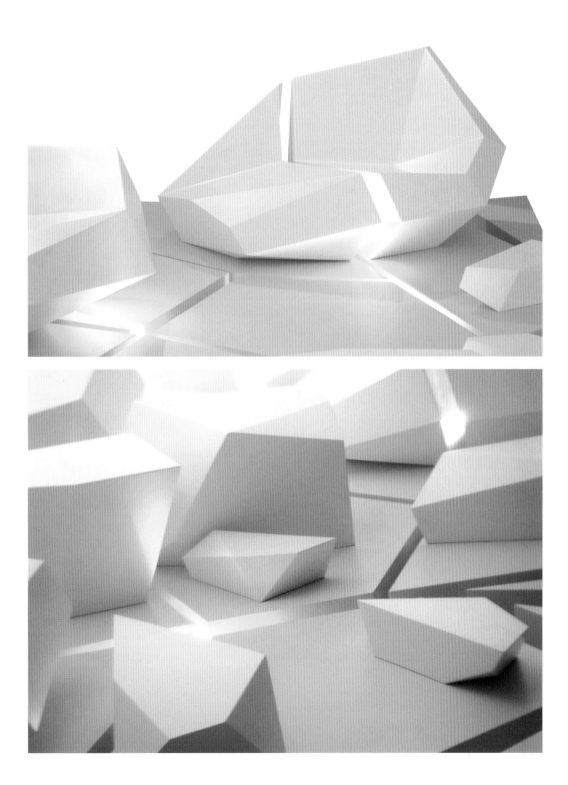

Hiroshi Tsunoda
Design Studio
Barcelona, Spain

Title	Boulevard
Type of Work	Furniture
Material	Laminated wood, Formica
Dimension / Size	2000 x 700 x 415 mm
Client	Formica
Year Produced	2005
Designer	Hiroshi Tsunoda

Description

A rocking chair and chaise longue in one. The laminas are gradated, giving it a special effect of depth from the side. This also makes Boulevard very stable and comfortable.

It is CNC cut with HPL lamination by Formica.

HPL + AR Plus (High Pressure Lamination + shiny finish) by Formica; made with a technology that provides higher resistance to friction, wear and tear and abrasion, meaning there is no loss of shine due to its use.

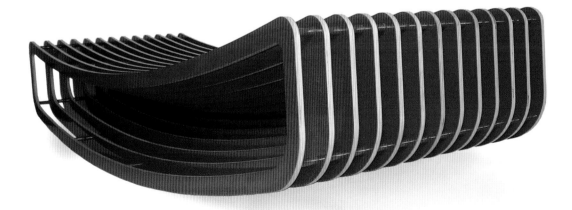

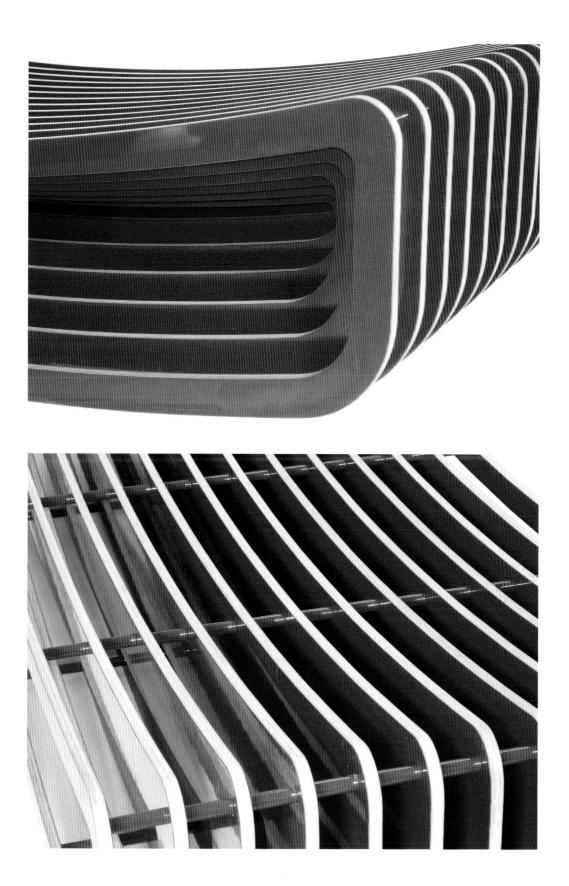

bookhou design
Toronto, Canada

Title
* Table Prototypes ** Bentwood tables

Type of Work
Furniture

Material
* Plywood ** Steam-bent hardwood-ash

Dimension / Size
* Vary
** Vary, Approx. 22" x 56" x 15"

Client
-

Year Produced
* 2002 ** 2005

Designer
John Booth

Description
* The initial experiments attempted to explore the decorative potential of linear elements within curvilinear structures. Many ideas were developed to continue his current work as in this current moment. The work shape and form are determined at the point of production. The nature of conventional design processes within the context of furniture-making where elements are designed and formed is prior to assembly. In addition, this work is 'aleatory' in approach, where repeating patterns and forms evolve into non-repeating forms.

** John used built-up laminated plywood to explore the potential of linear elements in forming curvilinear structures. These elements in turn form 2-dimensional surfaces without the need of conventional sub-structures.

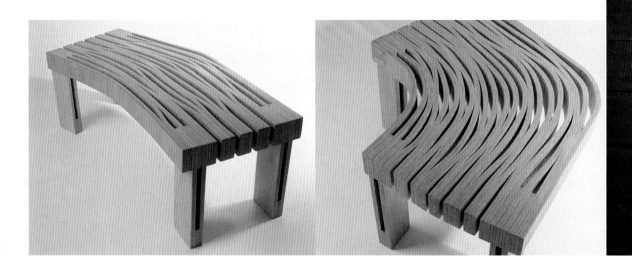

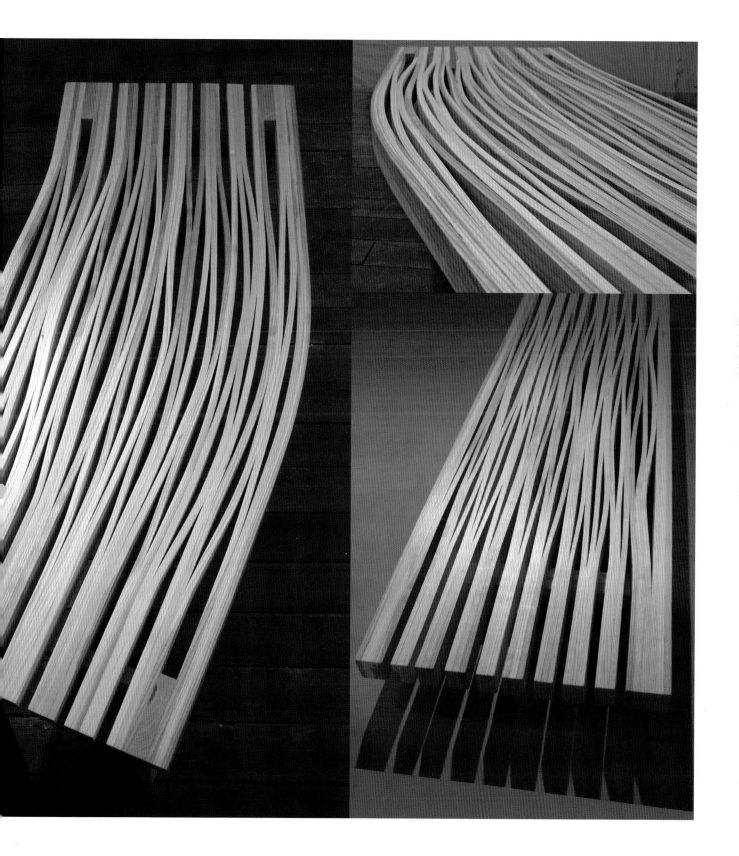

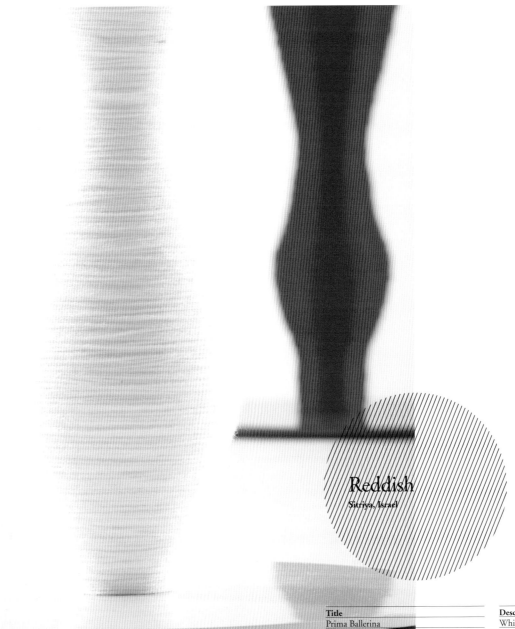

Reddish
Sitriya, Israel

Title
Prima Ballerina

Type of Work
Coffee table

Material
Aluminum, Wool thread

Dimension / Size
Red table – D 48 x H 62 cm
White table – D 56 x H 50 cm

Client
Reddish

Year Produced
2006

Designer
Naama Steinbock, Idan Friedman

Description
Whilst removing material makes the traditional turned wooden leg. The leg of the prima ballerina is made by adding material, by coiling thread around a pole.

This unusual combination produces graceful structures, with soft textured curves. With this technique, an endless number of leg styles is possible, made in different shapes and of different threads and colours.

The Prima Ballerina tables were chosen to be part of the 'Inspired by Cologne' exhibition (and finals of the 'interior innovation award' competition) 2006, in Köln, Germany.

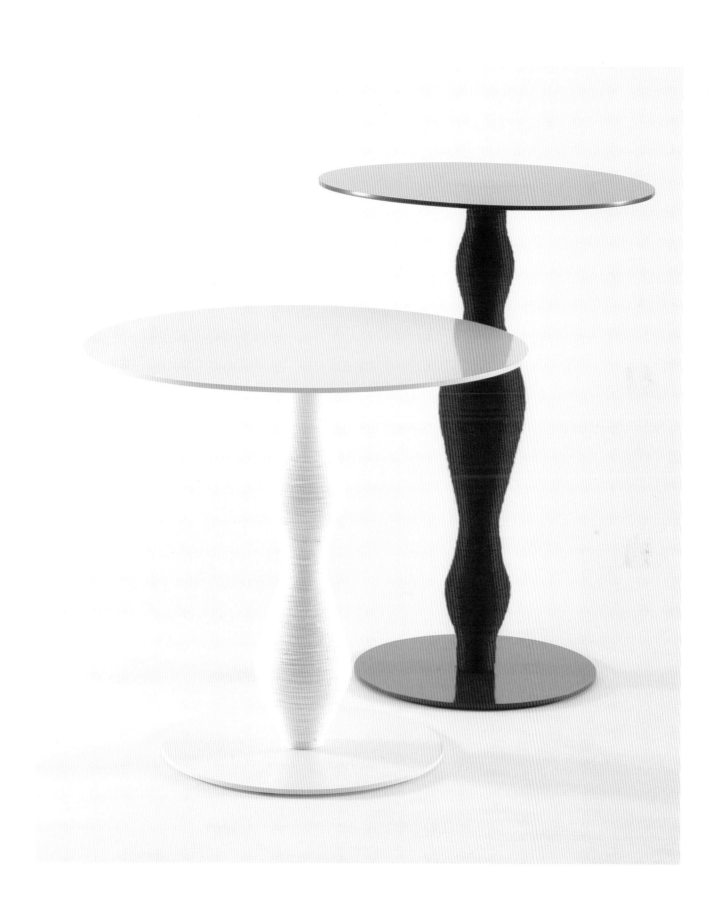

Autoban
Istanbul / Turkey

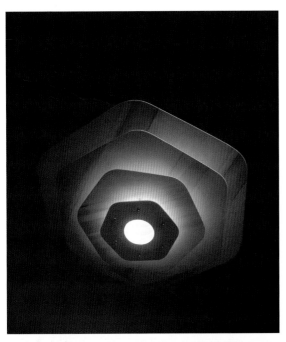

Title
Magnolia

Type of Work
Lighting

Material
Birch plywood

Dimension / Size
D 160 x 100 cm

Client
Autoban

Year Produced
2005

Designer
Seyhan Ozdemir, Sefer Caglar

Description
Hexagonal plywood plates of various sizes (the smallest one placed on top and the bottom) attached to each other by a set of chain cords and Magnolia. Just like the flower it takes its inspiration from, consists of multi layers. The bulb at the center emits the light through the dashes between the layers, creating a dramatic effect. By using plywood as the main material, Autoban once again underlines their attitude towards 'the natural.'

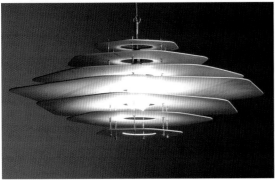

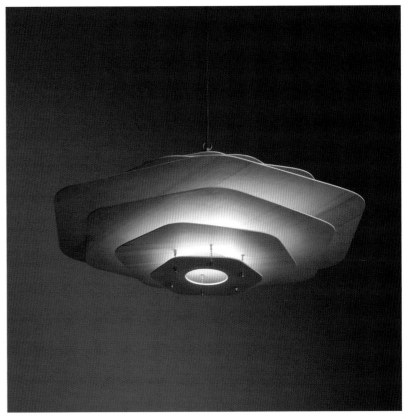

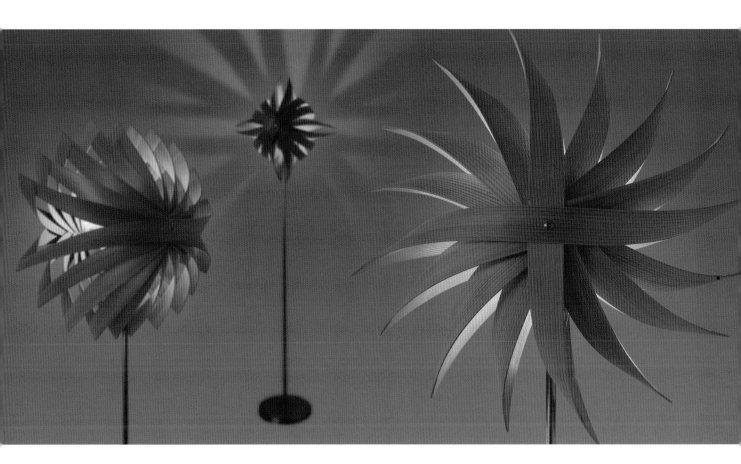

**Toshiyuki
Tani**
Yokohama-shi, Japan

Title	**Description**
Hanabi – Floor (Fireworks stand type)	A work adopted the traditional craft skill and technique called Mage-wappa in Japan.
Type of Work	
Wappa floor	
Material	
AKITA Japan Cedar	
Dimension / Size	
H 66.9" x W 21.6" x D 11.8"	
Client	
-	
Year Produced	
2003	
Designer	
Toshiyuki Tani	

t.n.a. design
studio
London, UK

Title
Square Moon

Type of Work
Lampshade

Material
Yuki Japanese Paper

Dimension / Size
W 25 x H 33 x D 25 cm

Client
Habitat, Stamp Creative

Year Produced
2007

Designer
Tomoko Azumi

Description
Sheets of paper hang across a raster frame. A slot is cut out of the individual sheets to allocate room for the bulb. The row of paper diffuses and directs the light.

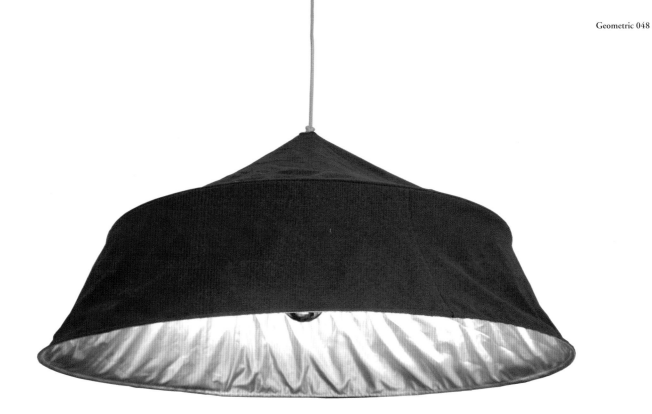

Studio
Bertjan Pot
BH Schiedam, The Netherlands

Title
Large Fold-Up

Type of Work
Light

Material
Textile, Glass fiber rings

Dimension / Size
Approx. D 100 x T 40 cm

Client
Goods

Year Produced
2003

Designer
Bertjan Pot

Description
Constructed like a light reflective screen used by photographers. However, this large foldable light shade is not the slickest thing around, but sure provides you with a nice light over a dinner table or a workspace.

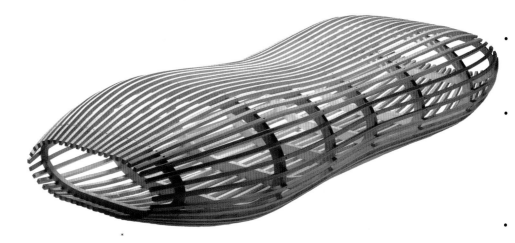

David
Trubridge
Ltd
Havelock North, New Zealand

Title
* Liferaft ** Garden Bench

Type of Work
Furniture, Lighting

Material
* Ash, Hoop pine plywood
** 316 stainless steel, Oiled oak, Painted
hoop pine ply

Dimension / Size
* L 21500 x H 430 x W 930 mm
** L 2200 x W 690 x H 400 mm

Client
David Trubridge Ltd

Year Produced
* 2002 ** 2004

Designer
David Trubridge

Description
* An indoor feature bench seat with a
sculptural form, made from steam bent ash
screwed to hoop pine fames that cut out on
a CNC router.

** An outdoor bench for the garden with a
nautical feel.

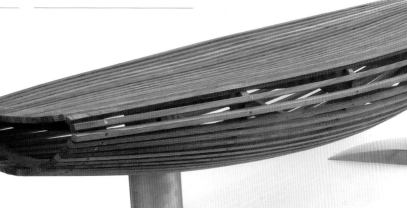

Julian Mayor
London, UK

Title
Impression Chair

Type of Work
Chair

Material
Laminate face plywood

Dimension / Size
650 x 650 x 700 mm

Client
-

Year Produced
2002 (Aluminium version 2007)

Designer
Julian Mayor

Description
Julian Mayor's chairs are an interpretation of the interface between human and technological visual forms; a theme which is present in much of his design and artistic work. The Impression chair was created from the map of a person's seat that was then digitised and sectioned on a computer, creating a realisation of a graphic model 'The way a computer sees is so imprinted into our visual acceptance of things... I created a chair that would look in reality as it does on a screen.'

Impression Chair is a limited edition.

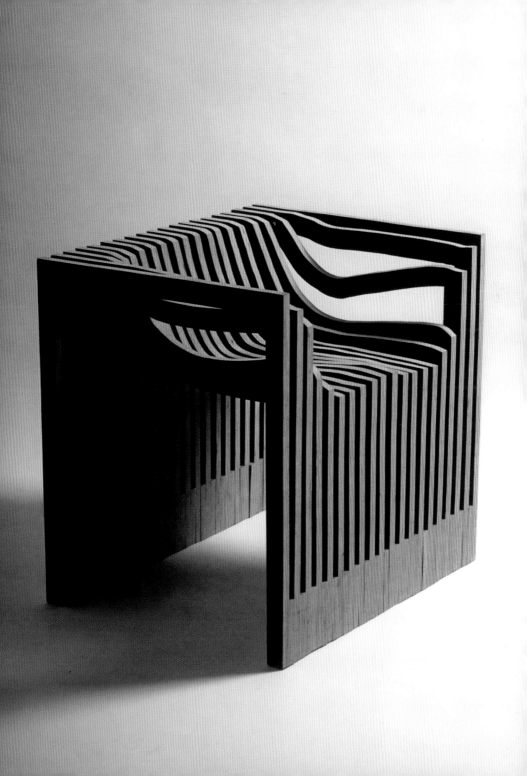

Julian Mayor
London, UK

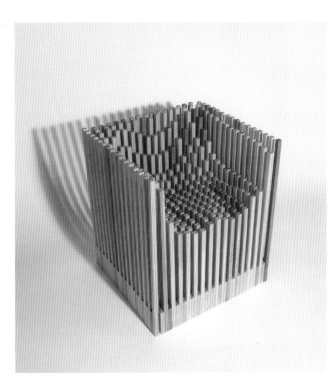

Title
Empress

Type of Work
Chair

Material
Red Deal wood

Dimension / Size
700 x 700 x 700 mm

Client
-

Year Produced
2003

Designer
Julian Mayor

Description
Julian developed the chair's form out of a model of a seated human, and transformed that impression into a computer model. The computer made it into a series of raised sticks. Each stick was cut by hand and glued together one by one. The original chair was made in San Francisco between 2000 and 2002. The designer was impressed by the scale and grids of the streets and buildings in the large American towns. He tried to relate to their scale and to search for a human space there.

Empress is a limited edition.

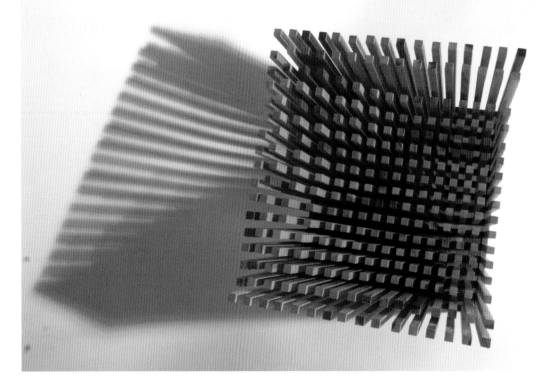

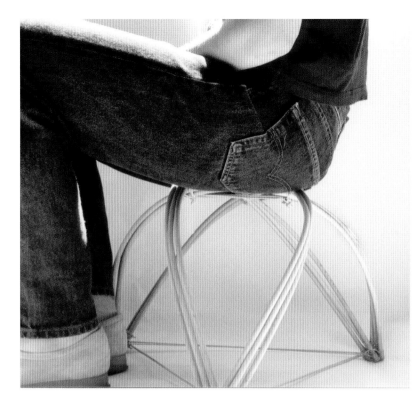

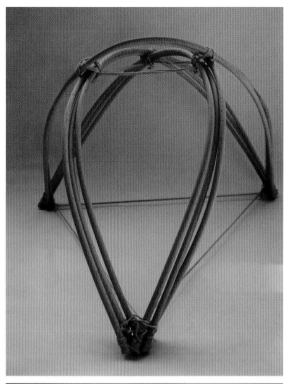

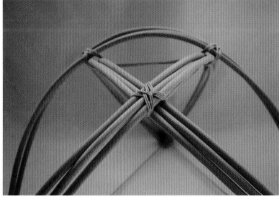

Sternform
Produktgestaltung
Ulm / Germany

Title
Asket

Type of Work
Stool

Material
Bent beech rods, Packaging cord

Dimension / Size
55 x 55 x H 35 cm

Client
Prototype

Year Produced
2001

Designer
Andrea Grossfuss,
Sternform Produktgestaltung

Description
The Asket is a sturdy lightweight stool that is solely built from bent and stretched beech rods and packaging cord.

Using the form of semi-circles which are arranged to form several triangles, the pressure distribution and stability reach an optimum. To keep the flexibility and with this the maximum load of the stool, no adhesives are used.

WOOD london

London, UK

Title
Umbrella

Type of Work
Table

Material
Layered laser-cut birch Ply, Circular
Perspex top

Dimension / Size
Folded: 23 x H 49 cm
Open: 93 x H 40 cm

Client
-

Year Produced
2006

Designer
Bethan Laura Wood

Description
'Umbrella' is a table based on its namesake.
It combines layered laser-cut birch ply with
a circular Perspex top, which may be hung
on the wall when the base is folded. It is
designed to be an object of beauty both in
use and folded. Unlike most other foldaway
tables the aesthetics of which are often lost or
awkward when folded. 'Umbrella' prompts
people to re-think the objects around them,
as to see the hidden beauty; its mechanism
provides both visual and physical pleasure.

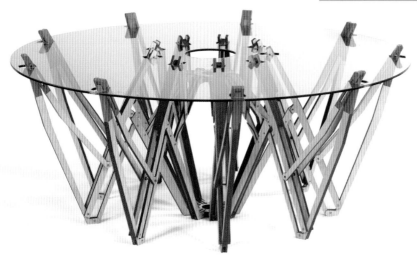

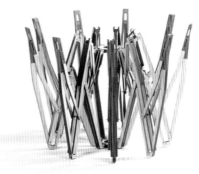

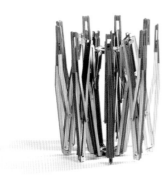

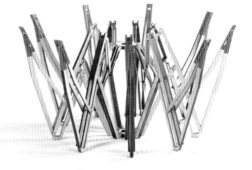

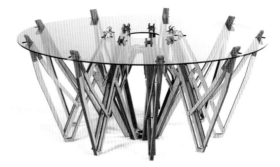

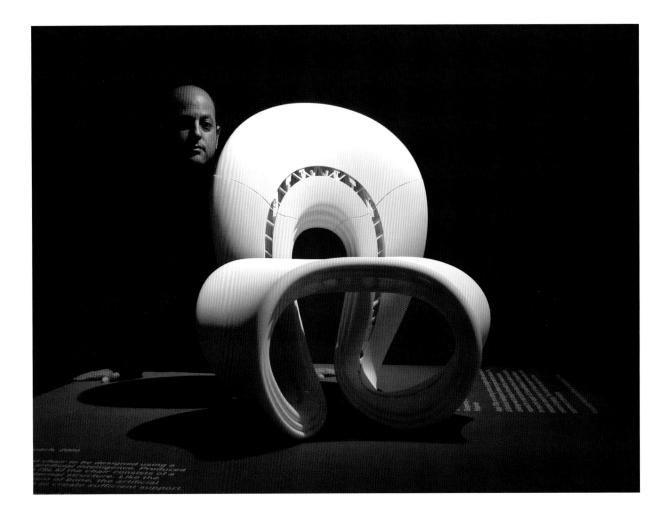

ASSA
ASHUACH
STUDIO
London, UK

Title
Osteon Chair

Type of Work
Chair

Material
Polyimide

Dimension / Size
130 x 70 x 50 cm sitting at 40 cm

Client
ASSA ASHUACH STUDIO

Year Produced
2006

Designer
Assa Ashuach

Description
The Osteon Chair is the first chair to be designed using 3-dimensional tools and AI (Artificial Intelligence) software.

Produced using Selective Laser Sintering (SLS) the chair consists of a cosmetic skin and intelligent internal structure. Like the biological structure and mechanism of bone, the AI software knows where to create sufficient support.

Together with Dr Siavash Mahdavi of Complex Matters we manage to create a progressive workflow were stress analysis and intelligent tools are being part of the design process.

The work is sponsored by EOS, Autodesk and London Metropolitan University.

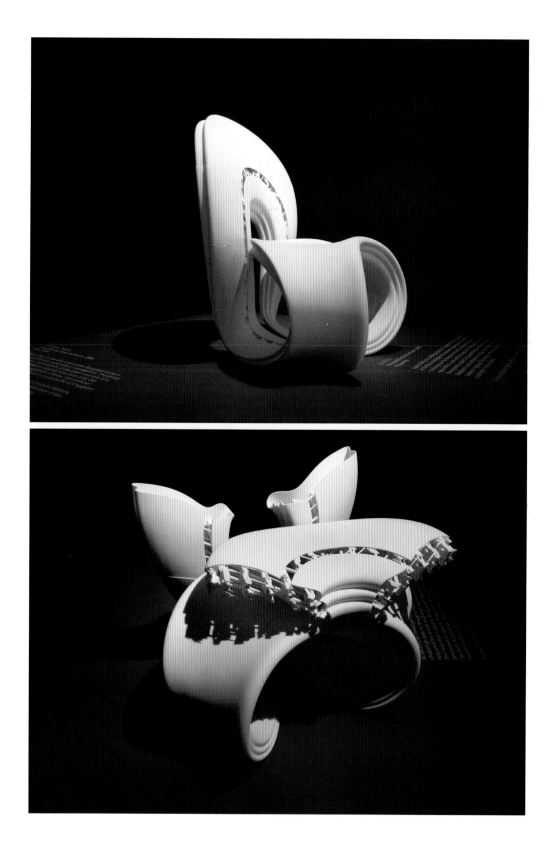

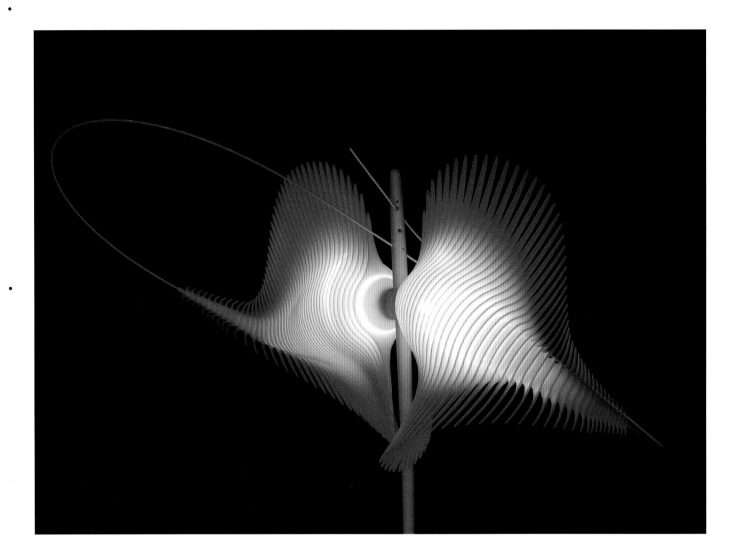

ASSA
ASHUACH
STUDIO
London, UK

Title
FLY.mgx prototype

Type of Work
Furniture

Material
Polyimide

Dimension / Size
FLY.mgx Table, 60 x 40 x 10 cm
FLY.mgx floor, 60 x 140 x 10 cm

Client
Materialise MGX

Year Produced
2006

Designer
Assa Ashuach

Description
FLY.mgx is the sister of OMI. As a table/
floor light it is designed to be viewed from
front rather then from bottom like the OMI
pendent. Like the OMI it can morph for
endless forms to be personalised for a user
or space. In the past we use to invest a lot
in creating expensive tools and moulds for
generating one look-alike product, today we
can take the same idea and modify it slightly
to perform better at different tasks with out
any additional cost.

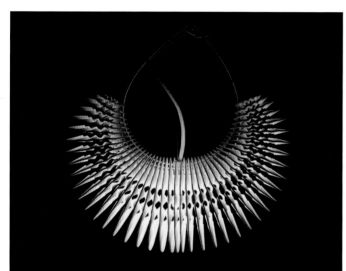

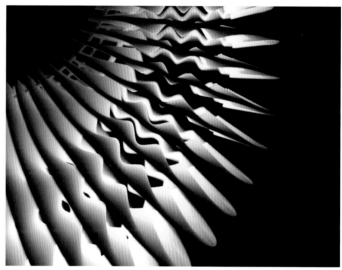

ASSA
ASHUACH
STUDIO
London, UK

Title
OMI.mgx

Type of Work
Lamp

Material
Polyimide

Dimension / Size
36 x 36 x 25 cm

Client
Materialise MGX

Year Produced
2005

Designer
Assa Ashuach

Description
The OMI.mgx lamp is a nylon structure. It is one part made from one material. The nylon diffuses the light very well and creates the illusion of 'solid light'. The form of the object, together with the natural flexibility of the nylon, creates the impression of a biological mechanism. By a bent or a twist this, structure's shape can be transformed. Like a worm or an armadillo, if you twist one end, the rest will follow. This behaviour makes this lamp a versatile product that can be either adjusted to different spaces, or function as a space manipulator using different light diffusions and sculptural elements.

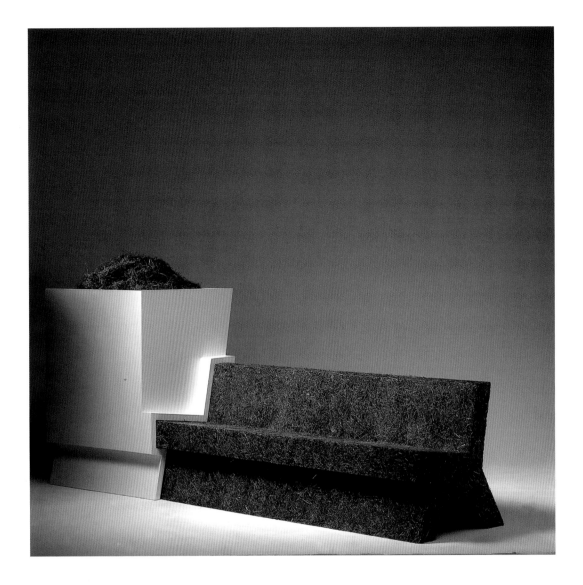

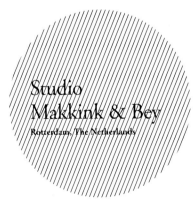

Studio
Makkink & Bey
Rotterdam, The Netherlands

Title
Extrusiebank (Gardening bench)

Type of Work
Artwork

Material
Wood, Hay

Dimension / Size
200 x 70 x 80 cm

Client
Droog Design for Oranienbaum

Year Produced
1999

Designer
Jurgen Bey

Photographer
Marcel Loermans

Description
The garden is well looked after, all year round. Each season has its own colours, smells and waste. The hay of the summer, the prunings and leaves of the Autumn, all of these can be used for non-durable furniture. Extrusion containers press the garden waste into endless benches which can be shortened to any length. It is up to nature to decide when it'll reclaim them back.

The work is under Droog Design 's collection.

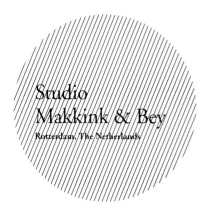

Studio
Makkink & Bey
Rotterdam, The Netherlands

Title
Extrusie stoelen (Gardening chair)

Type of Work
Wood, Mixed natural material

Material
Wood, Hay

Dimension / Size
Vary x 70 x 80 cm

Client
Droog Design for Oranienbaum

Year Produced
1999

Designer
Jurgen Bey

Photographer
Marcel Loermans

Description
The garden is well looked after, all year round. Each season has its own colours, smells and waste. The hay of the summer, the prunings and leaves of the Autumn, all of these can be used for non-durable furniture. Extrusion containers press the garden waste into endless benches which can be shortened to any length. It is up to nature to decide when it'll reclaim them back.

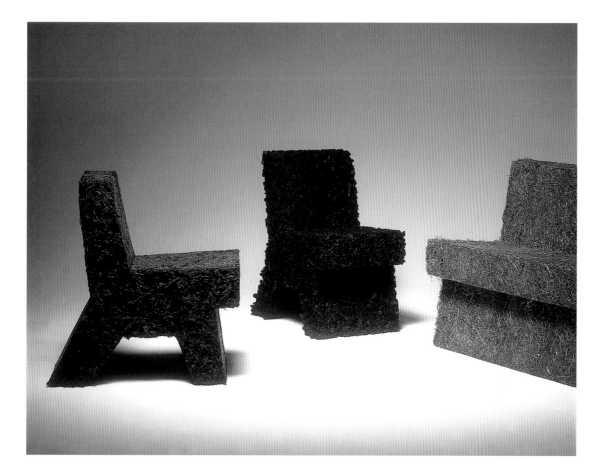

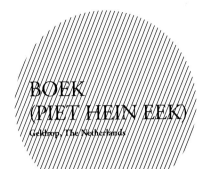

BOEK
(PIET HEIN EEK)
Geldrop, The Netherlands

Title
Dentist's denture moulds cabinet

Type of Work
Furniture

Material
Aluminium, Scrapwood high gloss laquer

Dimension / Size
300 x 50 x 90 cm

Client
Dentist

Year Produced
2004

Designer
Piet Hein Eek

Description
-

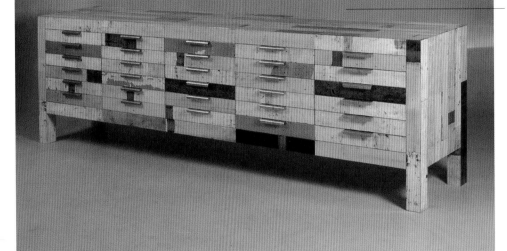

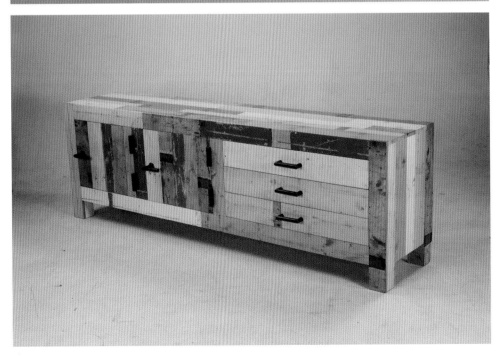

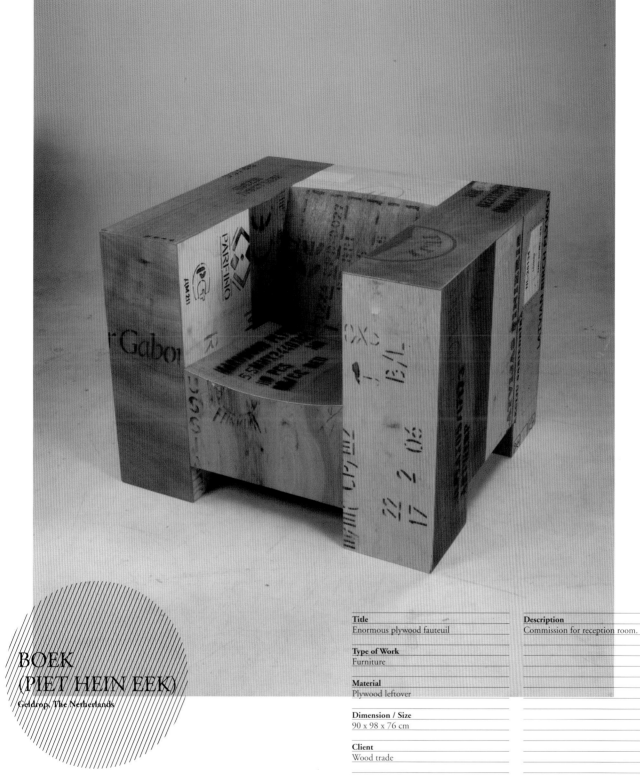

BOEK
(PIET HEIN EEK)
Geldrop, The Netherlands

Title	Description
Enormous plywood fauteuil	Commission for reception room.

Type of Work
Furniture

Material
Plywood leftover

Dimension / Size
90 x 98 x 76 cm

Client
Wood trade

Year Produced
2006

Designer
Piet Hein Eek

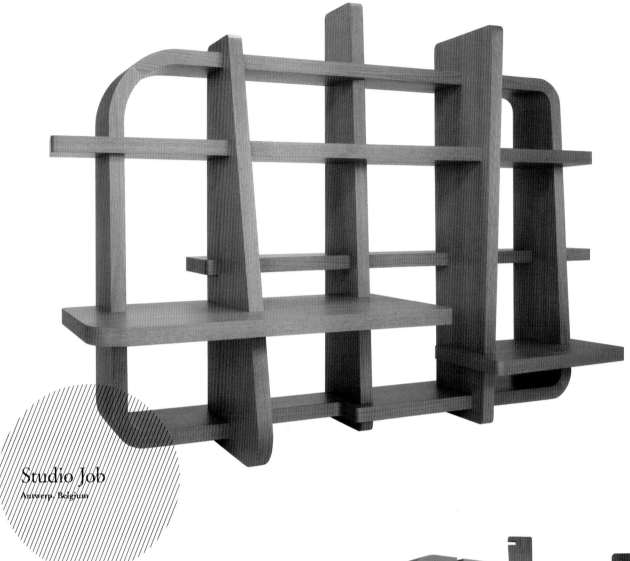

Studio Job
Antwerp, Belgium

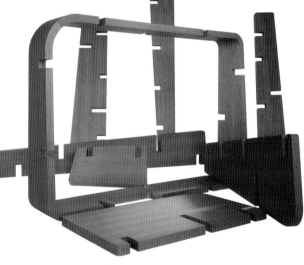

Title
Modular cabinet

Type of Work
Furniture

Material
Multiply board, French oak veneer

Dimension / Size
350 x 240 x 120 cm

Client
-

Year Produced
2000

Designer
Studio Job

Description
The work is collected by Stedelijk Museum Amsterdam.

Studio Job
Antwerp, Belgium

Title
* Be sofa ** Be chair

Type of Work
Furniture

Material
Multiply board, French oak veneer

Dimension / Size
* 40 x 80 x 40 cm
** 50 x 85 x 80 cm

Client
-

Year Produced
2001

Designer
Studio Job

Description
Both designs are collected by Central Museum Utrecht.

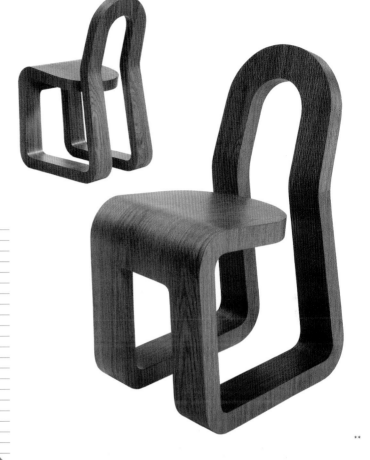

**

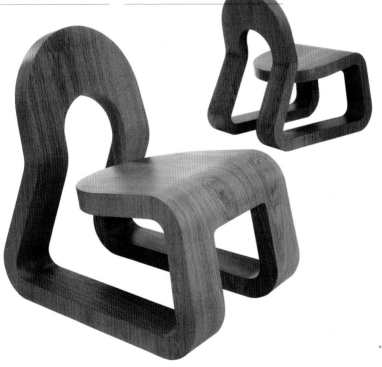

*

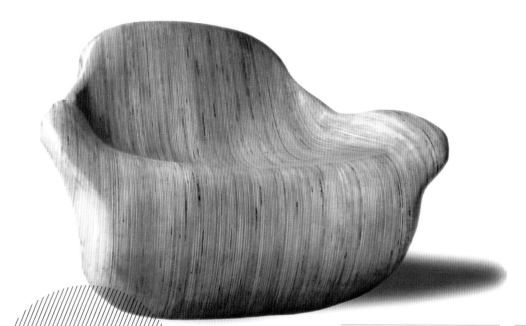

Stew Design
Workshop
Boston, USA

Title
Strata Chair

Type of Work
Furniture

Material
Laminated poplar plywood

Dimension / Size
W 35" x H 28" x D 35"

Client
Stew Design Workshop

Year Produced
2002

Designer
Jon Racek, Kevin Racek

Description
Inspired by the geological formations of the American Southwest, the Strata Chair borrows heavily from the process of erosion. The outside of the chair is ground and sanded to the point of smoothness and ergonomic satisfaction, while the inside of the hollow chair is left raw, as if untouched by the elements.

From some angles, the chair is monolithic but upon closer inspection it is actually layer upon layer of wood – 48 rings of laminated plywood. Continuous layers of sediment are later shaped and molded by erosion to expose nuances of colour and striations. Likewise, the process behind the Strata Chair reveals the subtleties of each piece of plywood in its composition, rendering each chair unique and beautiful.

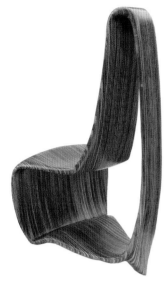

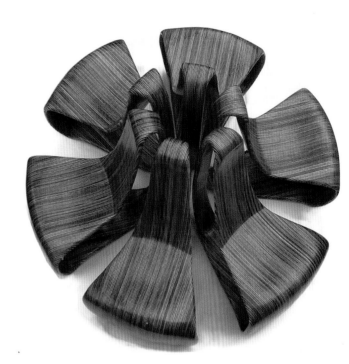

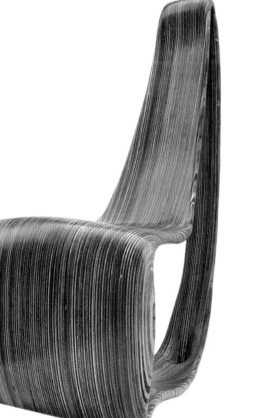

Stew Design
Workshop
Boston, USA

Title
Petal Chair

Type of Work
Furniture

Material
Laminated poplar plywood

Dimension / Size
W 26" x H 47" x D 33"

Client
Stew Design Workshop

Year Produced
2002

Designer
Jon Racek, Kevin Racek

Description
Equally fitting in a grand hotel lobby or at a dining room table. Petal Chair is inspired by the blossoms of a Dendrobium orchid commonly used in Hawaiian leis. As a solitary piece, the emphasis falls on the contrast between the slender back and the fuller front profile. When brought together in a grouping of 6, the organic nature inherent in the design becomes even more apparent.

Due to its mutability, banality and its hidden charms, plywood was the production material of choice in the construction of the Petal Chair. Plywood, mostly utilized by artists and designers in the last 50 years who sought to create beauty from commonplace materials. By highlighting the core of the plywood instead of the face, the tremendous scope of colours contained within in this everyday material is revealed and exalted.

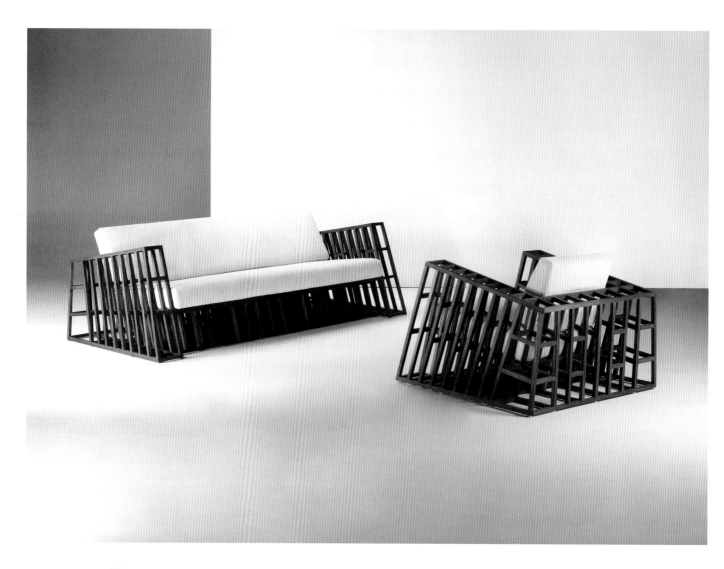

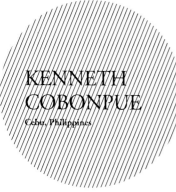

KENNETH
COBONPUE
Cebu, Philippines

Title
Tilt!

Type of Work
Furniture

Material
Walnut or mahogany (indoor)

Dimension / Size
Easy armchair: D 93 x W 93 x H 62 cm
Sofa: D 93 x W 207 x H 62 cm

Client
Kenneth Cobonpue

Year Produced
2002

Designer
Kenneth Cobonpue

Description
American Walnut or mahogany pieces are individually cut and fastened together with dowels.

organic
orgánicos
organisch
有機性
オーガニック
유기적인

'Organic,' which derives from organisms, it may be one of the greatest discoveries in history. The creation of life forms is always the most admiring yet mysterious topic of all. People are inspired by such creative idea; therefore, numerous works were done under the influence of fascinations.

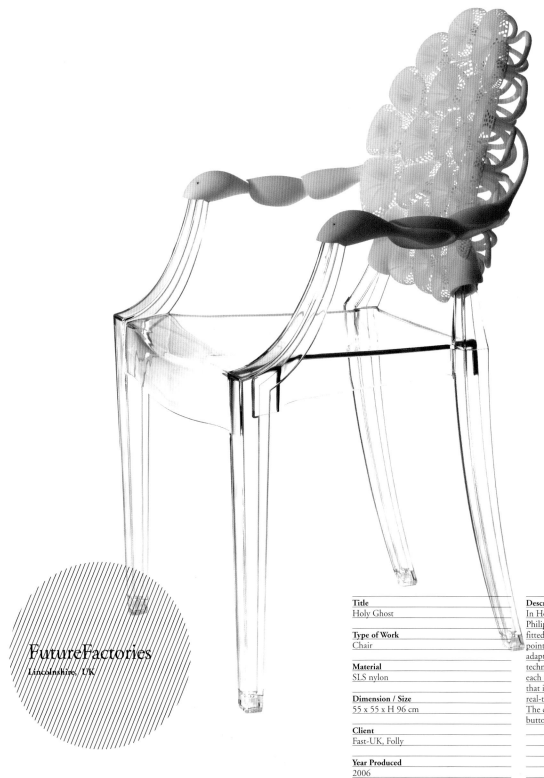

FutureFactories
Lincolnshire, UK

Title
Holy Ghost

Type of Work
Chair

Material
SLS nylon

Dimension / Size
55 x 55 x H 96 cm

Client
Fast-UK, Folly

Year Produced
2006

Designer
Lionel T Dean

Description
In Holy Ghost, Lionel has taken the idea of Philippe Stark's iconic Louis Ghost chair and fitted it with an alternative back and arms pointing out the creative possibilities for adaptation and personalisation that digital technologies offer. The starting point for each new back is a virtual design template that is constantly rebuilding itself in real-time. No two iterations are the same. The chair back, resembling alien, organic, button-leather, acts like a sprung mattress.

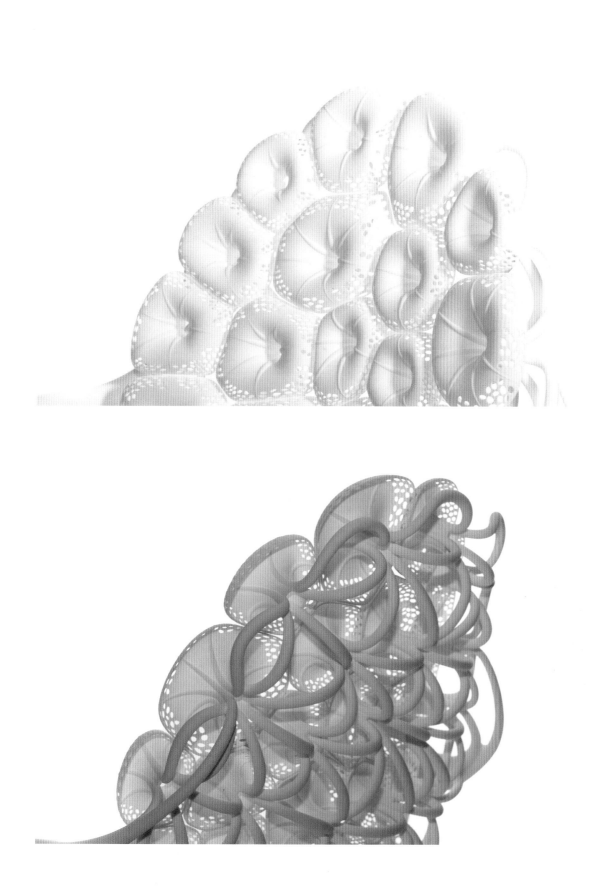

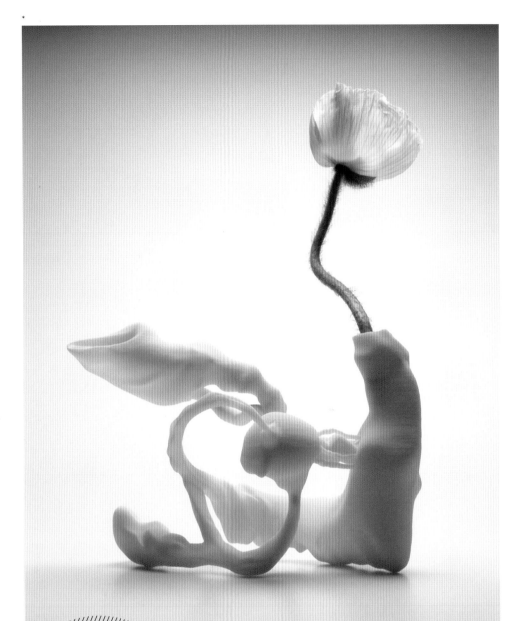

Marcel Wanders Studio
Amsterdam, The Netherlands

Title
Airborne Snotty Vases (* Ozaena ** Coryza
*** Influenza **** Sinusitis ***** Pollinosis)

Type of Work
Vases

Material
Polyamide

Dimension / Size
H 15 x W 15 x D 15 cm

Client
-

Year Produced
2001

Designer
Marcel Wanders

Photographer
Maarten van Houten

Description
Cappellini introduced the airborne snotty
vase in Milan 2001, and it is now part of
the Wanders Wonders collection. Airborne
Snotty Vases is a collection of 5 different
vases. The design is based on a 3D scan of
airborne snot and finally produced using a
digital prototyping technology.

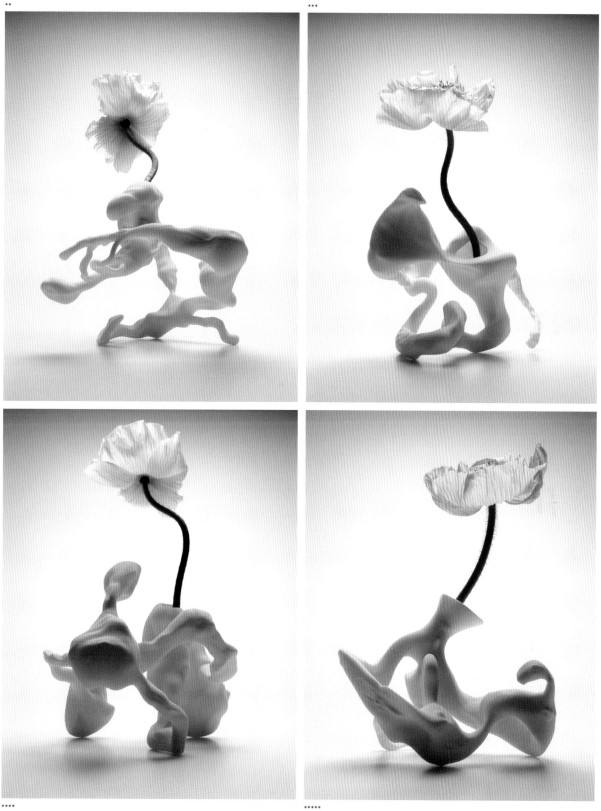

Studio Job
Antwerp, Belgium

Title
* Day in day out ** Cells

Type of Work
-

Material
Biscuit porcelain

Dimension / Size
* 18 cm round ** 15 cm round

Client
-

Year Produced
2005-2006

Designer
Studio Job

Description
Both designs are collected by Groninger Museum and produced by Royal Tichelaar Makkum.

*

**

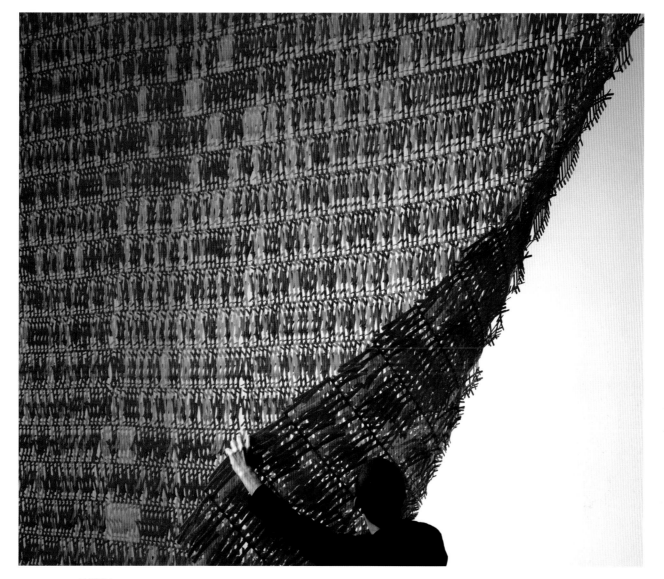

ERB
Paris, France

Title	**Photographer**
Twigs	Paul Tahon
Type of Work	**Description**
Wall installation / Branches	The project of the Twigs is based on the possible multiplication of a tiny 3D motif.
Material	This piece, which resembles a small branch, is injected in polypropylene. Simply, with
Polypropylene	different colours and various alternate
	connections, we tried to create an irregular
Dimension / Size	skin. In this instance the repetition generates
20.9 x 8.6 x 2.5 cm	a certain visual complexity.
Client	
Vitra, Switzerland	
Year Produced	
2002 (The Edition Vitra, 2004)	
Designer	
Ronan Bouroullec, Erwan Bouroullec	
Photographer	
Paul Tahon	

FutureFactories
Lincolnshire, UK

Title
Creepers

Type of Work
Modular LED lighting system

Material
SLS nylon

Dimension / Size
Stems: L 28 cm

Client
Materialise-mgx, Belgium

Year Produced
2005

Designer
Lionel T Dean

Description
Creepers floats 'cloud like' dividing living space with decorative light. A Creepers installation is made up of stems that clip between vertical low voltage suspension cables. The stems are attached to the wires in a seemingly random disorder, clustered in groups, and reaching out in 'spore-like' trails. The apparently chaotic jumble is in fact a series of highly efficient reflectors arranged to maximize the output from tiny, ultra low power consumption, LED's. The form is inspired by growth structures from the natural world and stems from the designer's work on generative designs.

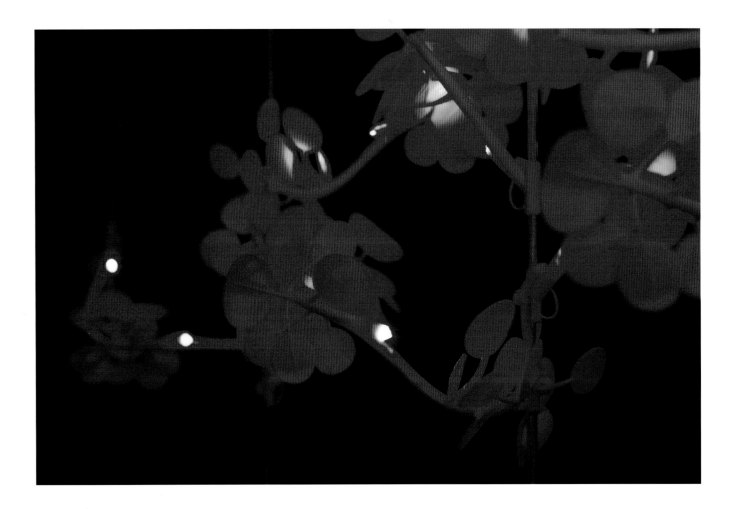

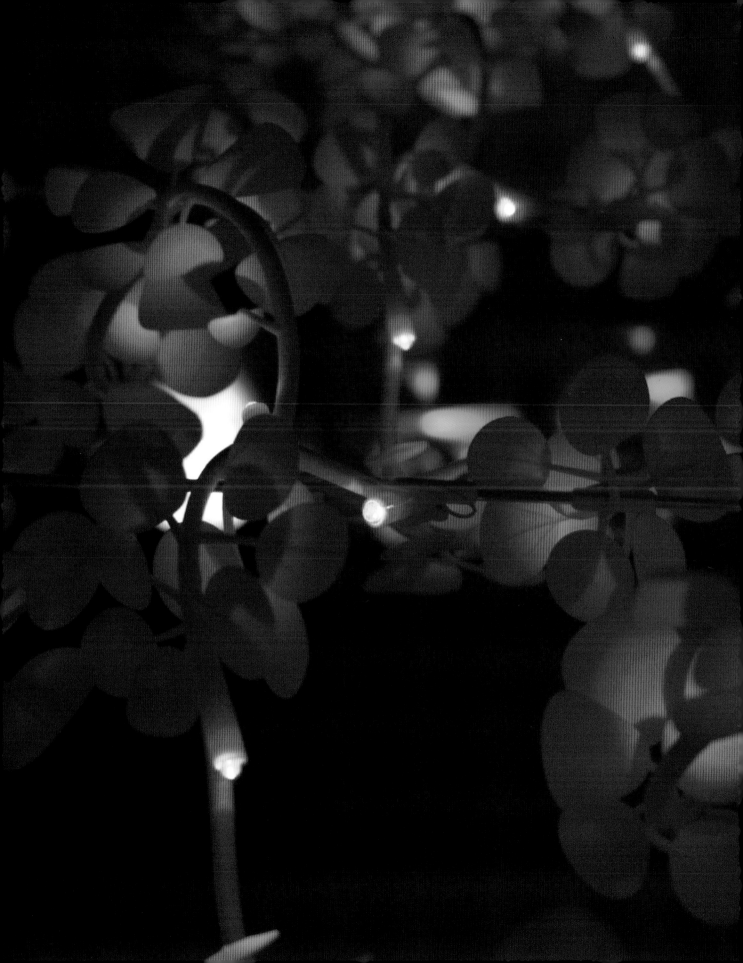

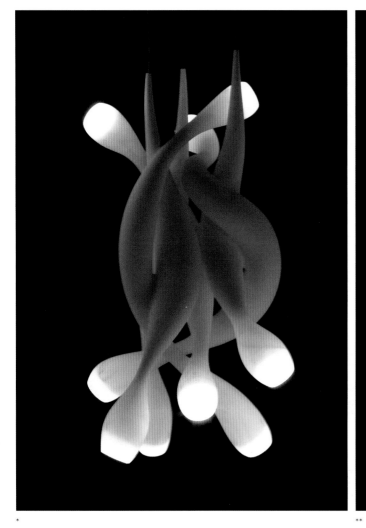

*

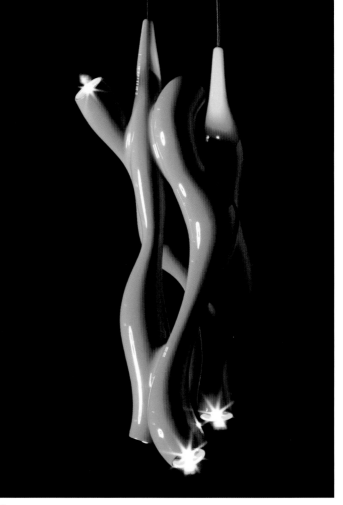

**

FutureFactories
Lincolnshire, UK

Title
* Tuber ** Tuber9 *** Lampadina Mutanta

Type of Work
LED suspension lamp

Material
* and ** Resin composite
*** Cast stainless steel

Dimension / Size
*12 x 12 x H 28 cm
** 22 x 22 x H 38 cm
*** 9 x 9 x H 26 cm

Client
FutureFactories production

Year Produced
* 2003 ** 2004 *** 2003

Designer
Lionel T Dean

Description
* and ** Tuber and Tuber9 are made up of
interwoven tuberous forms hanging from
fine, low voltage, cables. The forms are
derived from an animated virtual model
giving rise to a series of unique designs. In
2005 Tuber9 was acquired by MoMA, the
Museum of Modern Art in New York for its
permanent Design Collection.

*** The idea is that of a conventional GLS
light bulb that has mutated and sprouted led
tentacles – hence 'Lampadina Mutanta.'

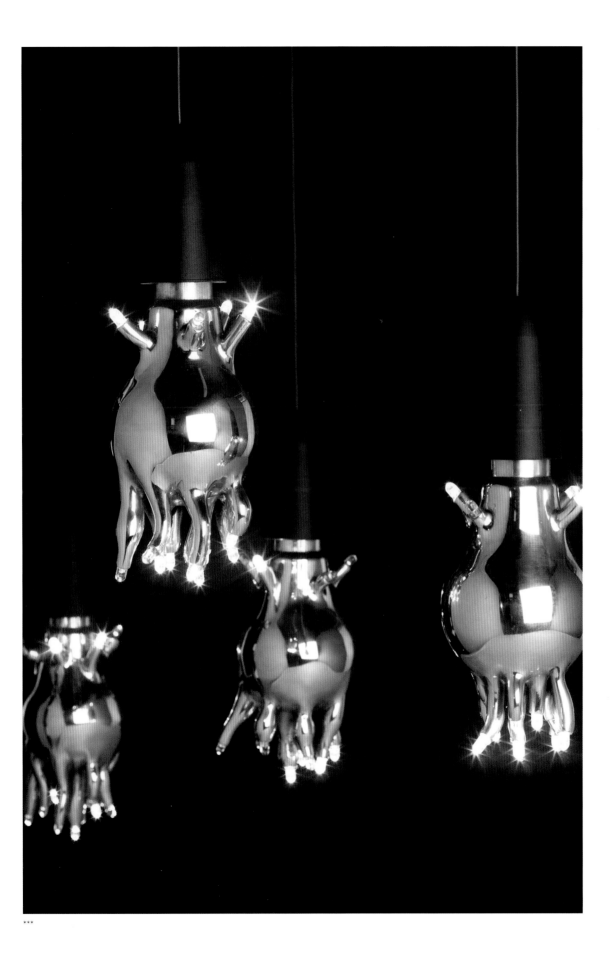

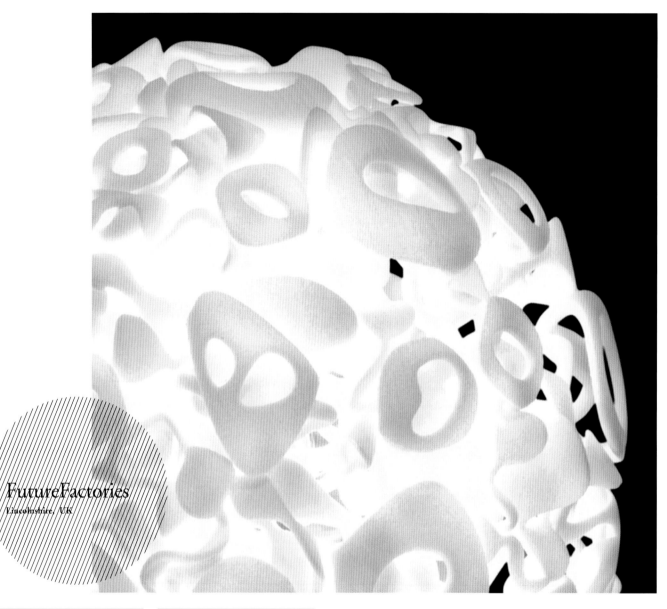

FutureFactories
Lincolnshire, UK

Title
Entropia

Type of Work
Table, suspension and wall lamp family

Material
SLS nylon

Dimension / Size
Diffuser: D 120 mm

Client
Kundalini, Milan, Italy

Year Produced
2006

Designer
Lionel T Dean

Description
Manufactured and marketed by Kundalini, Milan, Italy. In this design, FutureFactories algorithms create an interwoven growth of organic but alien flower like forms.

Oboiler
New York/ USA

Title
Plaited Cord

Type of Work
Electronics management experiment

Material
Knotted standard 110v extension cord

Dimension / Size
Approx. D 4" x L 24" (Segments)

Client
-

Year Produced
2006

Designer
Karl Zahn

Description
In an effort to keep the fantastic art of rope work alive and to solve the problem of overwhelming electronic entanglement, the designer attempts to link the 2 as a repurposed technology solution.

The Plaited Cord utilizes the very same knitting technique sailors used to create thick hawsers for mooring ships. Because of the stiffness of the electrical cord it has a hollow interior that serves as a tube for running other types of wire and cable to the same destination. The cords are individually about 24" long but can be connected like a standard electrical cord to form an infinitely long tube. The concept is adaptable to other forms of wire also and the Plaited Cord can be made to match any colour scheme.

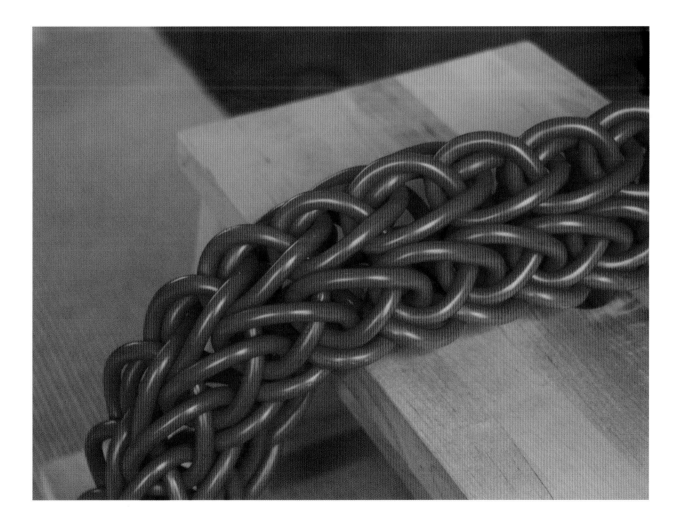

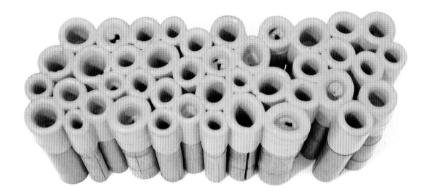

**Sylvain Willenz
Design Studio**
Brussels, Belgium

Title
Dr. Bamboozle

Type of Work
Seating – bench, stools

Material
Rubber, Bamboo

Dimension / Size
Bench: 100 x 40 x 30 cm
Stool: 43 x 25 x 25 cm

Client
Sylvain Willenz Design Studio

Year Produced
2006

Designer
Sylvain Willenz, James Carrigan

Description
An exploration into the cultural relevance of bamboo in a western context and production possibilities with rubber. Qualities of bamboo are celebrated and injected with a new material and process. Lengths of Bamboo are strapped into shape and dipped into a contrasting bright yellow rubber. Once cured, the rubber acts as a bonding agent, holding the seating structures together.

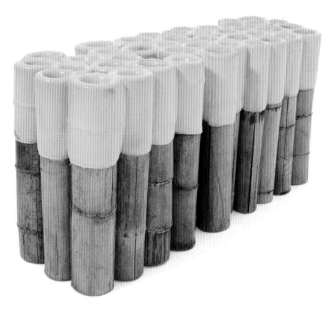

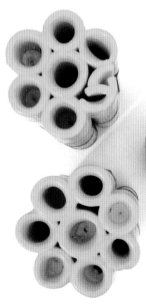

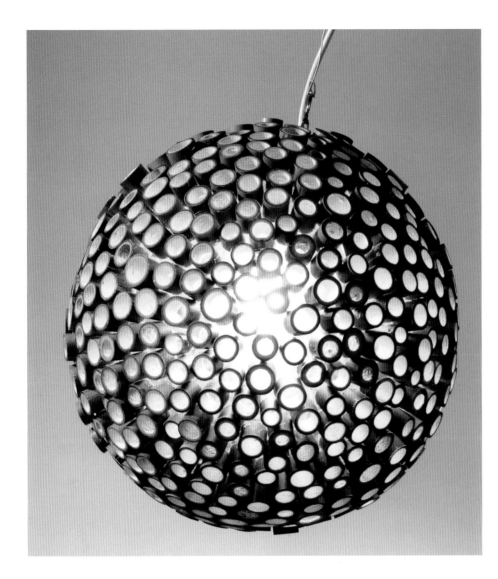

Object d'art
London, UK

Title
Bambooo

Type of Work
Lighting

Material
Sustainable Bamboo

Dimension / Size
Vary, D 400 m

Client
Lighting Association

Year Produced
2006

Designer
Tom Abbott

Photographer
Paul Tristram

Description
Bambooo by Tom Abbott is a ceiling and table light. It uses an energy saving bulb and fitment which is kind to the environment.

The natural beauty of this material emits glowing beams of soft light, casting elliptical contrasts of shadow and light around the room. Its organic form and material help to create a calming atmosphere.

Aqua
Creations
Ltd.
Tel Aviv, Israel

Title
Bubbles

Type of Work
Furniture

Material
Silver Lycra

Dimension / Size
H 71 x W 48 cm

Client
-

Year Produced
2000

Designer
Ayala Serfaty

Description
A byte-sized silver Lycra low stool.

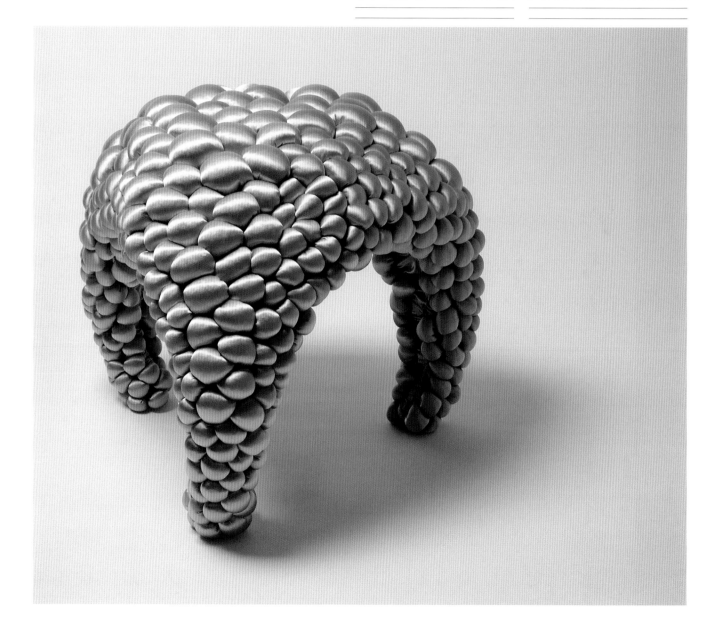

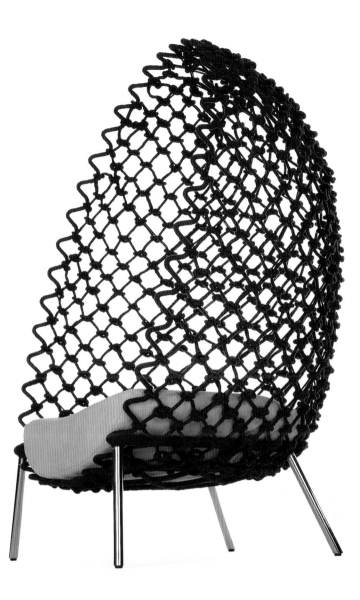

KENNETH
COBONPUE
Cebu, Philippines

Title
Dragnet

Type of Work
Furniture

Material
Indoor: Polycotton fabric, Steel
Outdoor: Sunbrella fabric, Steel

Dimension / Size
Lounge chair: D 84 x W 105 x H 136 cm

Client
Kenneth Cobonpue

Year Produced
2005

Designer
Kenneth Cobonpue

Description
Polycotton fabric (indoor) and Sunbrella
fabric (outdoor) is twisted and wrapped
around a frame of powder coated steel. Legs
are made of stainless steel.
.

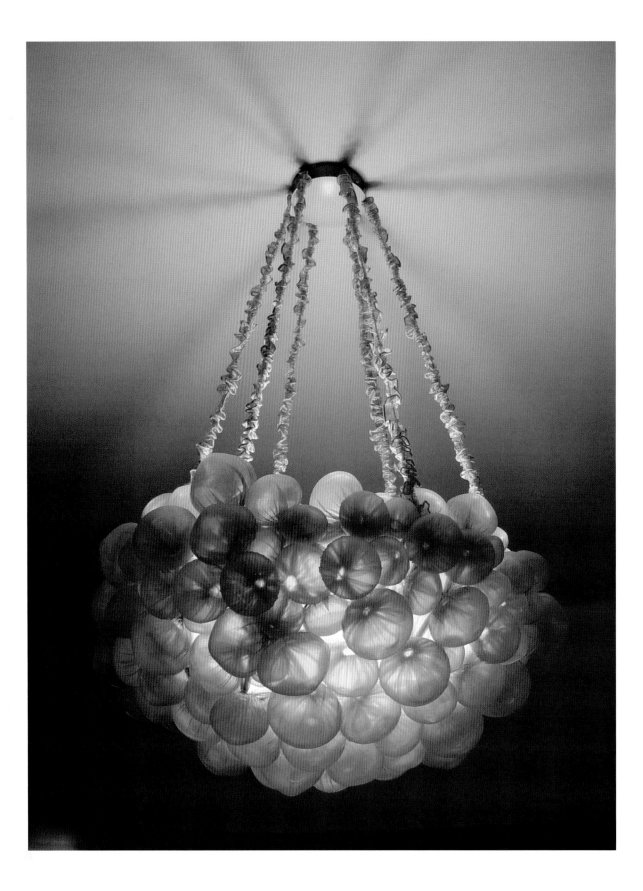

Aqua
Creations
Ltd.
Tel Aviv, Israel

Title
Blondie Eee

Type of Work
Lighting

Material
Hand-blown clear glass drops,
'Golden Mist' fabric

Dimension / Size
H 100 x L 50 x W 50 cm

Client
-

Year Produced
2000

Designer
Ayala Serfaty

Description
Blondie Collection is made of luxurious
hand-blown clear glass drops and wrapped
'Golden Mist' fabric.

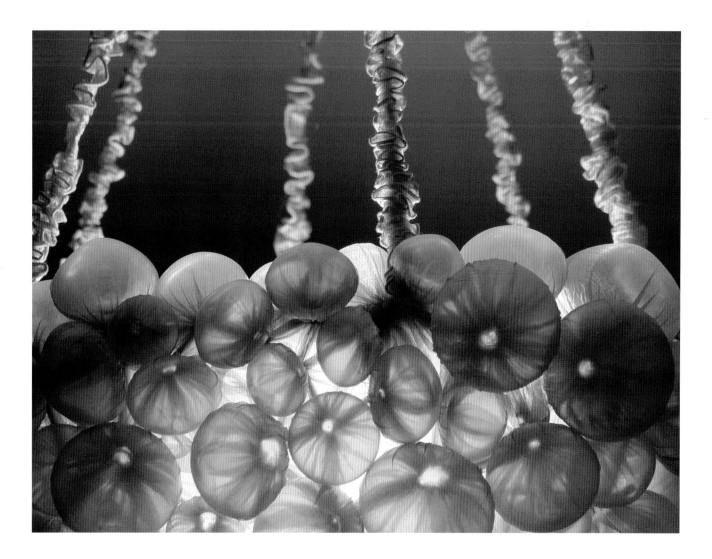

Tjep.
Amsterdam, The Netherlands

Title
XXLChair

Type of Work
Chair

Material
Fabric, 120kg of rice

Dimension / Size
90 x 90 cm

Client
Arco

Year Produced
2005

Designer
Frank Tjepkema, Janneke Hooymans

Description
As the proportions of people evolve to the standards of western consumerism so may the proportions of objects that surround us, and this project is a preview. The designers designed this chair with super size aesthetics in mind.

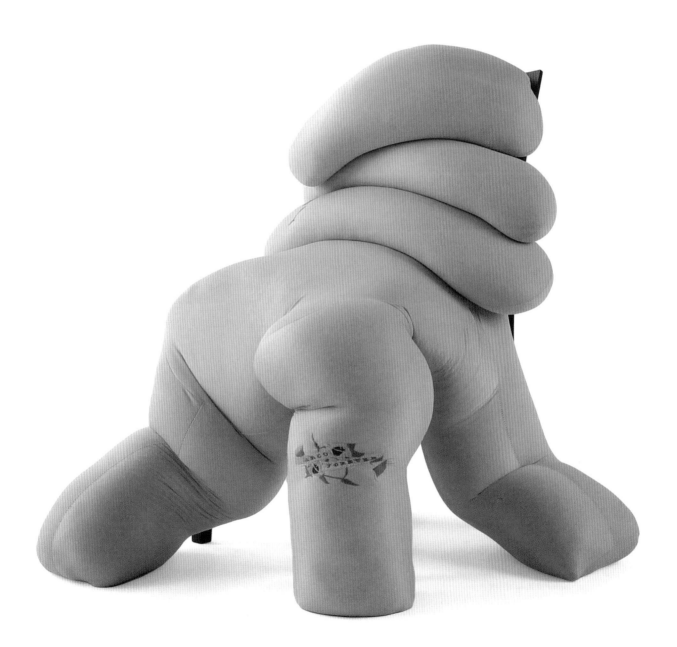

Aqua
Creations
Ltd.
Tel Aviv, Israel

Title
SOMA
(* Stormy September 2004
** Stormy close up)

Type of Work
Lighting

Material
Delicate handmade combination of clear
polymer web over tinted transparent glass
veins

Dimension / Size
H 65 x W 40 x D 45 cm

Client
-

Year Produced
Vary

Designer
Ayala Serfaty

Description
SOMA pieces investigate the relationship
between glass and polymer.

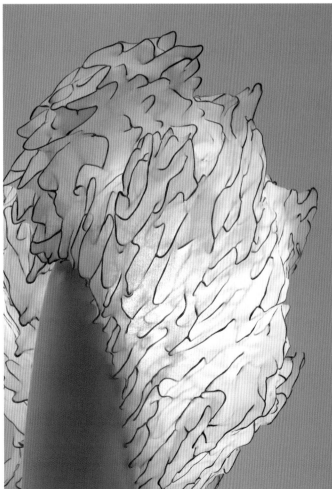

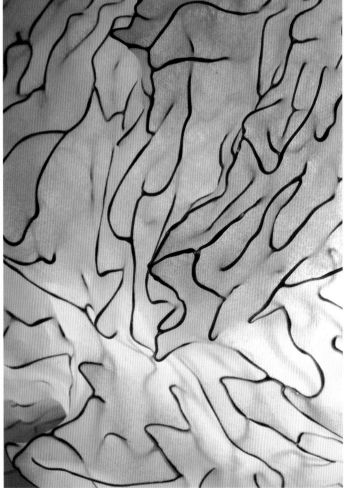

*

**

Aqua Creations Ltd.
Tel Aviv, Israel

Title
SOMA (* Fog January 2005 and Fog March 2005 ** Trust detail – October 2005)

Type of Work
Lighting

Material
Delicate handmade combination of clear polymer web over tinted transparent glass veins

Dimension / Size
Fog January 2005: H 63 x W 30 x D 36 cm
Fog March 2005: H 51 x W 27 x D 33 cm
Trust detail – October 2005: Custom

Client
-

Year Produced
Vary

Designer
Ayala Serfaty

Description
SOMA pieces investigate the relationship between glass and polymer.

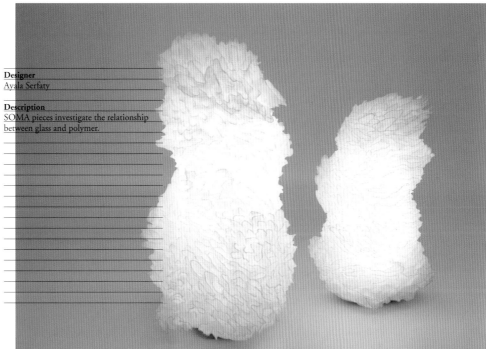

*

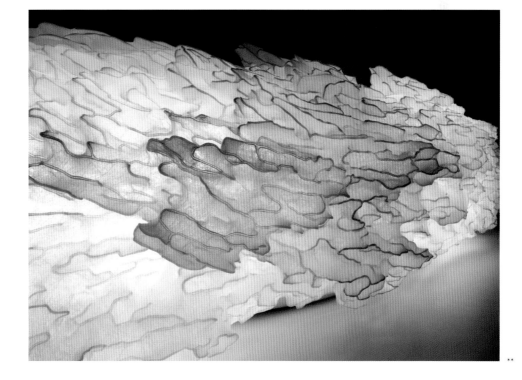

**

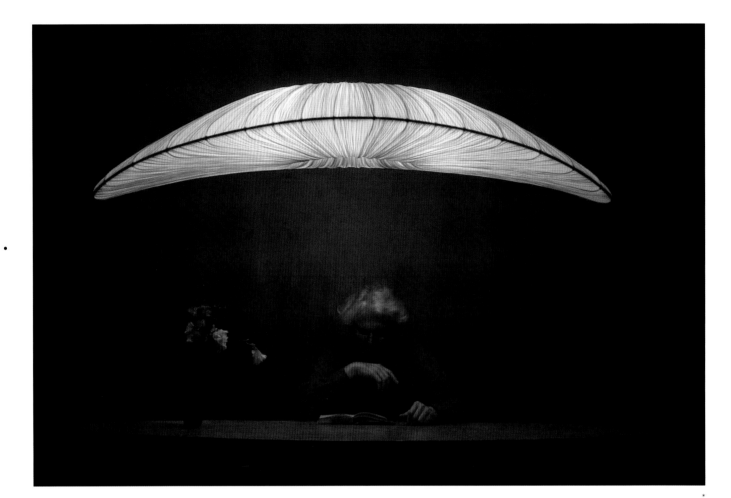

AQUA
CREATIVES
New York, USA

Title
* Liana S
** Stand By custom installation
*** Rigua table lamp

Type of Work
Lighting

Material
Treated crushed silk

Dimension / Size
* H 40 x L 183 x D 61 cm
** Site specific project
*** H 60 x L 76 x D 19 cm

Client
-

Year Produced
* 2003 ** 2002 *** 2003

Designer
Ayala Serfaty

Photographer
** Albi Serfaty

Description
* Pendant, suspended from 2 metal cables, with a clear electrical cord, 200cm – adjustable height. Made of treated crushed silk, resistant to mold and fire.

** Chandelier. Made of treated crushed silk, resistant to mold and fire, laid on metal structure, with brushed Chrome plated metal center column and 'arms.' The installation was made at Oceanographic Park Valencia.

*** Table lamp. Made of treated crushed silk, resistant to mold and fire, laid on metal structure.

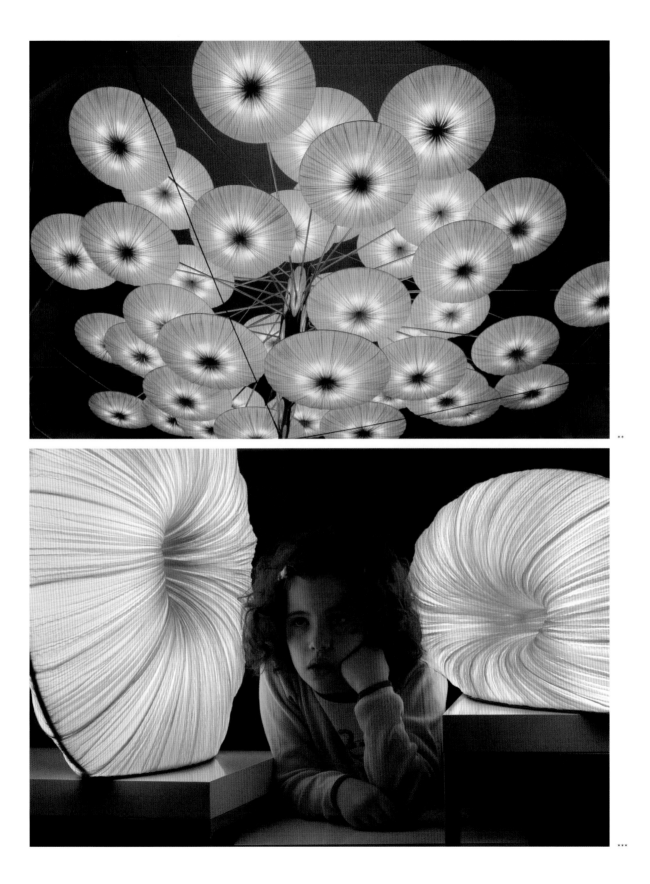

bookhou design
Toronto, Canada

Title
Vestiges

Type of Work
Sculpture

Material
Japanese paper, Salt, Copper wire

Dimension / Size
Vary

Client
-

Year Produced
2004

Designer
Arounna Khounnoraj

Description
Over the past few years, Arounna has been exploring notions of displacement and identity in sculptural form. The work appear as forms but at the same time they refer to an object or use that is no longer present, remaining only as a vestige.

The designer creates structures and forms that evolve through a slow accumulation of materials and repetitive gestures. Materials and construction may refer to food and sustenance or the use of actual forms in our daily lives and the accumulation of meaning in those forms.

Arounna's work is enigmatic, meditative and profoundly quiet – expressive of the slow, methodical and rhythmic nature of their fabrication.

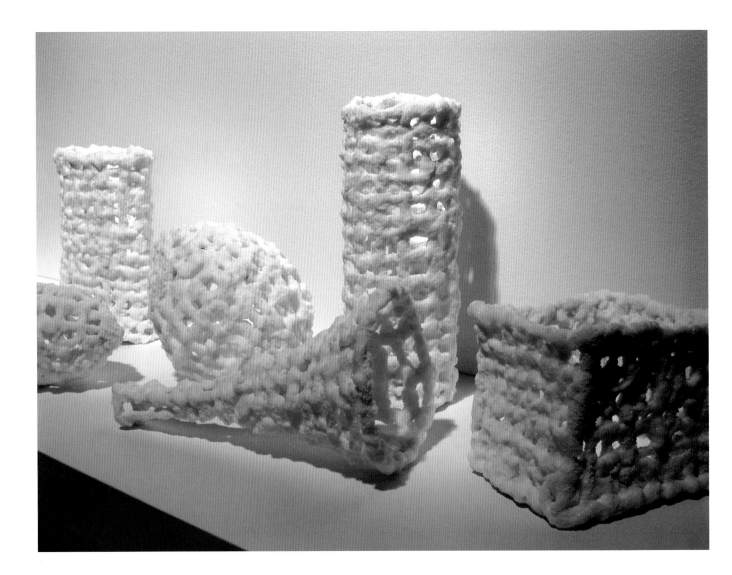

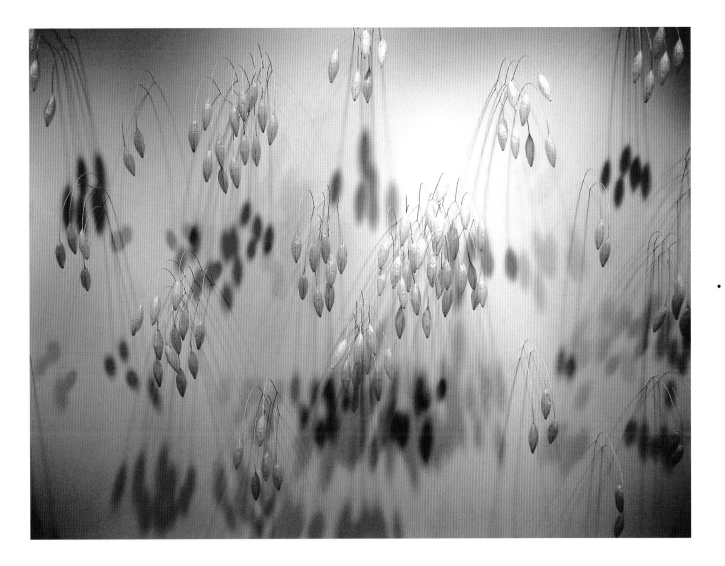

bookhou design
Toronto, Canada

Title	Description
Sowings	-

Type
Sculpture

Material
Japanese paper, Copper wire, Thread

Dimension / Size
Vary, Approx. 8'x 12' x1'

Client
-

Year Produced
2005

Designer
Arounna Khounnoraj

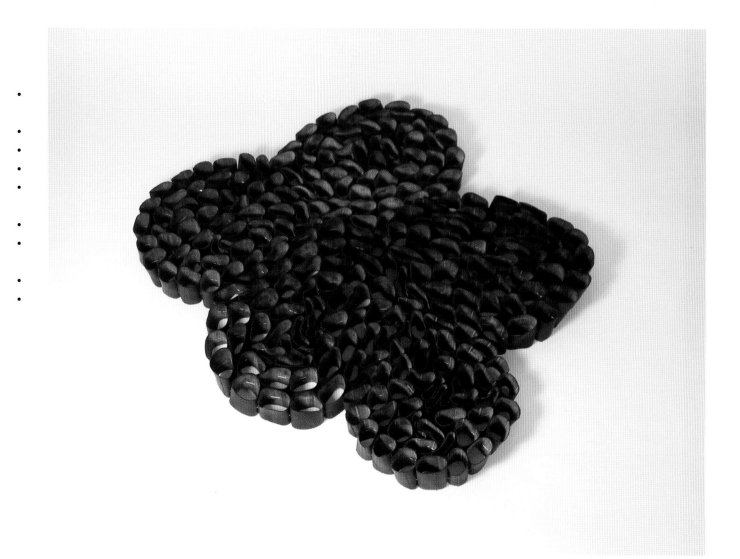

Tyson Boles
Philadelphia, USA

Title
Trod

Type of Work
Mat

Material
Rubber

Dimension / Size
W 5' x L 4' x H 3"

Client
Kim Walters

Year Produced
2002

Designer
Tyson Boles

Description
Tyson loves bikes and he has a lot of flats. He has a hard time throwing out the tubes so he started to sketch with them. Tyson was going to and wanted to see a full size rug.

Tyson Boles
Philadelphia, USA

Title
Stock

Type
Lamp

Material
Plastic

Dimension / Size
W 4" x L 4" x H 3'

Client
Tyson Boles

Year Produced
2002

Designer
Tyson Boles

Description
Tyson is trying to imitate nature. He feels if in our products we can imitate nature than the consumer will be unexplainably drawn to them. These patterns are based on flora patterns.

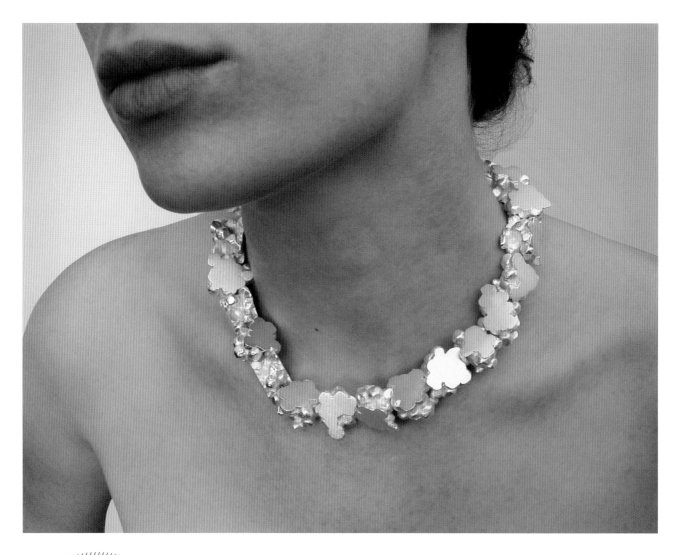

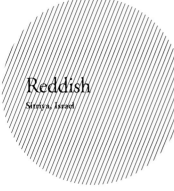

Reddish
Sumya, Israel

Title	
Grenadine	
Type of Work	
Jewellry collection	
Material	
Aluminum, Silver and gold coat	
Dimension / Size	
Bracelet – D 83 x 26 mm	
Necklace – D 160 x 17 mm	
Pendant necklace – 195 x145 x15 mm	
Client	
Reddish	
Year Produced	
2005	
Designer	
Naama Steinbock, Idan Friedman	

Description

The visual and physical characteristics of polystyrene (Styrofoam) are used to create one of a kind gems. This often overlooked material, mainly used for technical purposes, and it is consisted of chaotic small elements and has a complex, delicate and esthetic appearance. An Appearance which is the main feature in this jewellry collection.

During the casting process, the hit of the melted metal evaporates the polystyrene, and takes its place.

Perpetuating the beauty of the polystyrene grains in metal enables endless number of esthetic expressions.

The Grenadine collection exhibited at the Eretz Israel Museum as well as at the Victoria & Albert Museum in London.

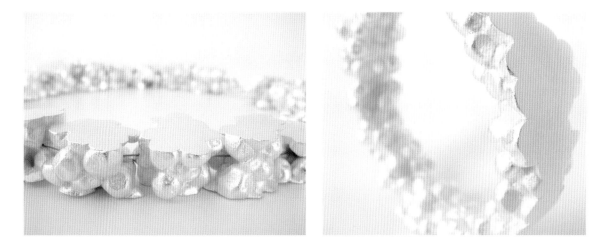

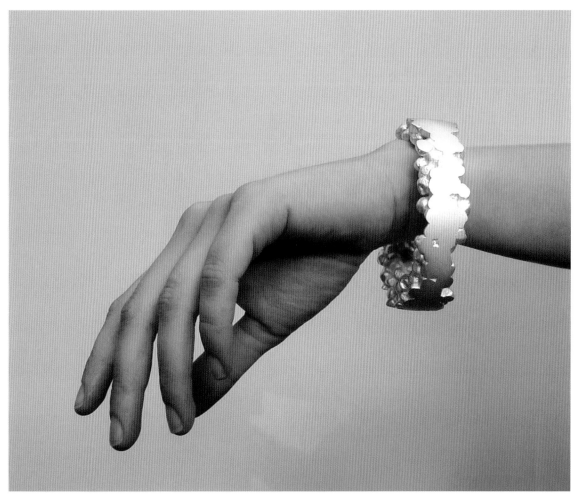

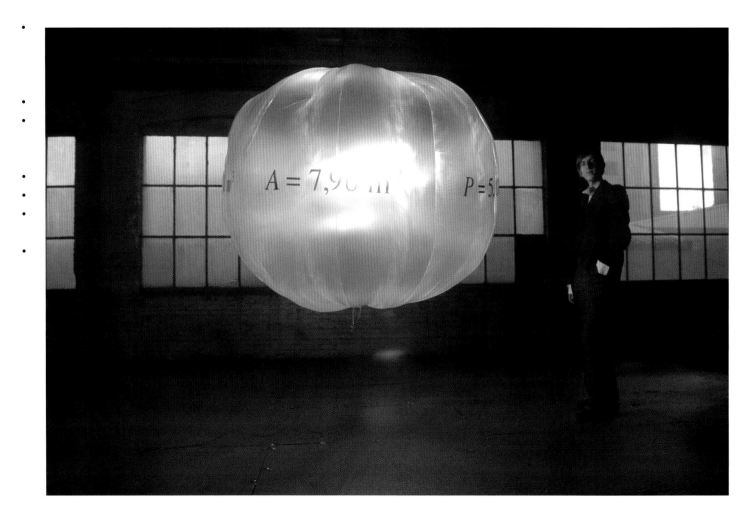

Eric
Klarenbeek
Zaandam, The Netherlands

Title	**Description**
The Floating Light Project	Out of Eric's interest for blowing bubbles, (obsessed by the weightless fragility and the influence of heat out of our lungs which can make a bubble float) he started experimenting with heating volumes out of lightweight materials. Experiencing that he could use lighting as an alternative heat source.
Type of Work	
Lighting	
Material	
Lamp, Stitched polyethylene, Stamped inscriptions	Searching a balance in weight, volume and light source based on the principle of an 'electronic' air balloon, which led to the Floating Light Project; lighting with the ability of floating on its own heat.
Dimension / Size	
D 1.5 - 3 m	
Client	Marcel Wanders found great interest in the concept and took one of the experiments in production, which is now part of the Moooi collection.
Eric Klarenbeek, Moooi	
Year Produced	
2003 onwards	
Designer	
Eric Klarenbeek	

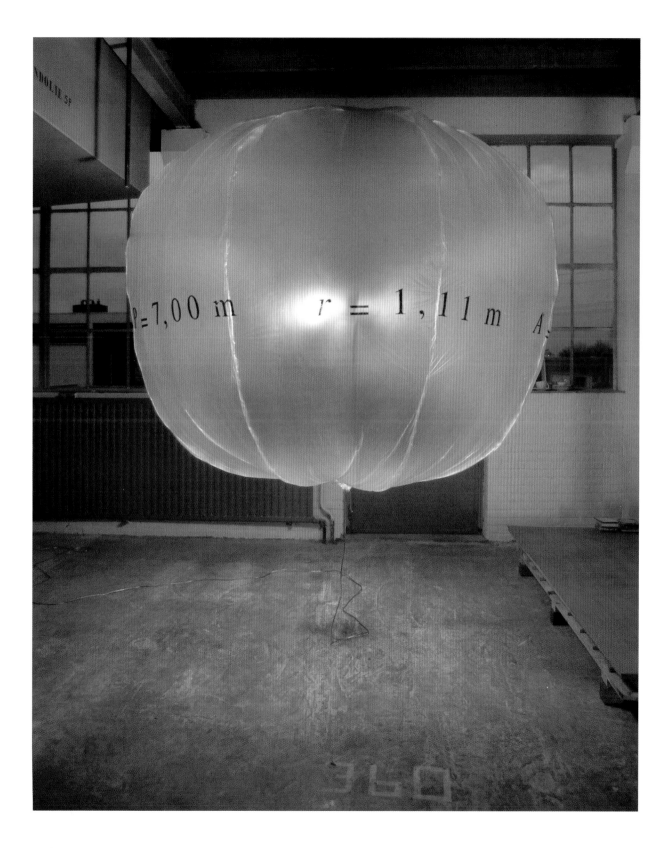

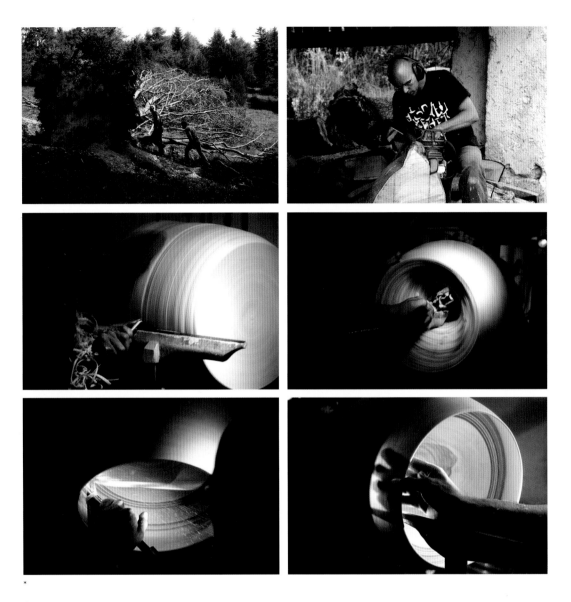

Ernst Gamperl
Munich, Germany

Title	**Designer**
–	Ernst Gamperl
Type of Work	**Photographer**
* Working process	* Pedro Gato Lopez, Germany
** to ***** The objects are turned at the	** to ***** Tom Vack (Object photos)
turning lathe	
Material	**Description**
Oak	* These pictures showing a tree in the moun-
	tains of Tremosine which could not stand his
Dimension / Size	ground against the wind, the cut of a rough
** to ***** D 16 - 55 x H 17 - 85 cm	form with the chain saw and the work on it
	on the turning lathe.
Client	
-	** to ***** All objects illustrated are made of
	oak. The surface is lime washed and fissures
Year Produced	are fixed with dove tails.
* 2006	
** to ***** 2005	

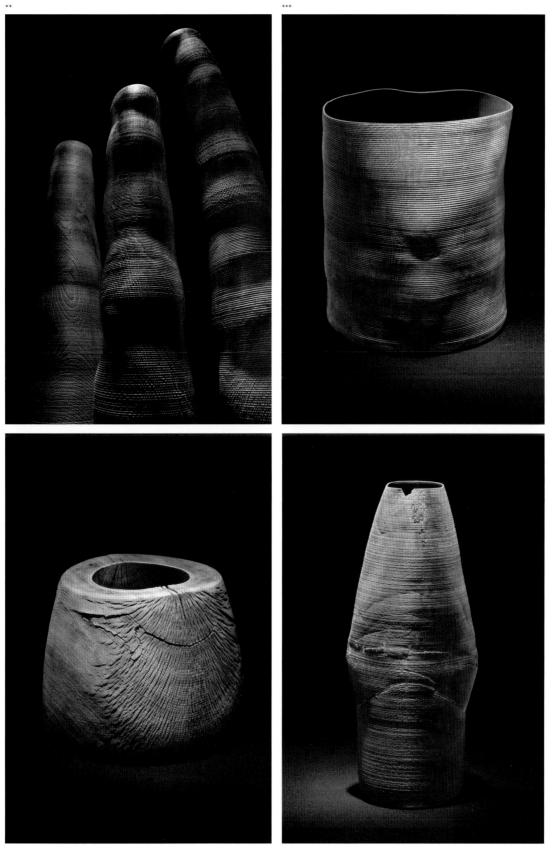

Tjep.
EV Amsterdam, The Netherlands

Title
Shock Proof

Type of Work
Vases, Shock proofed

Material
Ceramics/Polyurethane rubber

Dimension / Size
Vary

Client
Tjep.

Year Produced
2006

Designer
Frank Tjepkema, Janneke Hooymans

Description
Shock Proof is a collection of existing vases which Tjep. has applied the Do Break principle. Broken vases don't fall apart and remain watertight because of a special rubber coating is applied to the inside. The cracks formed a new superimposed decorative pattern, witnesses to dramatic events to which the vases may be subjected: anything from a lovers quarrel to earthquakes.

The first Shock Proof collection was presented at the ACME Gallery in LA, (April 2006) and realised upon special request of curator John Geresi. LA seemed to be a very suitable location to introduce the concept as the region is subject to frequent and sometimes intense seismic activity.

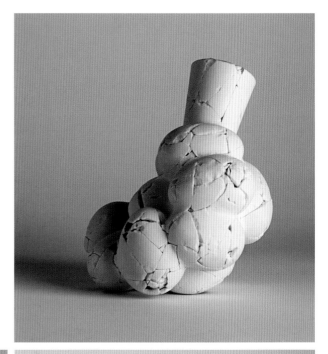

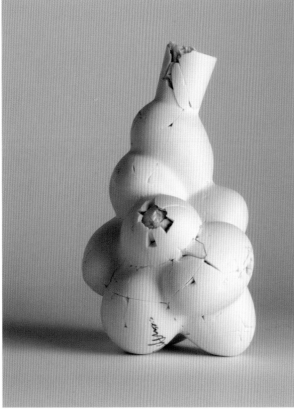

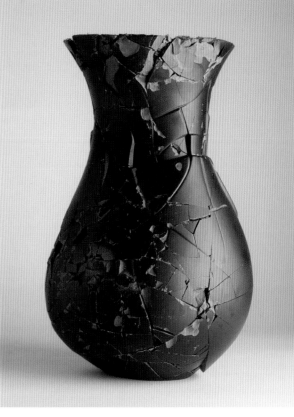

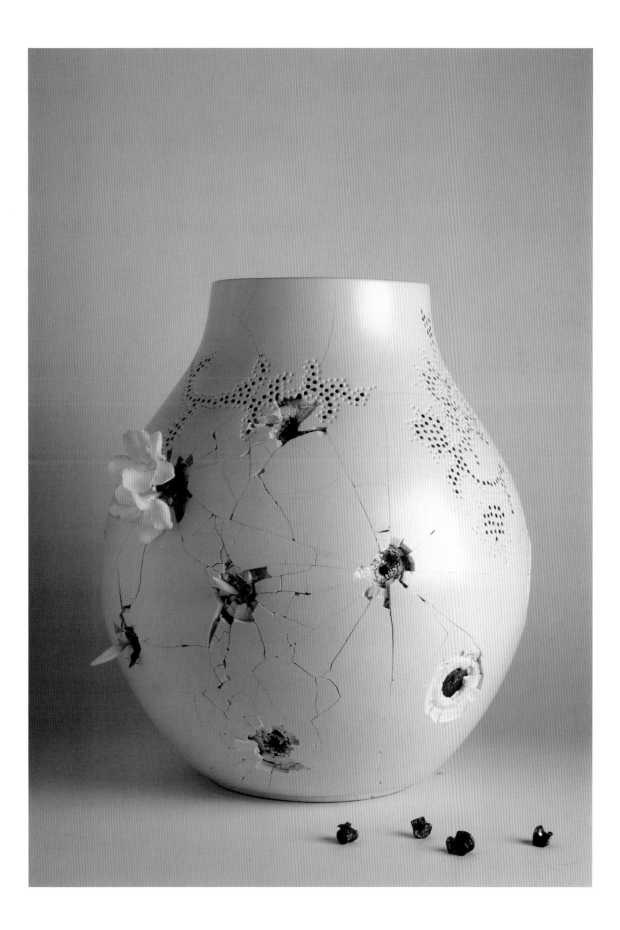

Karin van Lieshout

Eindhoven, The Netherlands

Title	
Time in design	
Type of Work	
Lighting	
Material	
14000 Cable-ties	
Dimension / Size	
2 sizes: D 80 cm, D 60 cm	
Client	
Eternally Yours	
Year Produced	
2003	
Designer	
Karin van Lieshout, Rachel van Outvorst (Monnikenwerk)	

Description

A pile of cable-ties shrunk and beautiful new structures emerged together by Monkish work.

A collection of handmade studies, produced during a 24-hour conference.

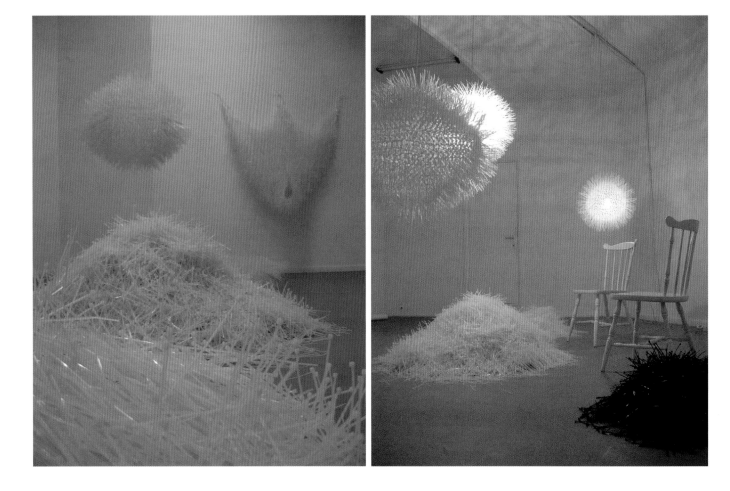

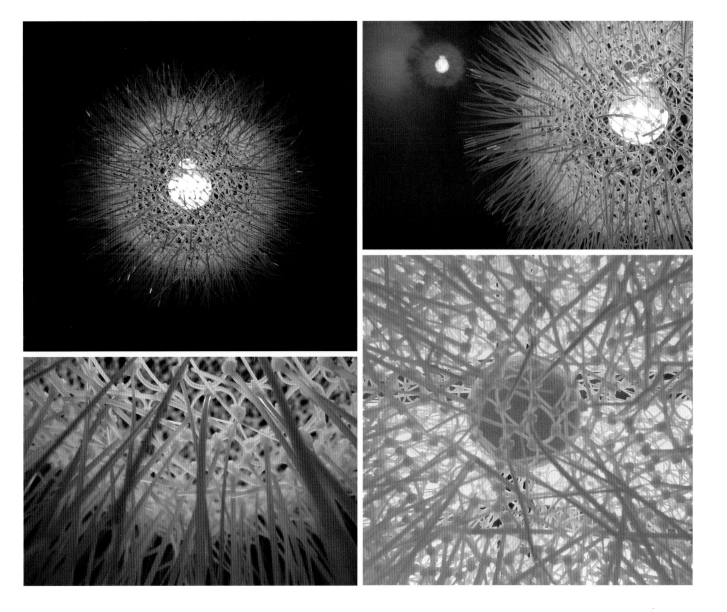

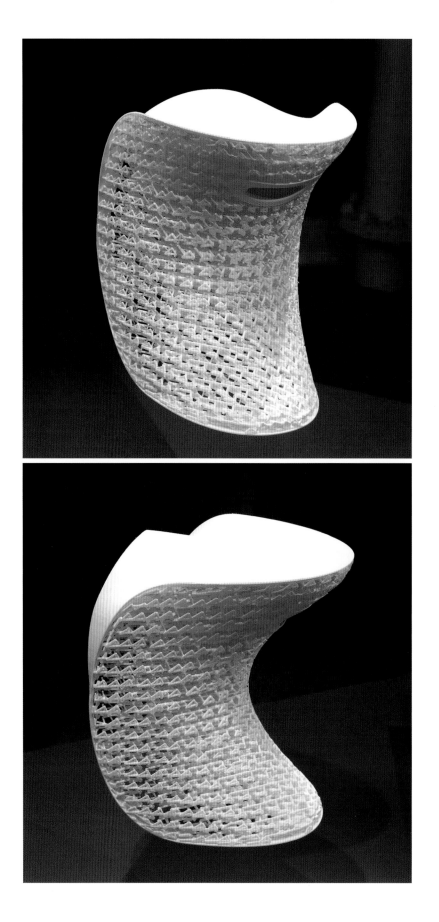

ASSA
ASHUACH
STUDIO
London, UK

Title
AI Stool

Type of Work
Stool

Material
Polyimide

Dimension / Size
43 x 36 x 46 cm

Client
Materialise MGX

Year Produced
2006

Designer
Assa Ashuach

Description
Apply 120kg on a 40cm height sitting surface and let the AI (Artificial Intelligent) software do its job. The AI stool born from the designer's tight collaboration with Dr Sia of complex matters. The challenge was to design a form with the minimum volume required for a seat and then instruct the AI software to calculate the required support. Dr Sia developed a spatial feature and created random AI typology, this is only one of many that came out.

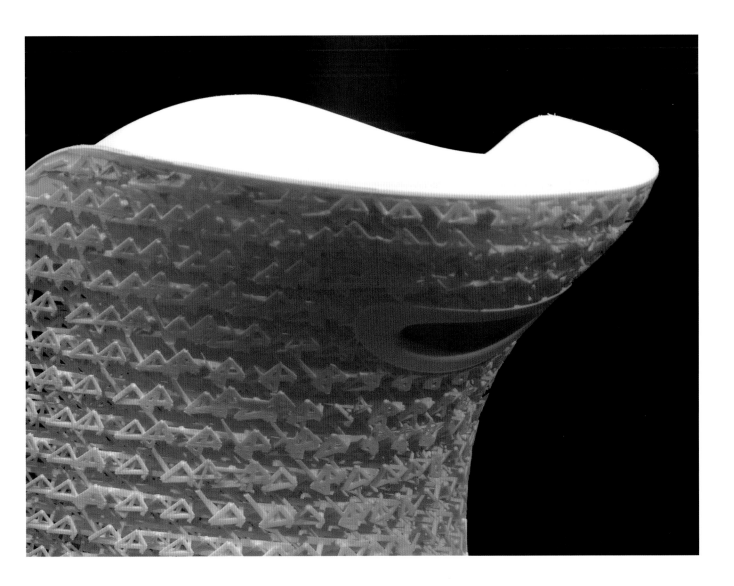

Studio
Bertjan Pot
Schiedam, The Netherlands

Title	**Description**
Knitted Lamp	These light shades are made by sucking a circular knit drained with resin onto a cluster of
Type of Work	balloons. The shape is different every time.
Lighting	Sizes vary in height from 45cm to 160cm. People who like them Bertjan still makes
Material	a chance in a while.
Acrylic knitting, Epoxy resin	
Dimension / Size	
Vary, Approx. D 50 cm	
Client	
Studio Bertjan Pot	
Year Produced	
1998	
Designer	
Bertjan Pot	

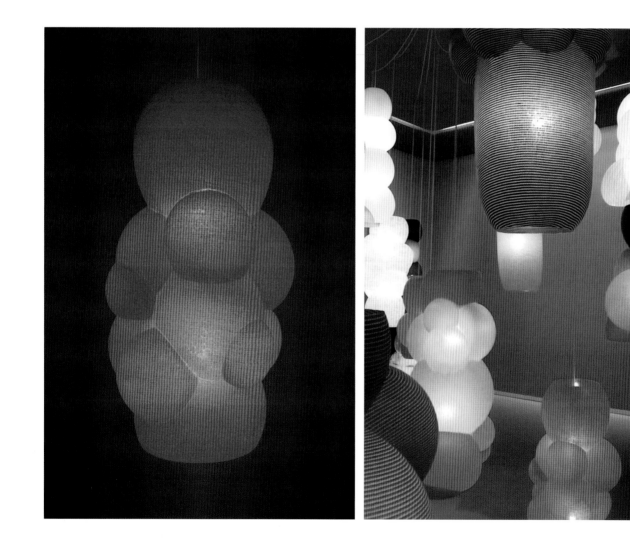

Studio
Bertjan Pot
Schiedam, The Netherlands

Title	**Description**
Netted Lamp	A knitted lamp spin-off. Instead of a knitting and resin sucked around a cluster of balloons, this time it was a circular net soaked in resin, (used in the diving industry) that was sucked around a cluster of balloons.
Type of Work	
Lighting	
Material	
Epoxy resin, Circular polyester netting	
Dimension / Size	
Approx. D 35 x T 100 cm	
Client	
Studio Bertjan Pot	
Year Produced	
2004	
Designer	
Bertjan Pot	

Philips Design
Eindhoven, The Netherlands

Title
Skin Probe

Type of Work
'Emotional Sensing' Soft Technology

Material
2 garments 'the Bubbelle' and 'Frisson'

Dimension / Size
Fashion apparel (body size)

Client
Philips Design

Year Produced
2006

Designer
Clive van Heerden, Lucy McRae, Sita Fischer, Nancy Tilbury, Rachel Wingfield, Stijn Ossevoort

Description
The Skin Probe project challenges the notion that our lives are automatically better because they are more digital. This project looks at more 'analogue' phenomena, like emotional sensing, and exploring technologies that are 'sensitive' rather than 'intelligent.'

Rather than exploring a single, static object or product, the designers explored the skin and the atmosphere around it as an artistic representation of complex technical biometric data and new interaction modalities. It was a process of simulation, translating biometric information into emotional feedback. Instead of creating something that switches on and off, they have created a sensitive, emotional interpretation; which can then be extrapolated and used as a basis for designing objects, products, buildings, or things around us.

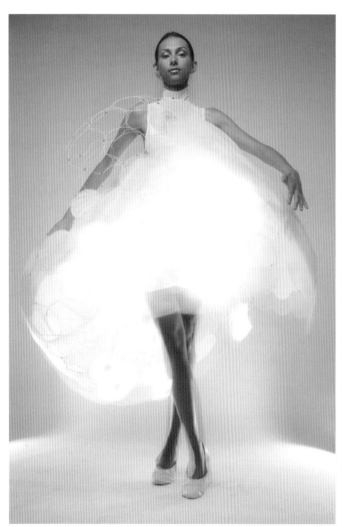

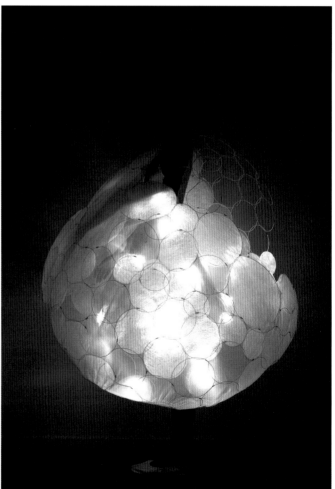

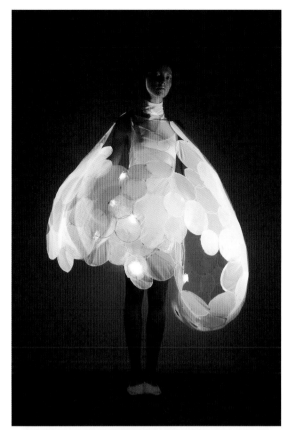
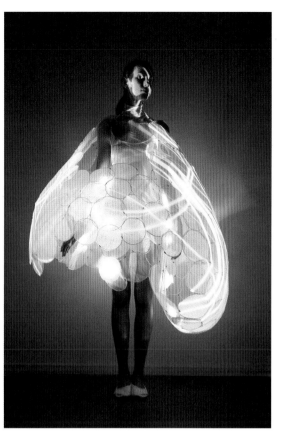
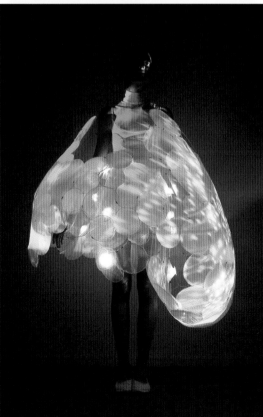

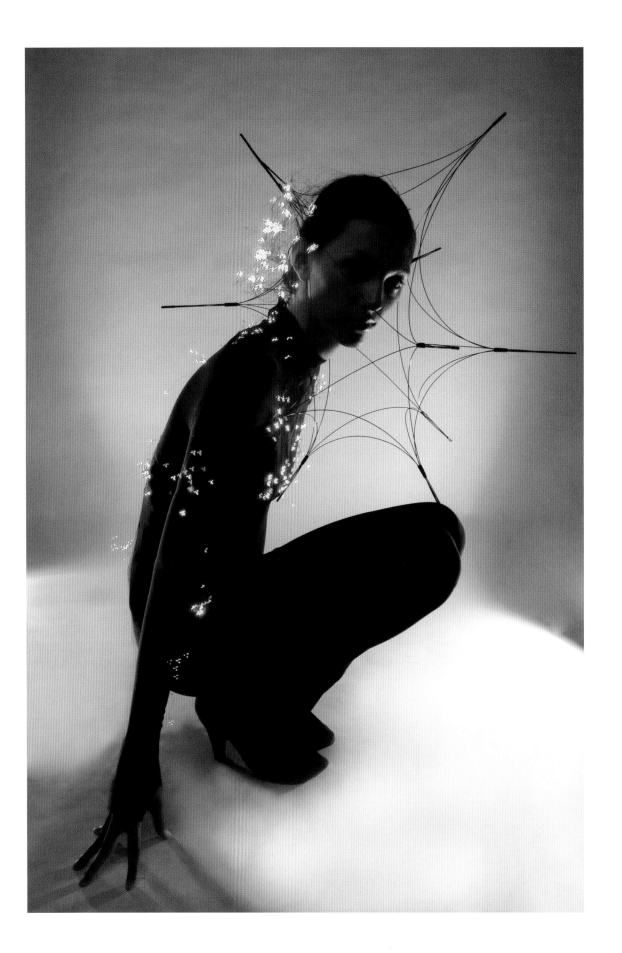

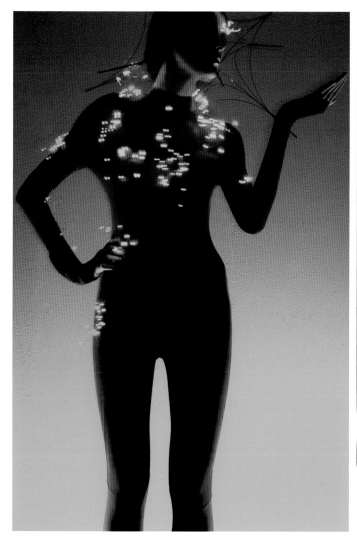

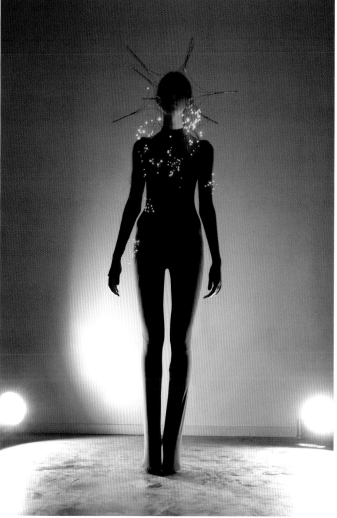

Philips Design
Eindhoven, The Netherlands

Title
Skin Probe

Type of Work
'Emotional Sensing' Soft Technology

Material
2 garments 'the Bubbelle' and 'Frisson'

Dimension / Size
Fashion apparel (body size)

Client
Philips Design

Year Produced
2006

Designer
Clive van Heerden, Lucy McRae, Sita Fischer, Nancy Tilbury, Rachel Wingfield, Stijn Ossevoort

Description
The Skin Probe project challenges the notion that our lives are automatically better because they are more digital. This project looks at more 'analogue' phenomena, like emotional sensing, exploring technologies that are 'sensitive' rather than 'intelligent.'

Rather than exploring a single, static object or product, the designers explored the skin and the atmosphere around it as an artistic representation of complex technical bio-metric data and new interaction modalities. It was a process of simulation, translating biometric information into emotional feedback. Instead of creating something that switches on and off, they have created a sensitive, emotional interpretation; which can then be extrapolated and used as a basis for designing objects, products, buildings, or things around us.

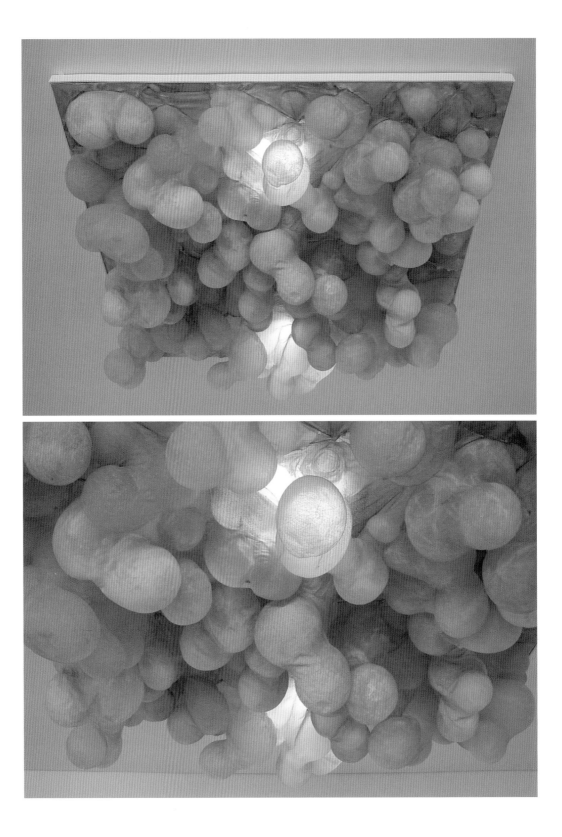

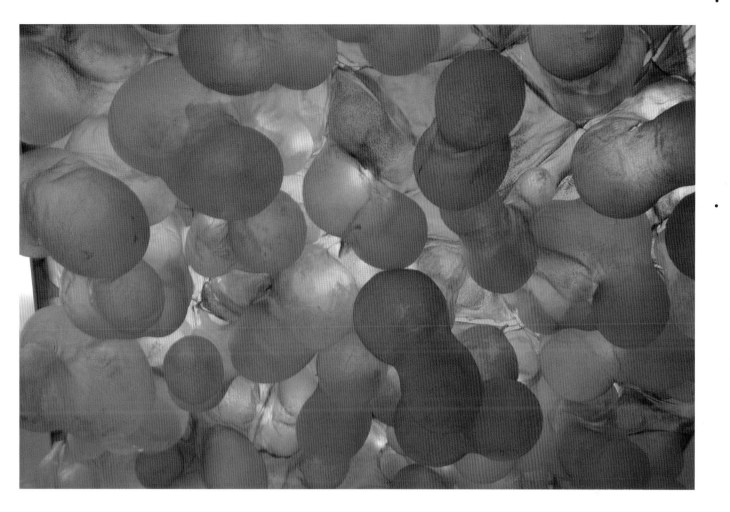

Julia Lohmann
London, UK

Title
Flock

Type of Work
Chandelier

Material
50 preserved sheep stomachs

Dimension / Size
180 x 180 x 50 cm

Client
-

Year Produced
2004

Designer
Julia Lohmann

Description
'Flock' is made of 50 sheep stomachs. The chandelier reminds people that we are surrounded and sustained by animal products. It triggers feelings oscillating between attraction and repulsion. Julia's aim is to initiate a more differentiated discussion about the way we regard and treat animal products through objects made of under-valued animal materials.

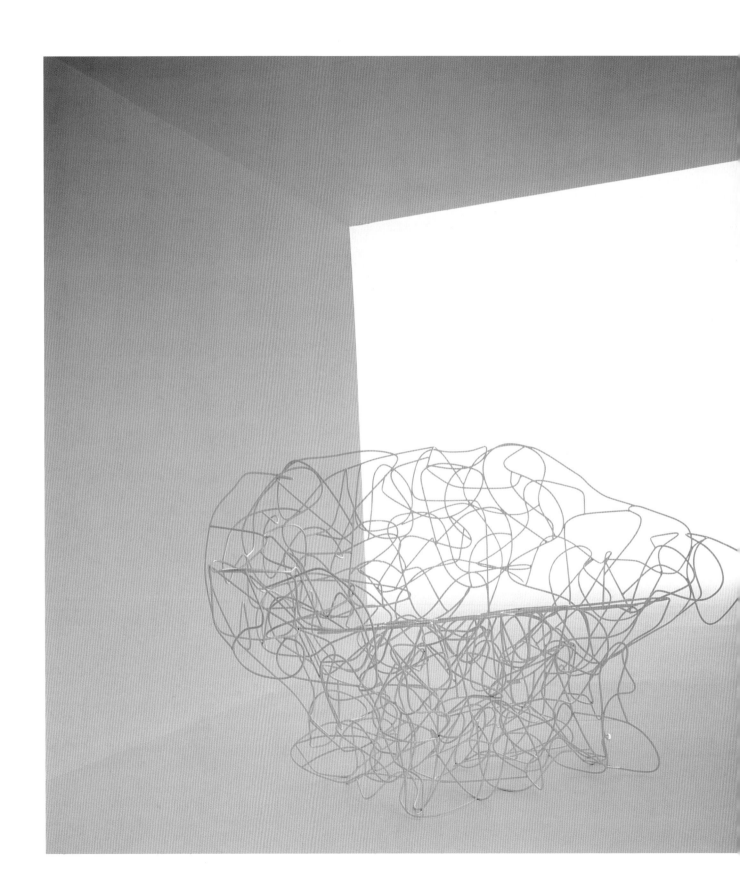

Estudio Campana
São Paulo, Brasil

Title
Corallo Chair

Type of Work
Chair

Material
Steel wire with coral pink epoxy paint finish

Dimension / Size
90 x 145 x 100 cm

Client
Edra, Italy

Year Produced
2004

Designer
Fernando and Humberto Campana

Description
The original Corallo chair (orange epoxi finish) is a Fernando and Humberto Campana design for Edra and was launched at the Milan Furniture Fair in 2004. It received the first prize at cDim award at the Valencia Furniture Fair 2005, and it is at the permanent collection of the New York MoMa, and Beaux Arts Museum in Montréal, Canada.
The white Corallo was launched in 2006 at the Milan Furniture Fair and integrates the White and Colour Collection.

The intention was to create a chair that had the lightness of a coloured line floating in the air.

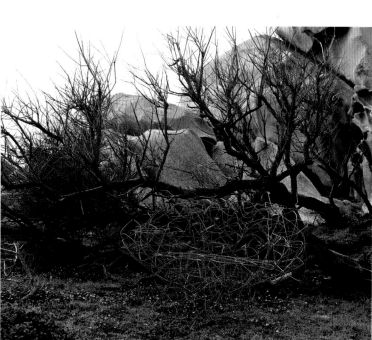

Sonia Chow
Studio
Tokyo, Japan

Title
Uni Lights

Type of Work
Lighting / Furniture / Sculpture

Material
Nylon-reinforced PVC hose, Nylon cable ties

Dimension / Size
Vary

Client
Sonia Chow Studio

Year Produced
2003

Designer
Sonia Chow

Photographer
Sonia Chow, except photo of Sonia weaving by T. Iwamoto

Description
After moving into a space near the central fish market, Sonia was inspired by her favourite sashimi. 'Uni' means 'sea urchin' in Japanese.

2 of the everyday objects combine to create a 3rd, unexpected object with no waste. Uni lights are handwoven from plumbing hose and cable ties. The translucent qualities of the materials filter and channel the light to the tips of the spikes, illuminating the entire form. Due to the synthetic materials, Uni is waterproof and can be used indoors or outdoors. The Uni ChairLight can also be used as a chair, with a recommended weight limit of 70kg.

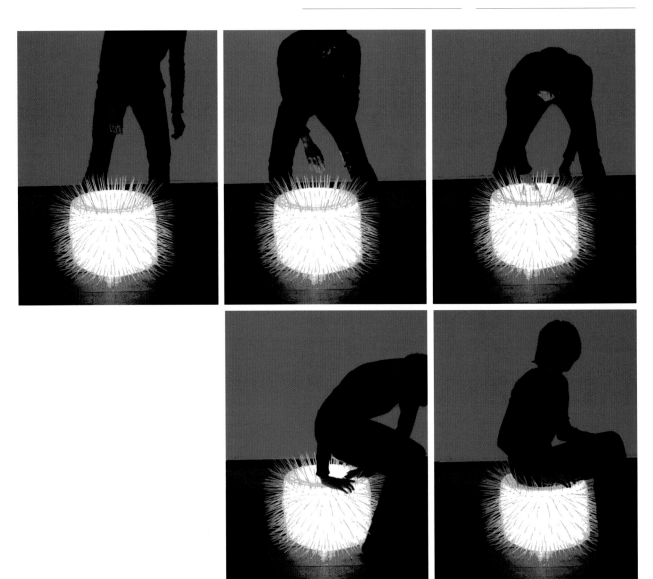

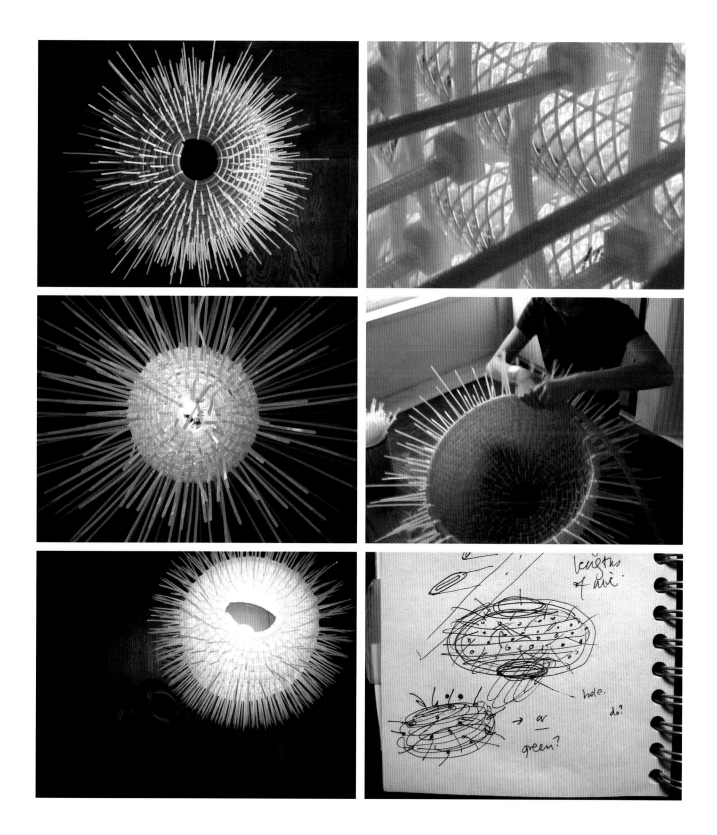

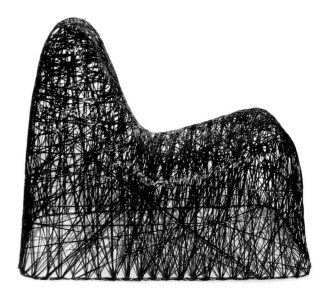

Studio Bertjan Pot
Schiedam, The Netherlands

Title
Random Chair

Type of Work
Chair

Material
Carbon fiber, Epoxy resin

Dimension / Size
50 x 100 x 70 cm

Client
Goods

Year Produced
2003

Designer
Bertjan Pot

Description
The Random Chair is the follow-up of the Random Light. Epoxy drained carbon fiber is coiled over single sided mould.

It won the 'materiaalfonds'-prize 2003.

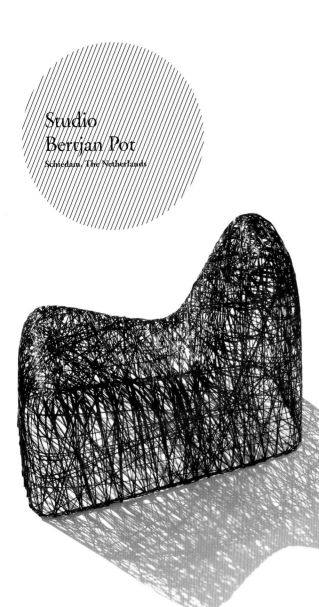

Studio
Bertjan Pot
Schiedam, The Netherlands

Title
Carbon Chair

Type of Work
Chair

Material
Carbon fiber, Epoxy resin

Dimension / Size
45 x 45 x 75 cm

Client
Moooi

Year Produced
2004

Designer
Bertjan Pot, Marcel Wanders

Description
In cooperation with Marcel Wanders and inspired by the Carbon Copy Bertjan made the Carbon Chair. This chair was completely hand coiled and 100% carbon fiber and epoxy. The pattern on the seat looks random but actually reflects the strength patter. Every point on the rim of the chair is connected with all 4 points where the seat is connected to base-frame.

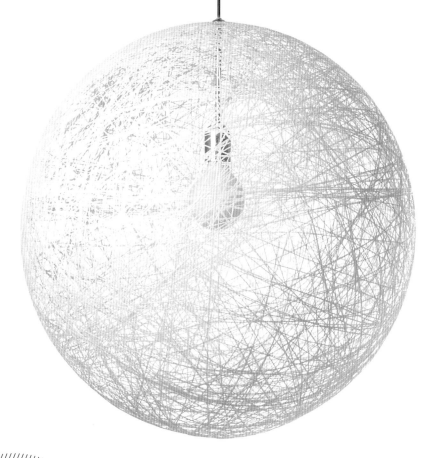

Studio
Bertjan Pot
Schiedam, The Netherlands

Title	**Description**
Random Light	Glass-fiber drained with resin was coiled around a big balloon. Sounds simple but it
Type of Work	took Bertjan 3 years to develop.
Light	
Material	
Glass fiber, Epoxy resin	
Dimension / Size	
D 50, D 85, D 110 cm	
Client	
Moooi	
Year Produced	
2000	
Designer	
Bertjan Pot	

Studio
Bertjan Pot
Schiedam, The Netherlands

Title
Shrunken Stool

Type of Work
Stool

Material
Eps foam, Acrylic knitting, Epoxy resin

Dimension / Size
30 x 30 x 42 cm

Client
Studio Bertjan Pot

Year Produced
-

Designer
Bertjan Pot

Description
This stool was made by sucking a resin drained circular knit on to an eps stool. Because of the forces created in the vacuum, the stool is slightly bent. This gives it an organic appearance. It used to be produced by goods but never was a big success.

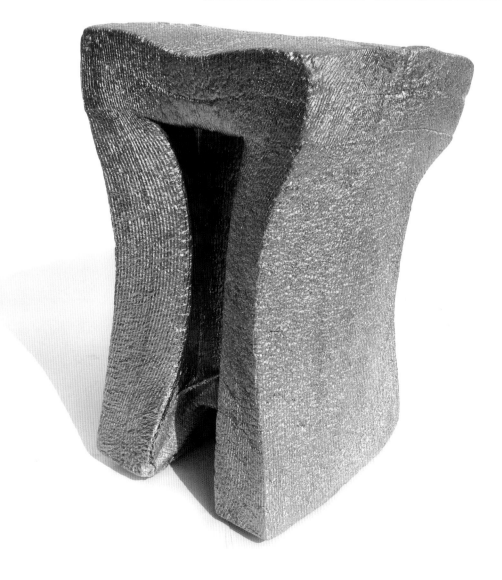

WOKmedia
London, UK

Title	**Photographer**
New Breed	Julian de Hautecloque Howe
Type of Work	**Description**
Installation	Even as adults we are still mesmerized about the genius simplicity of the perfect egg shape. The idyllic moment gets disturbed when there are cracks and when parts break off. What might be inside? What will it bring?
Material	
Porcelain, inside painted through a small opening	
Dimension / Size	'New Breed' looks into a state in between, in a transition or change where something is going to happen like before an Autumn storm brewing in the air.
W 330-380 x D 270-300 mm (each)	
Client	
Contrasts Gallery	
Year Produced	
2006	
Designer	
Julie Mathias, Wolfgang Kaeppner	

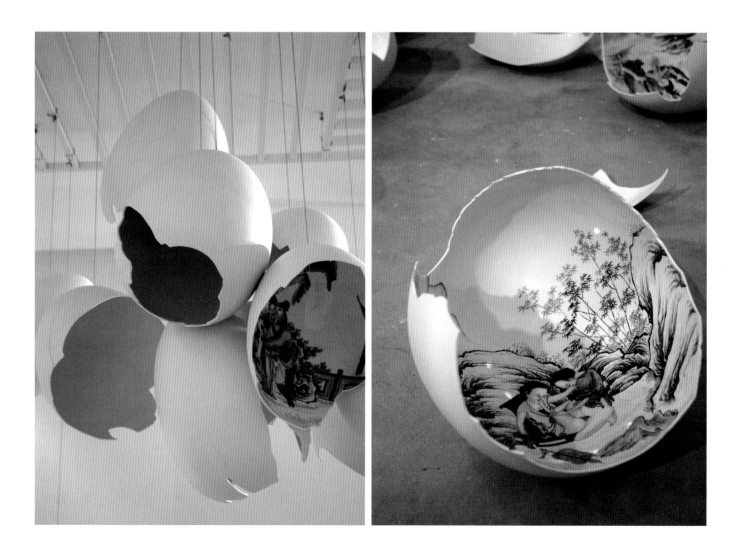

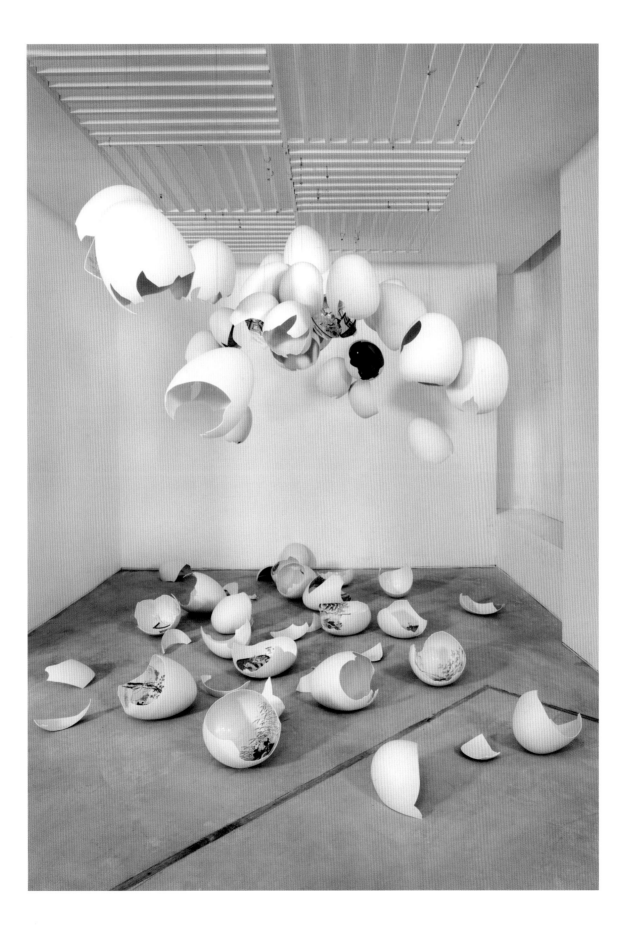

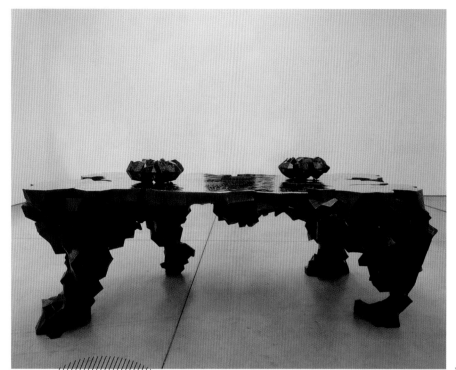

Studio Job
Antwerp, Belgium

Title
* Rock table ** Rock *** Rock chair

Type of Work
-

Material
Casted bronze (black patine and polished top)

Dimension / Size
* 225 x 77 x 125 cm
** 40 x 40 x 10 cm
*** 80 x 40 x 40 cm

Client
-

Year Produced
* 2002 ** 2002 *** 2003

Designer
Studio Job

Description
Rock table and Rock are both collected by Groninger Museum while Rock chair is collected by Stedelijk Museum.

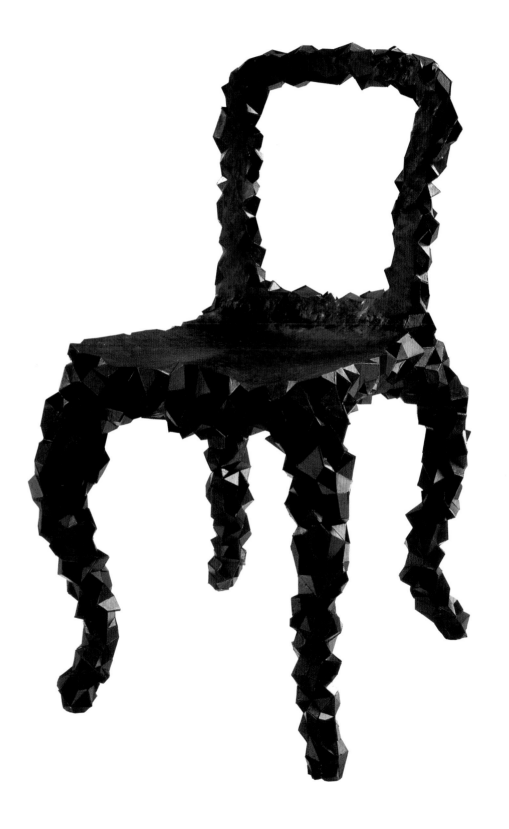

Radu Comsa
Bucuresti, Romania

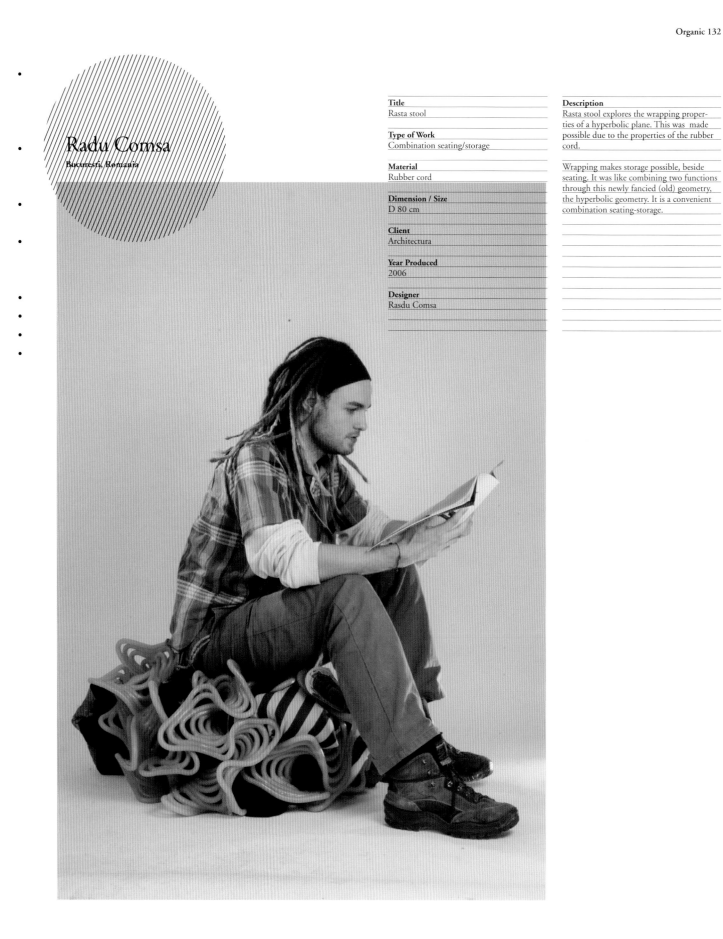

Title	Rasta stool
Type of Work	Combination seating/storage
Material	Rubber cord
Dimension / Size	D 80 cm
Client	Architectura
Year Produced	2006
Designer	Rasdu Comsa

Description

Rasta stool explores the wrapping properties of a hyperbolic plane. This was made possible due to the properties of the rubber cord.

Wrapping makes storage possible, beside seating. It was like combining two functions through this newly fancied (old) geometry, the hyperbolic geometry. It is a convenient combination seating-storage.

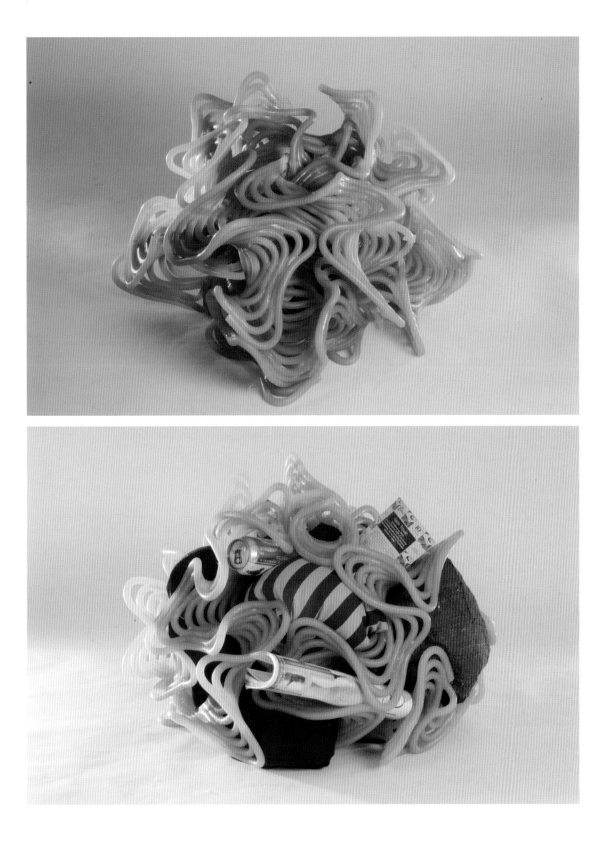

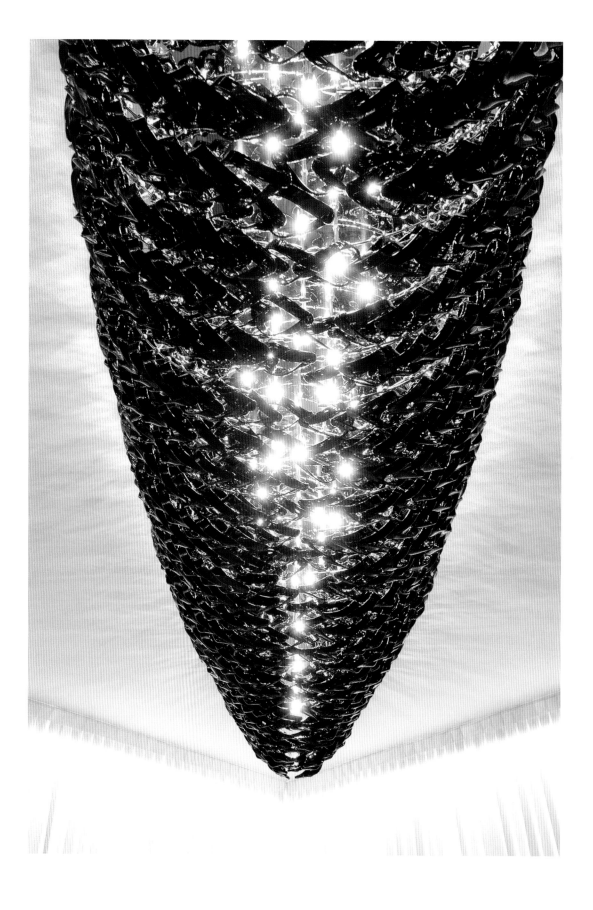

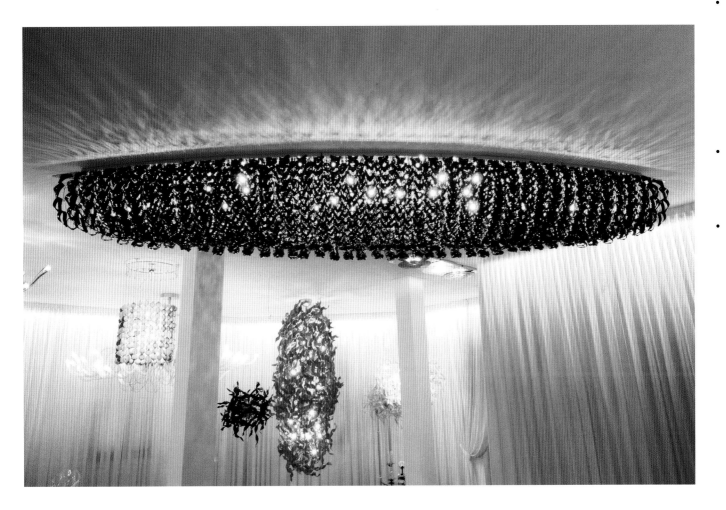

Karim
Rashid Inc.
New York, USA

Title	Description
Links	–

Type of Work
–

Material
–

Dimension / Size
–

Client
Andromeda

Year Produced
2006

Designer
Karim Rashid

ERB
Paris, France

Title	**Photographer**
Clouds	Paul Tahon, Ronan Bouroullec, Erwan Bouroullec
Type of Work	**Description**
Cloud modules	The polystyrene 'Clouds' are modules that can be laid over one another. It is like a proliferation of a shared abstract form or a growing plant, stubbornly repeating its structure of nodes. The clouds are designed to grow in an architectural space.
Material	
Polystyrene	
Dimension / Size	
105 x 187.5 x 40 cm	
Client	
Cappellini, Italy	
Year Produced	
2002	
Designer	
Ronan Bouroullec, Erwan Bouroullec	

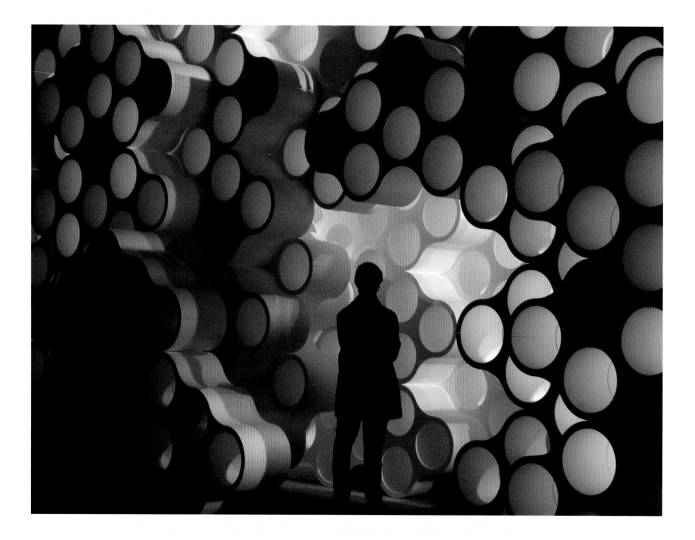

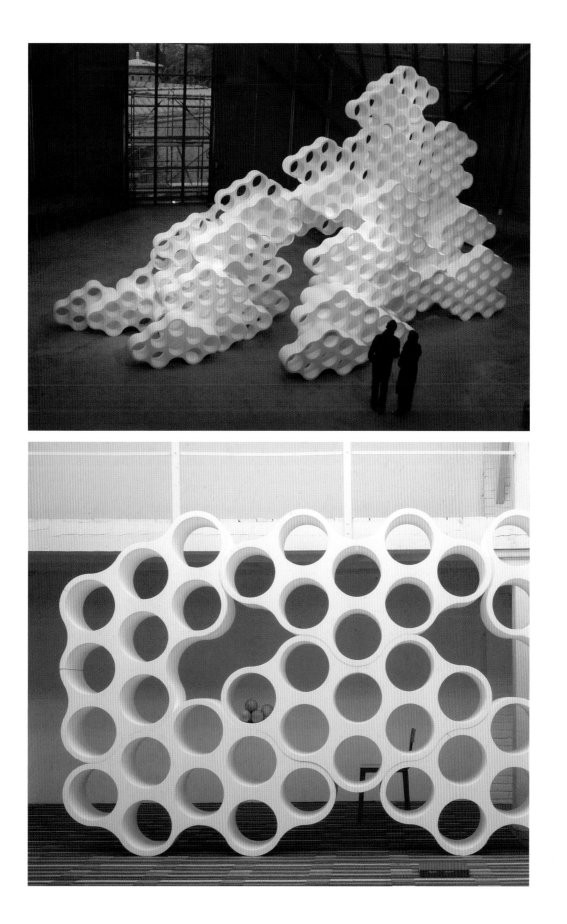

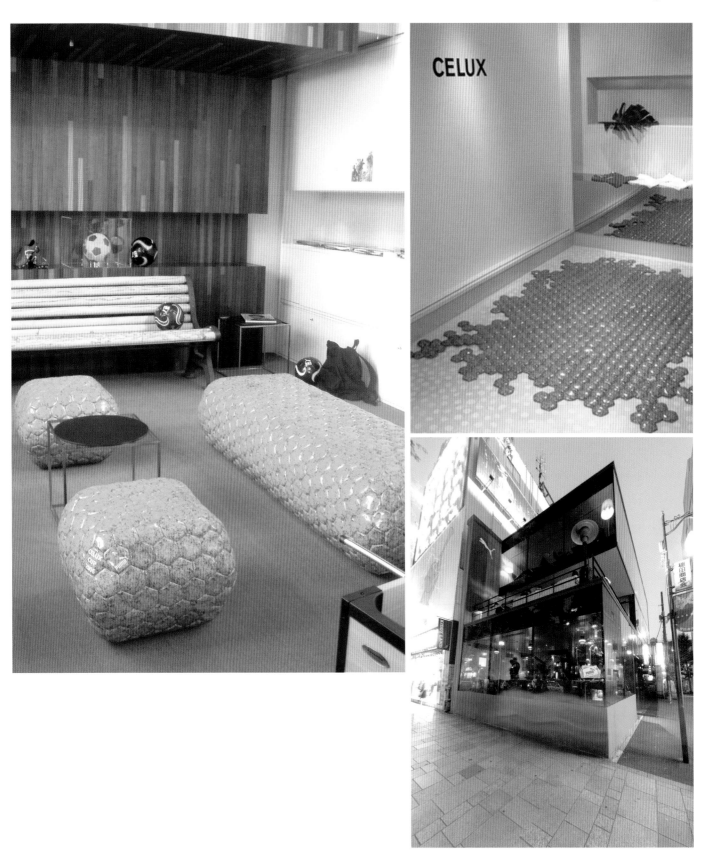

SUZUKIKE
Tokyo, Japan

Title
Welcome To Football House

Type of Work
Furniture

Material
Soccer ball

Dimension / Size
Cafe area: 80 m²

Client
PUMA

Year Produced
2006

Designer
Yohei Suzuki, Kohei Suzuki

Description
PUMA respects grass, and wanted to express the image with soccer balls. The designers changed the soccer balls into furniture, and fused the images with 'Welcome To Football House.' It contains 30 chairs, 4 rugs and 10 lights.

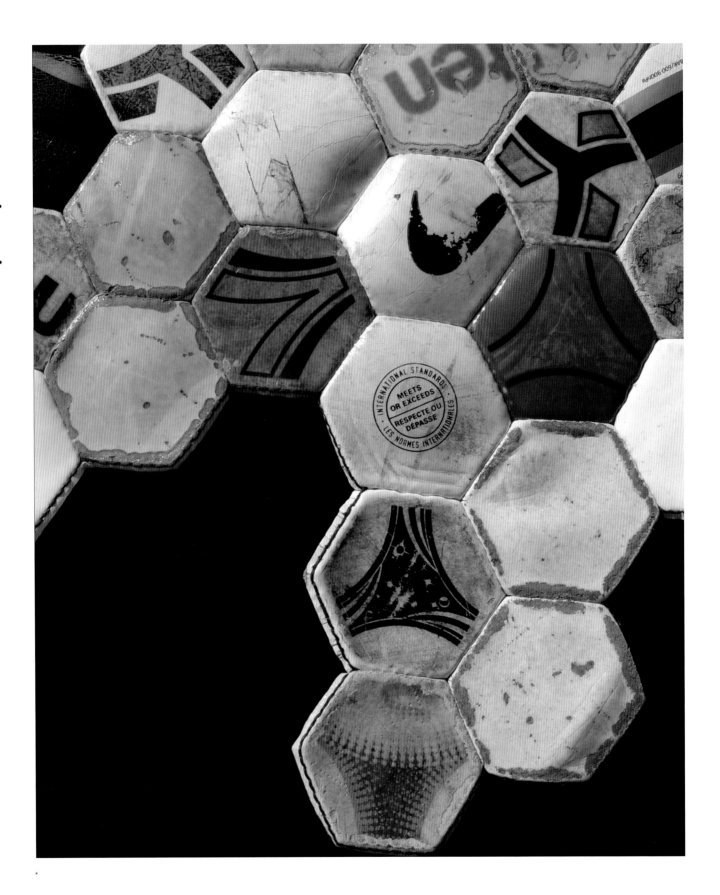

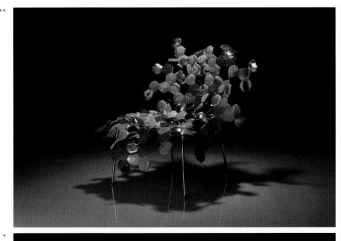

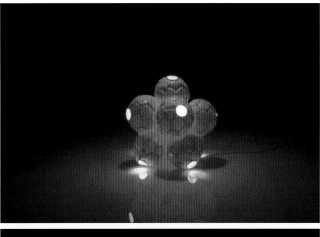

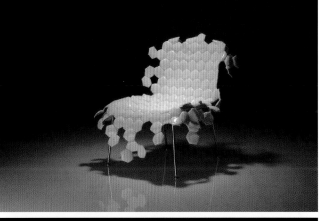

SUZUKIKE
Tokyo, Japan

Title
* RECCOS rug
** RECCOS(PUMA x SUZUKIKE)

Type of Work
Furniture

Material
* Soccer ball ** Soccer ball, Urethane

Dimension / Size
* W 300 x D 200 cm
** W 650 × D 650 × H 630 mm

Client
100% Design Tokyo 2005

Year Produced
2005

Designer
Yohei Suzuki, Kohei Suzuki

Description
Interior is fabricated out of a soccer ball. When we were kids, we used to yelled for sitting on a soccer ball. Now, it has become one of our fondest memories of our childhood. Giving shape to a small thought like this becomes RECCOS. Every child had once experienced it, and now there is the opportunity to re-experience the it again. This is how the designers, as childhood soccer players, express themselves.

Madelon
Galland
New York, USA

Title
Green Velvet Stump w/ Slip On Display

Type of Work
Installation art, Sculpture, Digital photography

Material
Velvet upholstered tree stump

Dimension / Size
Original stump dimensions:
H 36" x W 59" x D 48"
Archival Inkjet print: 13" x 19"

Client
Madelon Galland

Year Produced
2000

Designer
Madelon Galland

Description
Upholstery asserted as a solution in terms of a material that is both familiar and vividly juxtaposing with the mangled roots of an uprooted tree stump. Madelon used velvet because she felt the shapes of the tree were quite sensual. She wanted to convey sensuality and dignity in this piece, so she attached some upholstery as if it was an arm rest or a banister. There is also something aquatic about the flowing and frayed roots which helped to establish it in green velvet. This associates with furniture, dining establishments etc, and also a very direct relationship to the story of The Giving Tree (Shel Silverstein). Upholstering a cushion onto the stump is how the designer honours the life of the tree, dignifying it in its most diminished but vital state of being.

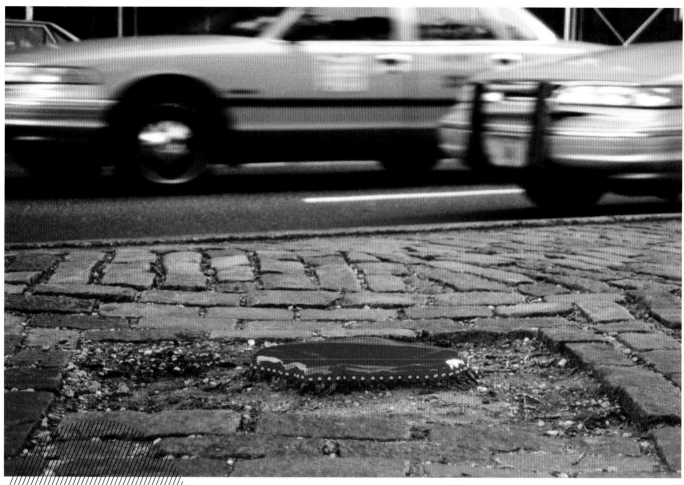

Madelon
Galland
New York, USA

Title
* Tribeca Poppy
** 7th Street Stump

Type of Work
Installation Art, Unauthorized Public Art

Material
Vinyl Upholstered Tree Stump

Dimension / Size
* 19" x 13"
** Approx. **W** 4" x H 3"

Client
Madelon Galland

Year Produced
1999

Designer
Madelon Galland

Description
This began as a gesture about care. Uphol-
stery asserted itself as a solution in terms of
a material that is both familiar and vividly
juxtaposing in the context of a sidewalk
upholstered tree stump. The use of vinyl in
particular for the public works serves both
as a protection in water proofing, and as
a bright contrast to the surrounding grey
asphalt and the competitive visual noise
that is a cityscape. The associations are with
furniture, dining establishments etc, and also
a very direct relationship to the story of The
Giving Tree (Shel Silverstein), in which the
tree once depleted, will offer up her stump
as a seat, happily and selflessly, as it is all she
has left to give. Upholstering a cushion onto
the stump is how she honours the life of the
tree, appreciating it in its most compromised
state and bringing it back into our pedestrian
radar.

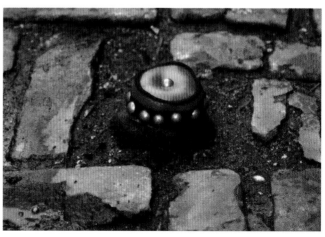

**

decorative
decorativas
decoratief
装飾
デコレイティヴ
장식의

Decoration, which is used as adornment and enrichment, it is the focus of this section. The visual embellishment may not have the actual function but it is definitely what catches our attention. 'Decorative' shows how ordinary objects are translated into incredible designs with decorations and add-ons.

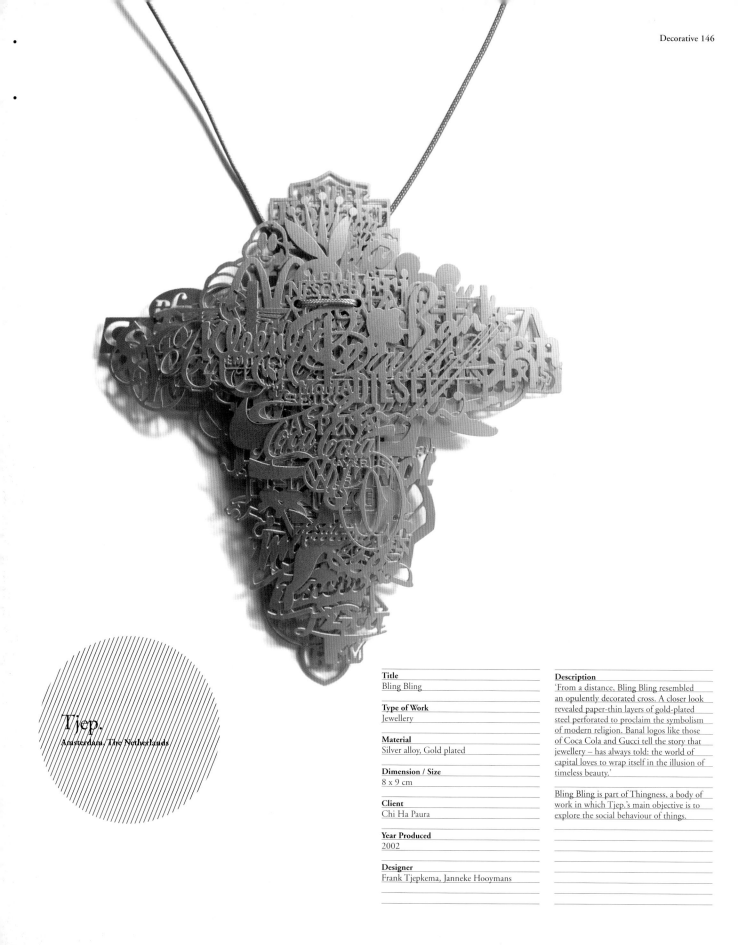

Tjep.
Amsterdam, The Netherlands

Title
Bling Bling

Type of Work
Jewellery

Material
Silver alloy, Gold plated

Dimension / Size
8 x 9 cm

Client
Chi Ha Paura

Year Produced
2002

Designer
Frank Tjepkema, Janneke Hooymans

Description
'From a distance, Bling Bling resembled an opulently decorated cross. A closer look revealed paper-thin layers of gold-plated steel perforated to proclaim the symbolism of modern religion. Banal logos like those of Coca Cola and Gucci tell the story that jewellery – has always told: the world of capital loves to wrap itself in the illusion of timeless beauty.'

Bling Bling is part of Thingness, a body of work in which Tjep.'s main objective is to explore the social behaviour of things.

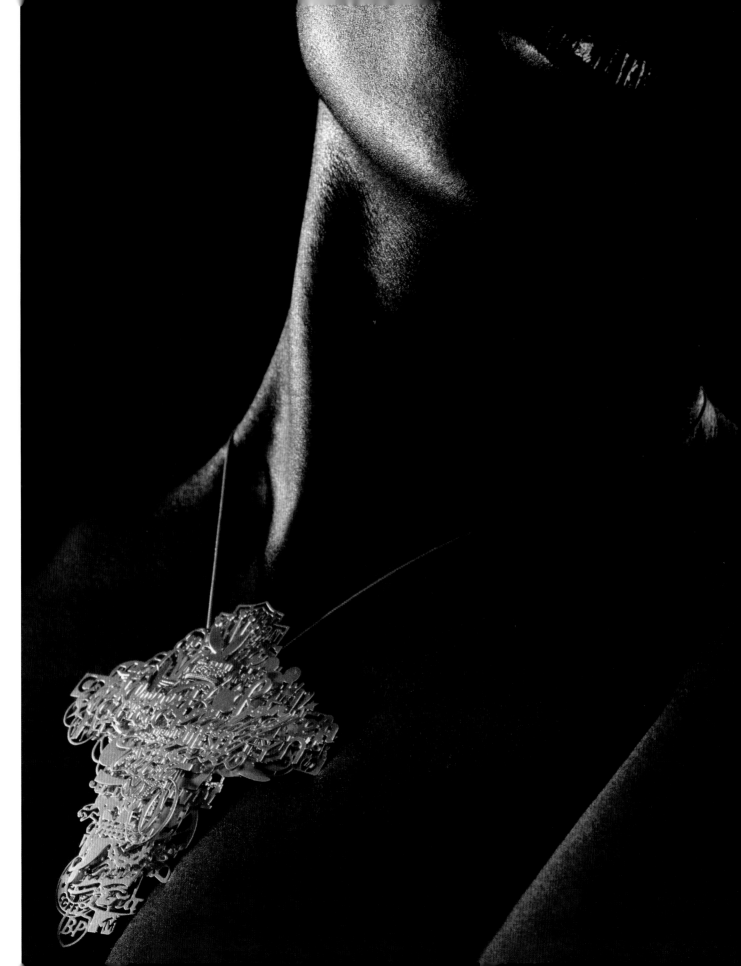

Buro Vormkrijgers
Eindhoven, The Netherlands

Title of Work
Therese

Type of Work
Lighting

Material
PMMA, Acrylic plastic

Dimension / Size
840 x 940 mm

Client
Cultivate

Year Produced
2002

Designer
Sander Mulder, Dave Keune

Photographer
Raoul Kramer

Description
Together with the Triptich room divider, standing lamp Josephine and Marie-Louise, and chandelier Therese, this sophisticated lamp design forms the OVERDOSE series from Buro Vormkrijgers.

With its 16 contours illuminated by a dimmable fluorescent bulb, this freestanding lighting fixture revitalizes the traditional ambient lamps. Through the use of special materials and accurate CNC machining, the whole body emits a soft magic glow. The fixture is made from transparent plastic and it can be customized with 16 different colour-filters.

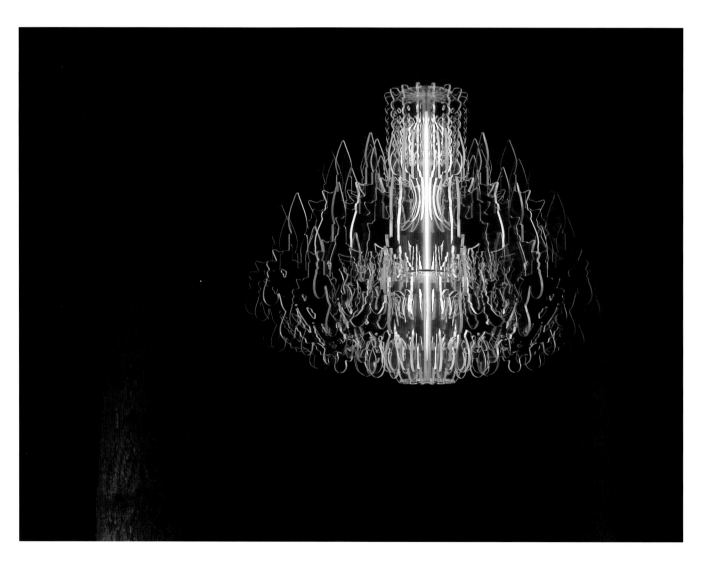

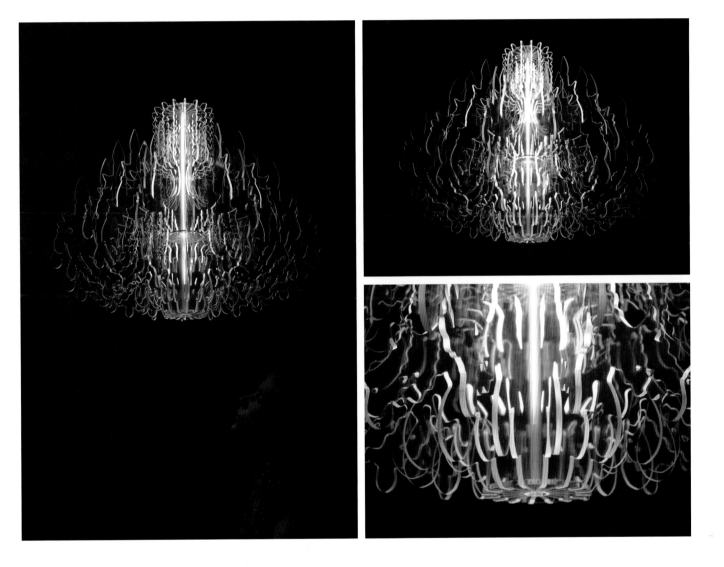

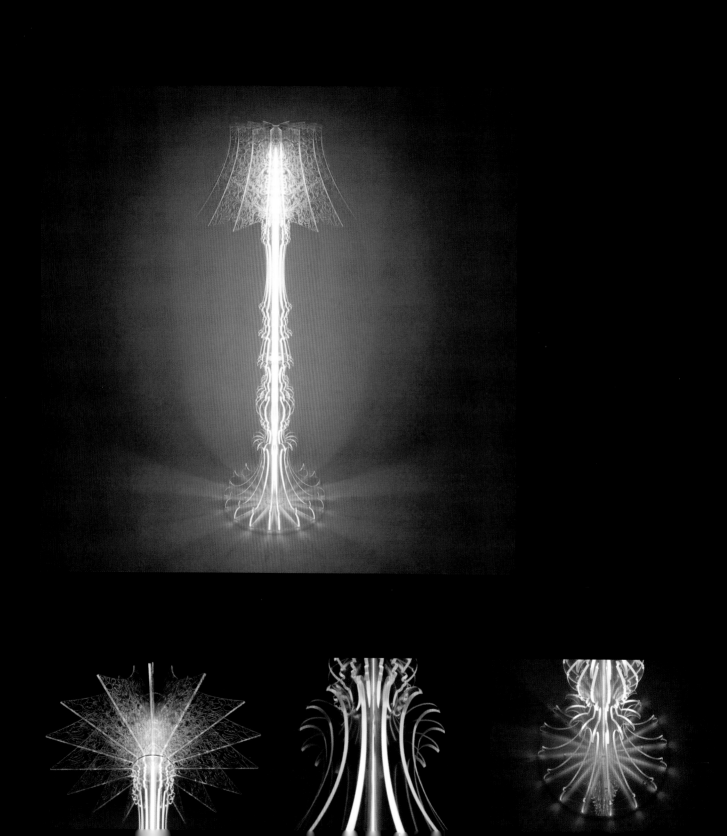

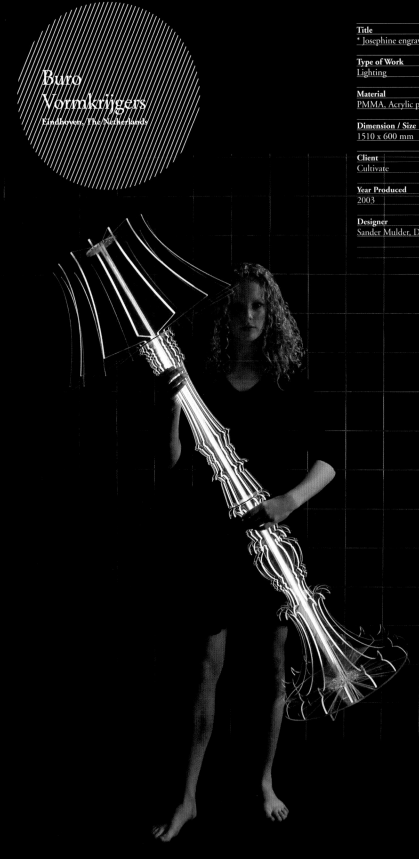

Buro Vormkrijgers
Eindhoven, The Netherlands

Title	**Photographer**
* Josephine engraved ** Josephine	Raoul Kramer
Type of Work	**Description**
Lighting	Together with the Triptich room divider, standing lamp Josephine and Marie-Louise, and chandelier Therese, this sophisticated lamp design forms the OVERDOSE series from Buro Vormkrijgers.
Material	
PMMA, Acrylic plastic	
Dimension / Size	With its 16 contours illuminated by a dimmable fluorescent bulb, this chandelier revitalizes the traditional ambient lamps. Through the use of special materials and accurate CNC machining, the whole body emits a soft magic glow. The fixture is made from transparent plastic and it can be customized with 16 different colour-filters.
1510 x 600 mm	
Client	
Cultivate	
Year Produced	
2003	
Designer	Josephine is also available with a decorative pattern engraved in its hood sections.
Sander Mulder, Dave Keune	

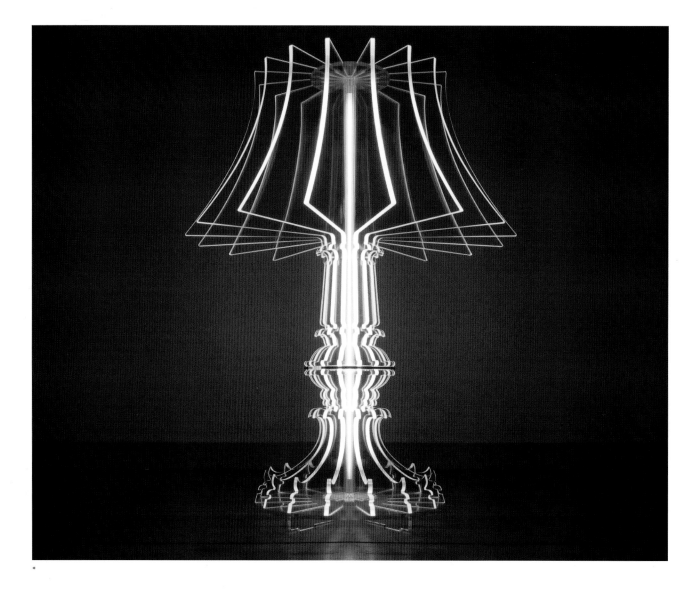

*

Buro Vormkrijgers
Eindhoven, The Netherlands

Title
* Marie-Louise ** Marie-Louise engraved

Type of Work
Lighting

Material
PMMA, Acrylic plastic

Dimension / Size
585 x 450 mm

Client
Cultivate

Year Produced
2002

Designer
Sander Mulder, Dave Keune

Photographer
Sander Mulder

Description
Together with the Triptich room divider, standing lamp Josephine and Marie-Louise, and chandelier Therese, this sophisticated lamp design forms the OVERDOSE series from Buro Vormkrijgers.

With its 16 contours illuminated by a fluorescent bulb, this freestanding lighting fixture revitalizes the traditional ambient lamps. Through the use of special materials and accurate CNC machining, the whole body emits a soft magic glow. The fixture is made from transparent plastic and it can be customized with 16 different colour-filters.

Marie-Louise is also available with a decorative pattern engraved in its hood sections.

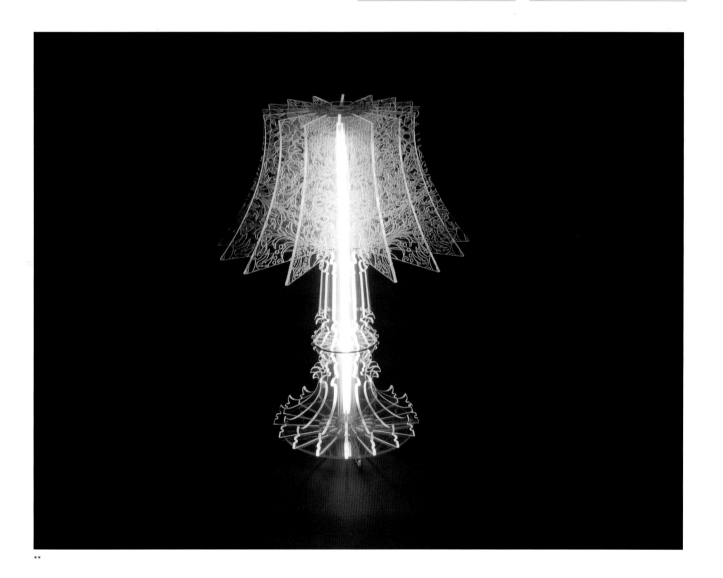

**

Buro
Vormkrijgers
Eindhoven, The Netherlands

Title
Triptich

Type of Work
Room divider

Material
PMMA, Nylon

Dimension / Size
Open: 1660 x 2200 x 200 mm
Closed: 1660 x 1100 x 400 mm

Client
Cultivate

Year Produced
2002

Designer
Sander Mulder, Dave Keune

Photographer
Dave Keune

Description
Triptich is a room divider that reveals its golden settings when being exposed to light. The entire content is engraved in transparent PMMA by hand, it represents a modern view on the ancient themes heaven, earth and hell. The frame, hinges and legs are made of nylon which creates a mystic occurrence. Triptich is part of the OVERDOSE series of Buro Vormkrijgers. A collection in which is experimented in excess, both in matter as in ornament.

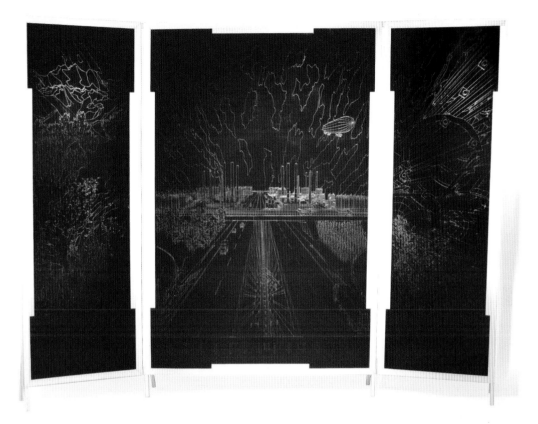

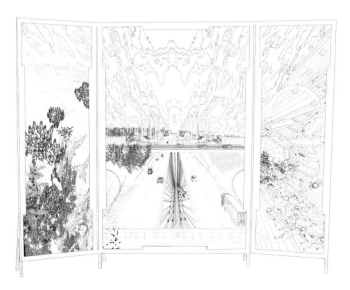

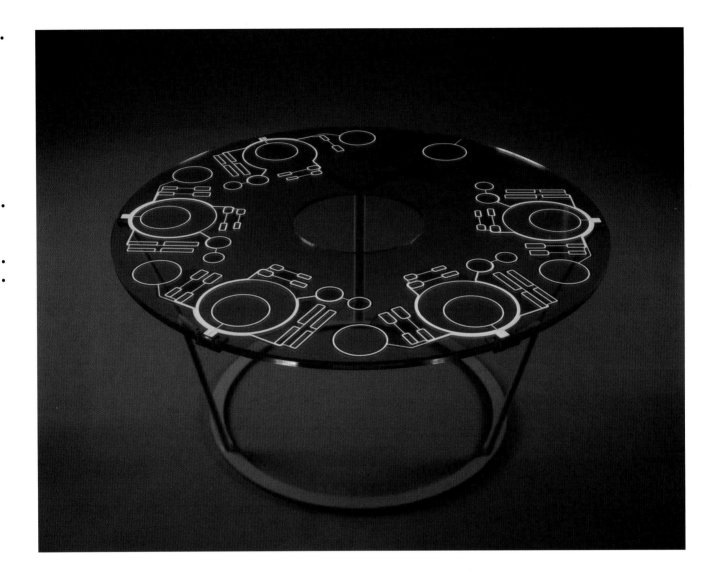

Sam Buxton
London, UK

Title
SIOS Table

Type of Work
Active table

Material
Electroluminescent displays, Laser cut acrylic, Steel structure, Sequencing electronics

Dimension / Size
1620 ø x 720 Tall mm

Client
SB studio

Year Produced
2003

Designer
Sam Buxton

Photographer
Peter Mallet

Description
Part of the SIOS, Surface Intelligent ObjectS, series that explores the activating of physical surfaces around us with information display.

Sam Buxton
London, UK

Title
Clone Chaise

Type of Work
Chaise longue

Material
Electroluminescent displays, Laser cut acrylic, Steel frame, Sequencing electronics

Dimension / Size
1850 x 750 x 600 mm

Client
SB studio

Year Produced
2006

Designer
Sam Buxton

Photographer
Peter Mallet

Description
Part of the SIOS, Surface Intelligent ObjectS, a series that explores the activating of physical surfaces around us with information display.
A chaise longue that reveals the relationship of the living body to an object.

As you approach the heart illuminates and starts to beat... the lungs breath and the veins come alive.

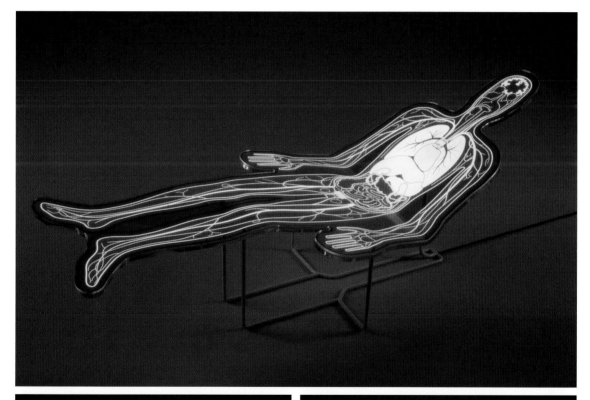

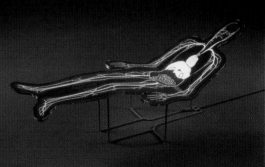

Sam Buxton
London, UK

Title
* MIKRO-Cube Bath ** MIKRO-House
*** MIKRO-Man Jungle, Office, Muscle

Type of Work
Sculptural product

Material
Acid etched stainless steel

Dimension / Size
* Folded: 70 Tall x 55 Wide x 60 Deep mm
** Open: 325 x 85 mm *** Open: 35 x
95 mm

Client
MIKRO

Year Produced
* 2006 ** 2003 *** 2000 - 2006

Designer
Sam Buxton

Photographer
* Dave Willis ** Eugene Franchi *** Dave
Willis

Description
** A complete living environment folding
out from a single acid etched 0.15mm thick
stainless steel sheet.

*** Started because of the boredom of hav-
ing a traditional printed business card. By
deploying a chemical milling process he had
discovered in the electronics industry where
he created a flat stainless steel card and the
various parts of which unfolded into a 3D
replica of himself working at his computer.

The original card was displayed at the
Design Museum London in 2001, and it
was put into production by Worldwide Co.
as part of the first 4 MIKRO designs. The
MIKRO-Man Office remains Sam's business
card now.

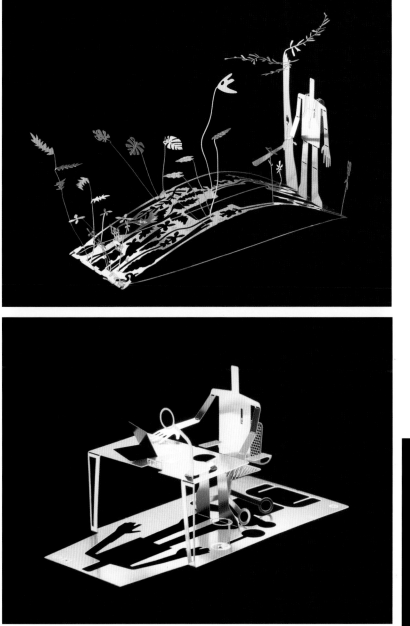

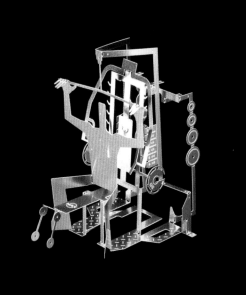

Sam Buxton
London, UK

Title	**Photographer**
MIKRO-City	Nick Turner
Type of Work	**Description**
Sculptural installation	Sam was commissioned by the Design Museum London to build an installation for the Tank - a 24-hour glass box exhibition space outside the museum. It is known as MIKRO-City; a series of laser cut stainless steel buildings placed close to the glass, echoing the cityscape outside.
Material	
Laser Cut and acid etched stainless steel, Laser cut acrylic	
Dimension / Size	An office block with floors filled with row after row of Office Men. MIKRO inhabitants sit at home in tiny flats playing Playsation. A hospital with a ward of MIKRO Accidents. Satellite TV dishes cover the tower blocks and the network of roads connecting the buildings is constantly monitored by CCTV towers. A MIKRO snapshot of the modern City. The work was sponsored by is IKEA UK.
Design Museum Display tank: 5 x 3 m	
Client	
Design Museum London	
Year Produced	
2003	
Designer	
Sam Buxton	

Tjep.
Amsterdam, The Netherlands

Title
House Of Textures

Type of Work
Metal structure being laser-cut

Material
Glass, Metal

Dimension / Size
24 x 12.5 cm

Client
NAI, exiblition 'Nu Binnen'

Year Produced
2005

Designer
Frank Tjepkema, Janneke Hooymans

Description
In order not to fall back onto traditional decorative patterns, the designers devised an archetypal house in 4 cut-through layers of different textures from graffiti to wallpaper, including bricks, tubing, carpets etc.

They used the iconography on all these elements to build up a new layered house (scale 1:25) out of 2 materials: glass and metal, with the metal structure being laser-cut. To add some drama they included personally designed elements such as a heart shape door, but also included graffiti found on the internet, such as the beautiful 'Love and honesty in our struggle' tag by the Bolevian group Mujeres Creando.

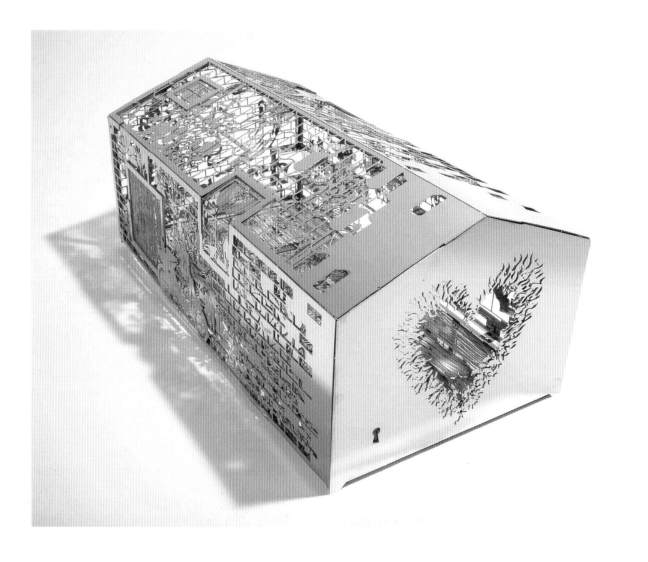

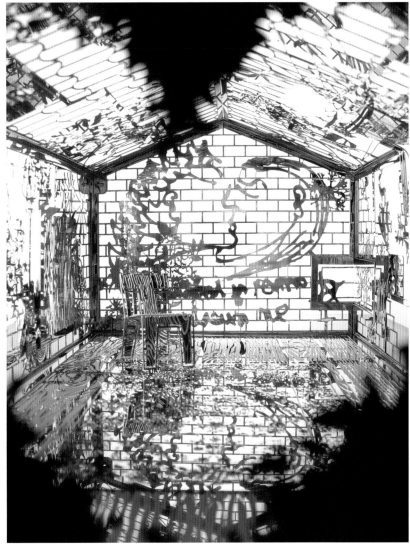

Eva Menz
Design Ltd
London, UK

Title
Money Can't Buy Me Love

Type of Work
Chandelier, Lighting sculpture

Material
Recycled plastic bottles

Dimension / Size
55 x 70 cm

Client
Eva Menz Collection

Year Produced
2003

Designer
Eva Menz

Description
Chandelier made from recycled plastic bottles and 'found objects' – antique jewellery elements, buttons and pearls give a disregarded selection of items a new life.

Chandelier creates a glamorous object by using waste material and recycling 150 plastic bottles.

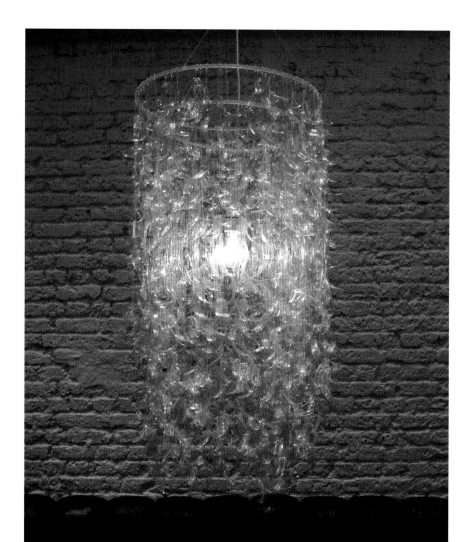

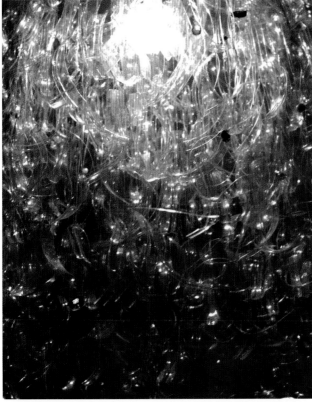

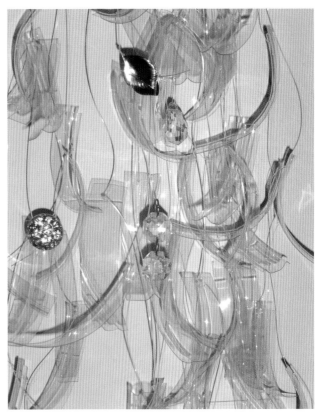

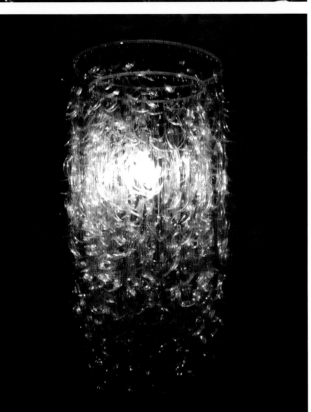

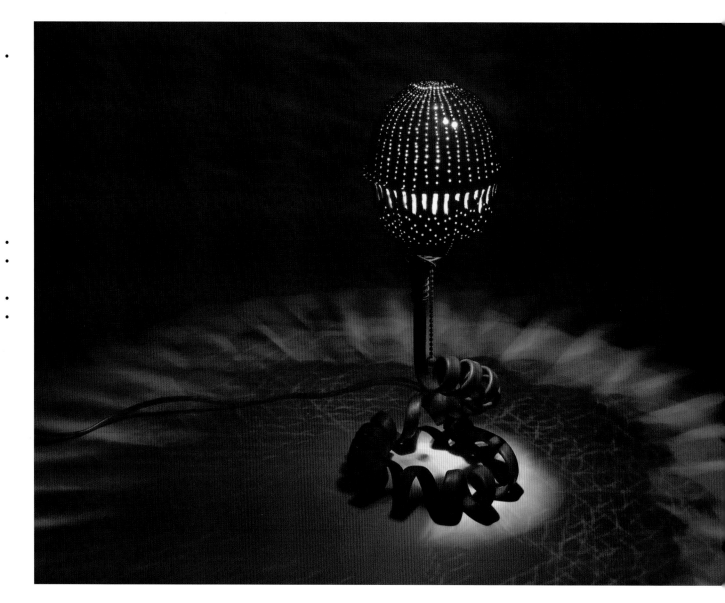

Tyson Boles
Philadelphia, USA

Title
Boa Lamp

Type of Work
Lamp

Material
Copper

Dimension / Size
W 18" x L 4" x H 4"

Client
Tyson Boles

Year Produced
1995

Designer
Tyson Boles

Description
Tyson likes to go into stores and try to find new ways to use the products for sale. These were all found in plumbing supply warehouses.

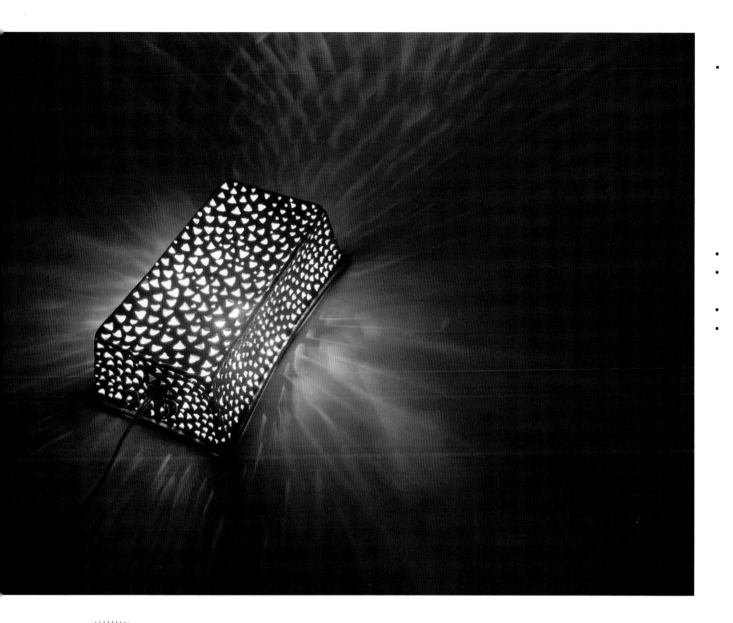

Tyson Boles
Philadelphia, USA

Title	**Description**
Pan	Tyson loves punch tin lanterns. He found this breadpan in a thrift shop and wanted to make sconces for his kitchen.
Type of Work	
Lamp	
Material	
Aluminum	
Dimension / Size	
W 10" x L 4" x H 3"	
Client	
Tyson Boles	
Year Produced	
1995	
Designer	
Tyson Boles	

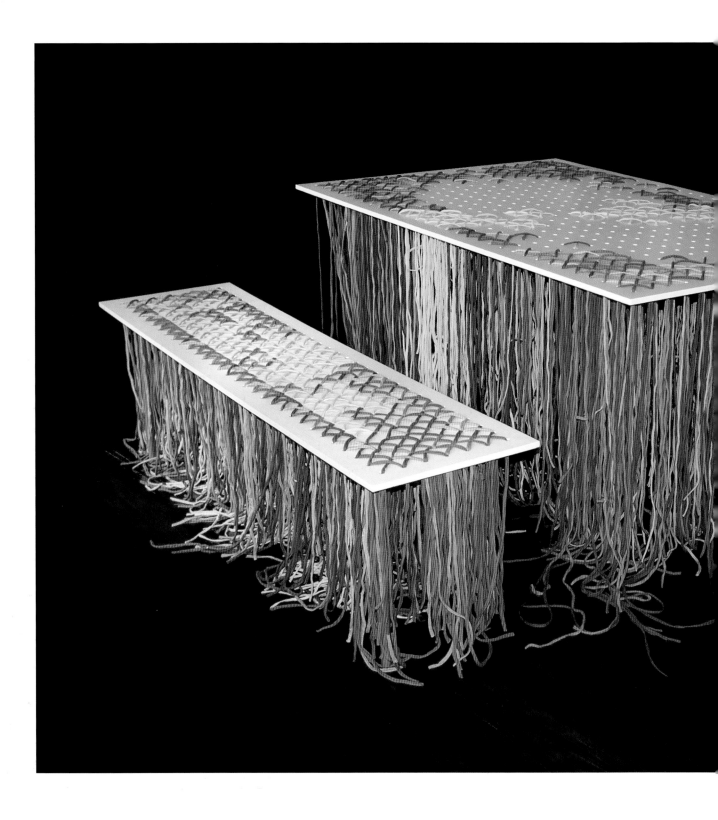

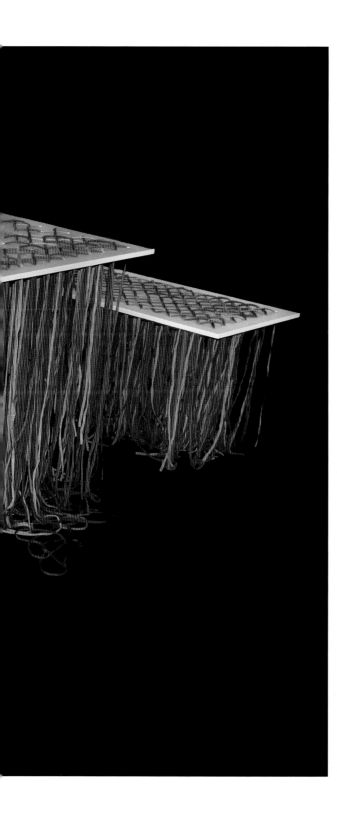

WOKmedia
London, UK

Title	**Photographer**
Hidden	WOKmedia
Type of Work	**Description**
Table and benches	The table was made as a series of project themes around childhood. The table, Hidden, uses the theme of hiding. It is not just for children to hide in, but to hide all the things adults do under tables, or to make secret stores of things tied into the jungle of string.
Material	
Corian, Dyed cotton strings	
Dimension / Size	
140 x 70 x 70 cm	
Client	
WOKmedia, Dupont Corian	
Year Produced	
2005	
Designer	
Julie Mathias, Michael Cross	

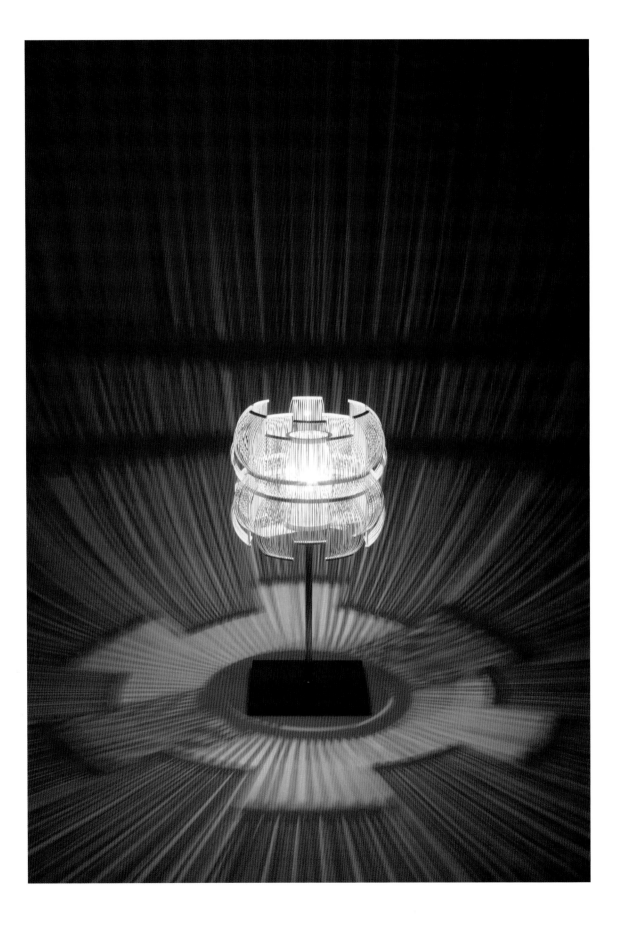

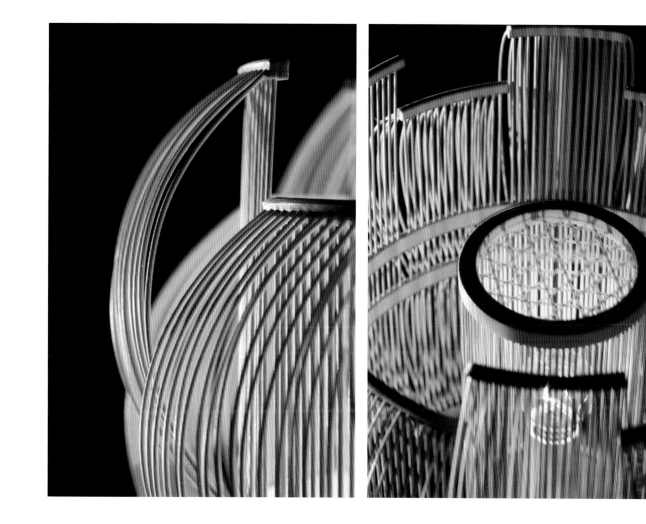

Toshiyuki Tani
Yokohama-shi, Japan

Title
Sen

Type of Work
Lighting

Material
Bamboo (Take-sensujizaiku) (Fine workman-ship)

Dimension / Size
H 18.1" x W 10.0" x D 10.0"

Client
-

Year Produced
2004

Designer
Toshiyuki Tani

Description
A work adopted the traditional craft skill and technique called Take-sensujizaiku (Fine workmanship) in Japan. The shadow is the work.

Reddish

Sitriya, Israel

Title
X Bread

Type of Work
Bread Stand

Material
Wood, Coloured thread

Dimension / Size
L 47 x W 17 x H 5 cm

Client
Reddish

Year Produced
2004

Designer
Naama Steinbock, Idan Friedman

Description
This is an offspring of a bread stand and a napkin – a cross stitched bread stand.

The delicate embroided wood enables the anonymous bread board to leave the kitchen and become a respected center piece.

Handcrafted with care, the hard wood is softened by the touch of embroidery.

Reddish
Sitriya, Israel

Title
Yakuza

Type of Work
Low table

Material
Wood (veneered MDF)

Dimension / Size
L 110 x W 60 x H 34 cm

Client
Reddish

Year Produced
2006

Designer
Naama Steinbock, Idan Friedman

Description
A digitally tattooed wooden table. In its design, the table is treated as a living body, receiving its character from a tattoo printed on its surface.
A large-scale digital printing technology, usually used for advertising purposes, enables to create customized furniture. Using the ability to print detailed images and transparencies on hard surfaces, the table's design is a unique combination of the wooden texture and the printed pattern.

Each table can be easily treated individually, giving each piece a strong personal identity.

Yakuza just won the 1st prize of the inspired by cologne 06 – interior innovation award imm cologne, in Köln, Germany.

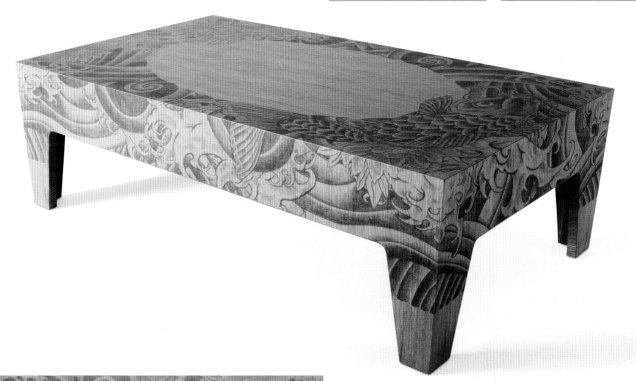

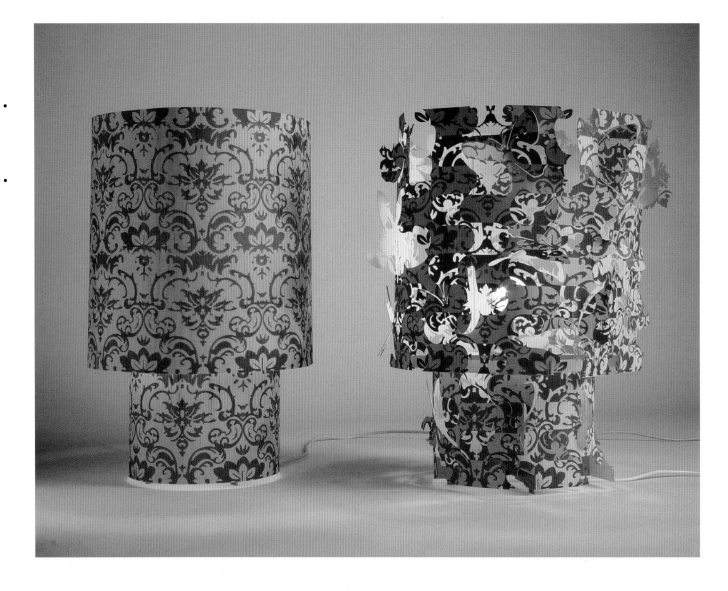

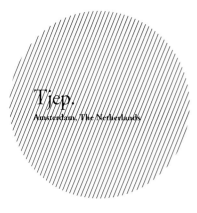

Tjep.
Amsterdam, The Netherlands

Title
Destructive Deco

Type of Work
Lamp

Material
Laser cut veneer

Dimension / Size
H 58 x D 39 cm

Client
Droog

Year Produced
2005

Designer
Frank Tjepkema, Janneke Hooymans

Description
The machine is programmed to apply decorations. Oops, something goes wrong... The machine just won't stop. As chaos takes over, Destruction becomes beauty.

The lamp designs are made of laser etched veneer which comes in 3 models. The laser was set to apply 3 independent overlapping patterns. The first is based on a traditional baroque wallpaper; the second is a 60s pattern; and the third is an illustrative butterfly pattern. As the laser operates, it goes deeper and deeper into the material, until it reaches a point where it is actually causing destruction instead of applying decoration. When should the laser stop? Until when does it add to the beauty of the object? The most expensive lamp is the one that has been 'treated' the longest by the laser, as operation minutes are costly with such high-end technology.

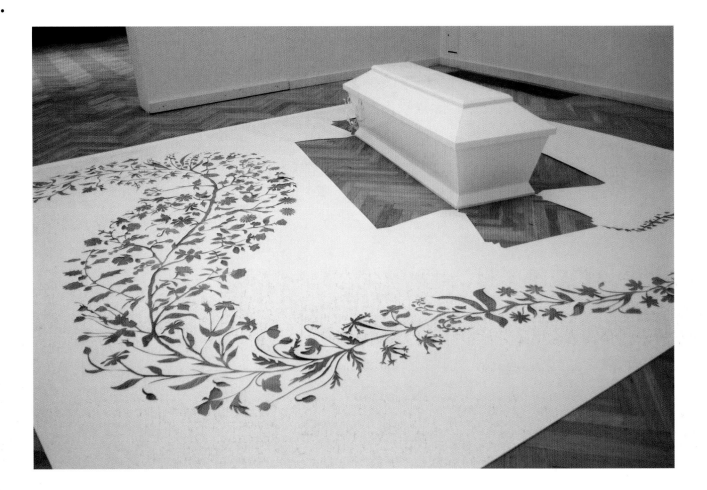

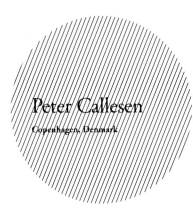

Peter Callesen
Copenhagen, Denmark

Title
Everything Comes To This

Type of Work
Sculpture

Material
350g. acid free paper

Dimension / Size
Dimensions variable

Client
Exhibited Charlottenborg udstillings bygning, Copenhagen Denmark, Courtesy emilyTsingou gallery, London

Year Produced
2006

Designer
Peter Callesen

Description
Fine art.

All images courtesy of the artist, Helen Nyborg Contemporary, Copenhagen, and Emily Tsingou Gallery, London

Eva Menz
Design Ltd
London, UK

Title
Red Princess

Type of Work
Bespoke Chandelier

Material
Tyvek

Dimension / Size
D 1 m

Client
Peel Gallery, Houston, Texas

Year Produced
2006

Designer
Eva Menz

Description
Chandelier made from 1400 origami lilies for gallery launch. This piece is entirely handmade using a paper-like material, called Tyvek.

'Red Princess' is part of a chandelier collection by Eva Menz titled 'Life is beautiful'.

The inspiration for the collection was to create breathtaking and glamorous objects with a small amount of material and focus primarily of the work effort and that has been put into making them.
The origami chandeliers are essentially made from a pile of flat sheet paper-like material folded into something voluamous and intricate. The pieces are to demonstrate that a immaterial things such as time spent can create value and provoke the thought of what makes something precious.

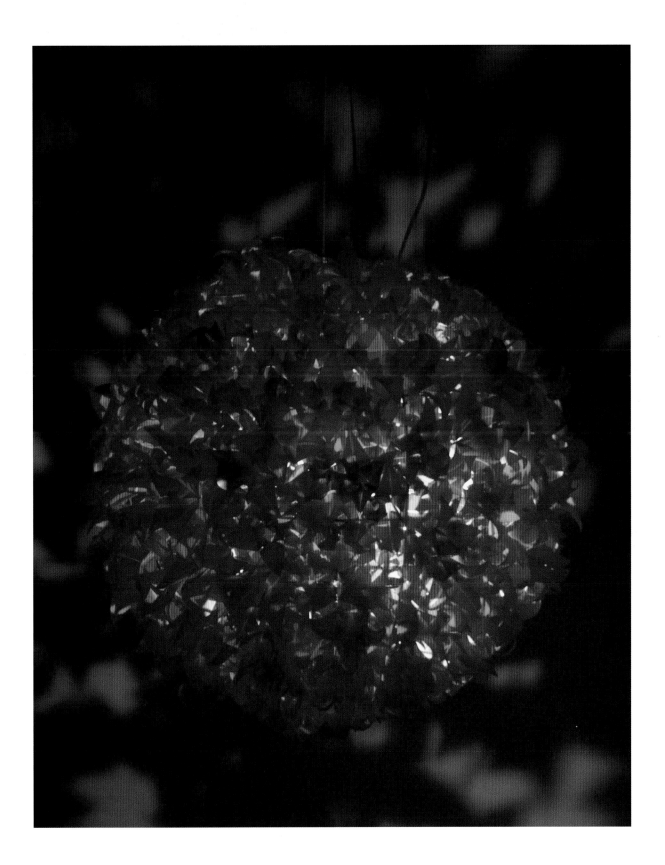

Eva Menz
Design Ltd
London, UK

Title
Free As a Bird

Type of Work
Bespoke Chandelier

Material
Tyvek

Dimension / Size
D 1 m

Client
Eva Menz Collection

Year Produced
2006

Designer
Eva Menz

Description
'Free as a bird' is part of a chandelier collection by Eva Menz titled 'Life is beautiful'.
It is said that folding 1000 origami cranes grants the artisan a free wish.

The inspiration for the collection was to create breathtaking and glamorous objects with a small amount of material and focus primarily of the work effort and that has been put into making them.
The origami chandeliers are essentially made from a pile of flat sheet paper-like material folded into something voluamous and intricate. The pieces are to demonstrate that a immaterial things such as time spent can create value and provoke the thought of what makes something precious.

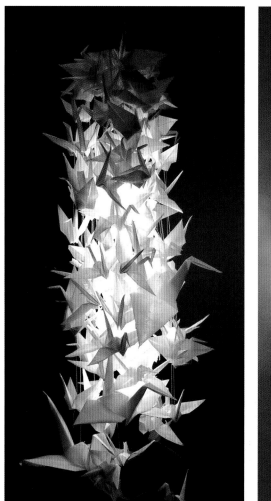

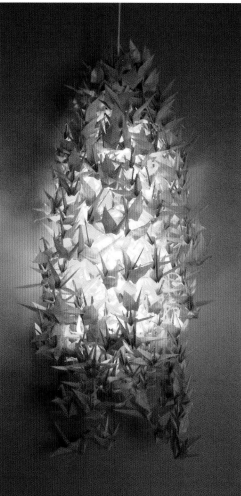

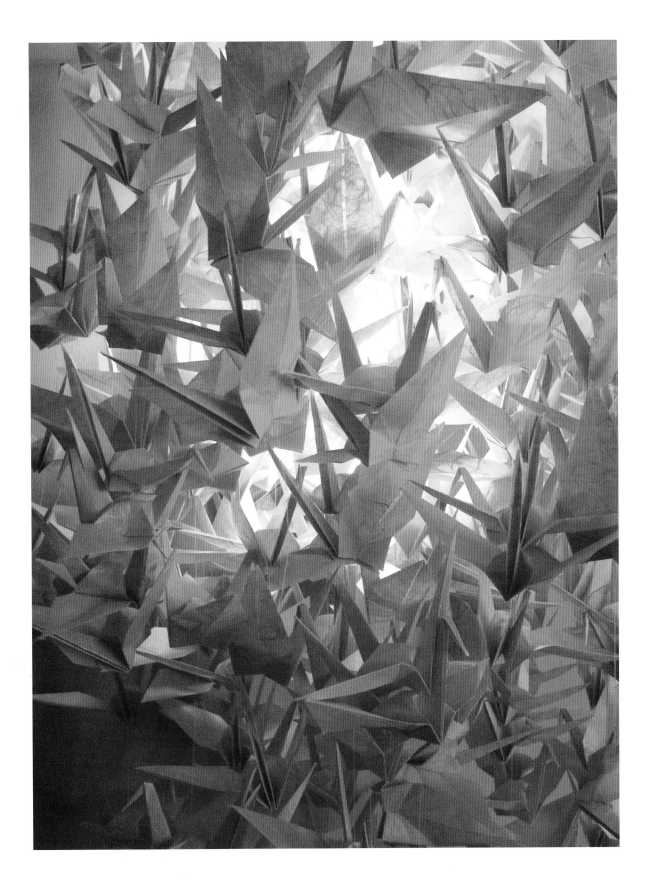

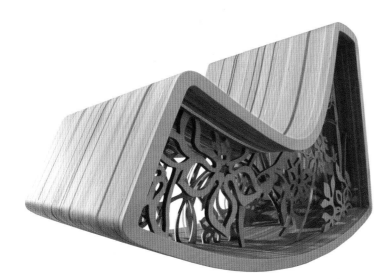

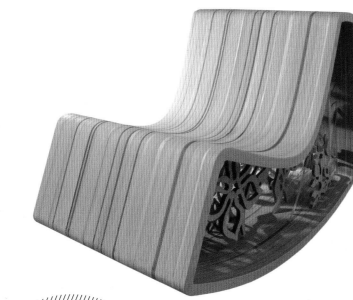

Studiobility
Seltjarnarnes, Iceland

Title
Rocking beauty

Type of Work
Furniture

Material
Aluminum, Macralon, Plywood

Dimension / Size
H 760 x W 1050 x D 600 mm

Client
Studiobility

Year Produced
2006

Designer
Gudrun Lilja Gunnlaugsdottir

Description
Inner beauty is not only about beauty but also about uniqueness. It is made up of laser cut plywood that layers randomly put together to create panorama of flowers. The designer is looking for the inner beauty of things and the depth we have as human beings, the story within things and the world usually hidden.

Rocking beauty is an extension of the inner beauty concept. It is a piece where femininity meets the masculinity in the form of decorations and materials. Where materials play the function of colours. Where the storytelling finds its place. The layers of materials and how they are combined is what makes each item unique 'barcode stripes' on the outside and the flower pattern on the inside.

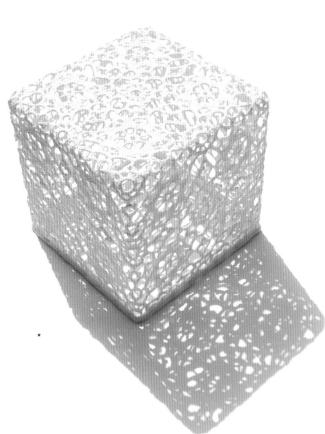

*

Title
* Crochet Table ** Lace Table

Type of Work
Furniture

Material
* Crocheted cotton, Epoxy ** Swiss lace, Epoxy

Dimension / Size
* H 30 x W 30 x D 30 cm
** H 30 x W 30 - 60 x D 30 cm

Client
–

Year Produced
* 2001 ** 1997

Designer
Marcel Wanders

Photographer
* Henk Jan Kamerbeek
** Marcel Wanders Studio

Description
* It is produced and distributed by Moooi.
** With Swiss lace as the basic material that is hardened with resin a transparent series of tables is made. The sweetmeats character of these tables is really very special and gives this products a crystal-like appearance.

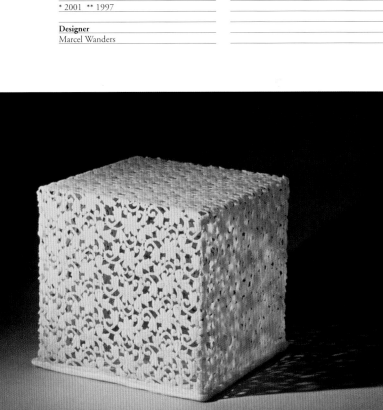

**

Studiobility
Seltjarnarnes, Iceland

Title
Flower chair

Type of Work
Furniture

Material
Plywood, Fiberglass

Dimension / Size
H 776 x W 894 x D 600 mm

Client
Studiobility

Year Produced
2006

Designer
Gudrun Lilja Gunnlaugsdottir

Description
To camouflage or to fit in the environment was the designer's thoughts for the design. It is in a limited edition of 10 from layered plywood - fiberglass version comes in 4 colours - black, white, red and metal.

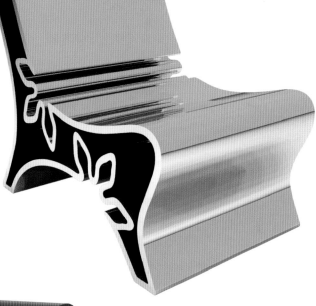

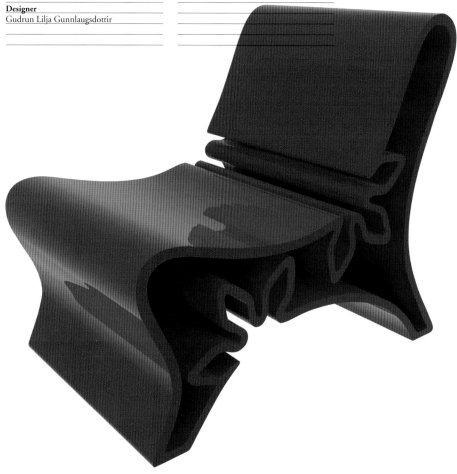

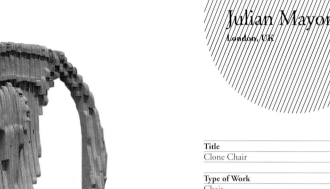

Julian Mayor
London, UK

Title
Clone Chair

Type of Work
Chair

Material
Plywood

Dimension / Size
500 x 500 x 850 mm

Client
-

Year Produced
2005

Designer
Julian Mayor

Description
Julian Mayor's work explores the boundaries between man and machine, also between real and artificial. The clone chair is based on a Queen Anne chair from the collection of the Metropolitan museum in New York that has been sampled. The piece was originally made for an show called 'clone' at Londons NOG gallery on Brick Lane in 2005, which Julian co-curated.

The show's idea was based on the difference between the real and an illusion ceases to be clear, and the two begin to fuse themselves together. The piece hopefully keeps an appreciation of the form and formality of the original, but has been transformed into something that is more about the idea of possibility.

Clone Chair is a limited edition.

HAYON®
STUDIO
Barcelona, Spain

Title
BD Showtime Collection

Type of Work
Furniture (Cabinet)

Material
Laquered wood

Dimension / Size
Vary (Each module: 50 x 100 cm)

Client
BD Barcelona

Year Produced
2006

Designer
Jaime Hayon

Description
This modular system was meant to change the way modular storage is perceived. The designer wanted to create a piece that was functional and fun and could be combined in many different ways. There are 12 different legs and each was originally hand turned by different artisans to emphasize their individual personalities.

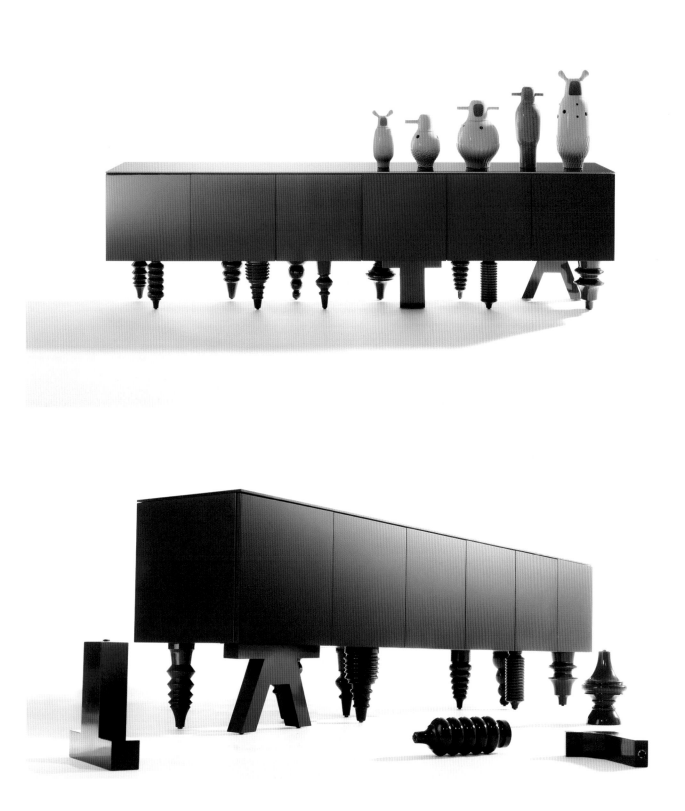

Studio van Eijk &
van der Lubbe
Geldrop, The Netherlands

Title
Bobbin Lace Lamp

Type of Work
Lamp

Material
Bobbin laced glassfibre

Dimension / Size
D 40 x 200 cm,
D 80 x 300 cm

Client
Niels van Eijk

Year Produced
2002

Designer
Niels van Eijk

Description
A glass fibre Bobbin Lace Lamp; a lamp
without a bulb. The lighting is being
transported through the glass fibre.
Therefore, the shade of the lamp becomes
the light source.
The lamp contains 500m of glass fibre and
is illuminated from a black box of 10 x 10
x 20 cm.
The Bobbin Lace Lamp is handmade and
can be custom made for a particular place.

Contraforma
Vilnius, Lithuania

Title
Romance

Type of Work
Tables

Material
Powder coated metal

Dimension / Size
Vary

Client
Contraforma

Year Produced
2004

Designer
Neringa Dervinyte

Description
The Romance came with an idea to create an elegant and contemporary piece of furniture. The stark durability of laser-cut, powder-coated steel offset by fragile perforation, which allowed cold and hard metal material to convert into light and visually soft piece of furniture.
Romance is folded from one sheet almost avoiding welds. Flowers in azure in strict rectangular form are the main accent which creates romance and magic in the play of light and shadows. Double colour combination (one colour inside, another outside) is particularly attractive and innovative. The special manufacturing technique is used to produce 2 colour product using powder coating. This furniture looks perfect both in homely and public atmosphere. It can be used indoors as well as outdoors.

Sebastiaan
Straatsma
Schiedam, The Netherlands

Title	**Description**
Dustcollector	Inspired by objects and shapes who at first hand have a dual us-aged: function and decoration. These pieces are based on the classical vases we normally see on antique cupboards. They have the vase function but are hardly never used that way. They are status symbols of the past and used as decoration. There real function switched to collecting dust and being beautiful. So why not be honest and make them totally decoration and dust collecting.
Type of Work	
Vase	
Material	
Epoxy resin	
Dimension / Size	
Vary	
Client	
Various clients	
Year Produced	
2006	
Designer	
Sebastiaan Straatsma	

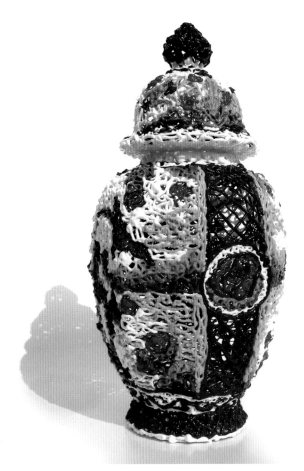

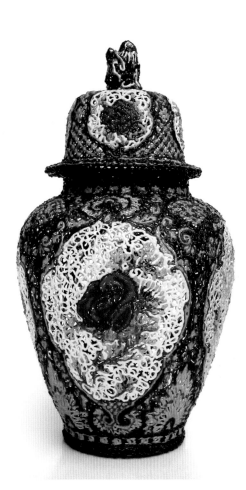

L.A. Galerie - Lothar Albrecht
Schweiz, Germany

Title of
* New China Series TV ** Car

Type of Work
Sculpture

Material
Porcelain

Dimension / Size
* 38 x 27 x 25 cm ** 75 x 28 x 32 cm

Client
L.A. Galerie – Lothar Albrecht

Year Produced
* 2007 ** 2006

Designer
Ma Jun

Description
Ma Jun used the traditional Chinese porcelain-making technique for the smaller objects of his 'New China Series' (begun in 2005). The glazes in the traditional colours, the floral patterns, the folkloristic subjects and the characteristic surfaces that make the objects appear like very valuable arts and crafts. This combination of the shapes and forms of 'modern' Western products with traditional Chinese ways of production makes for hybrid objects. In an almost metaphorical way, the process of the models of industrial mass-production being fired and decorated in the traditional way exemplifies how a traditional pattern can cast over everything and turn it into something different. It also demonstrates, however, how arbitrarily these patterns can be utilized, as there no longer exists any meaningful interplay between object and decoration.

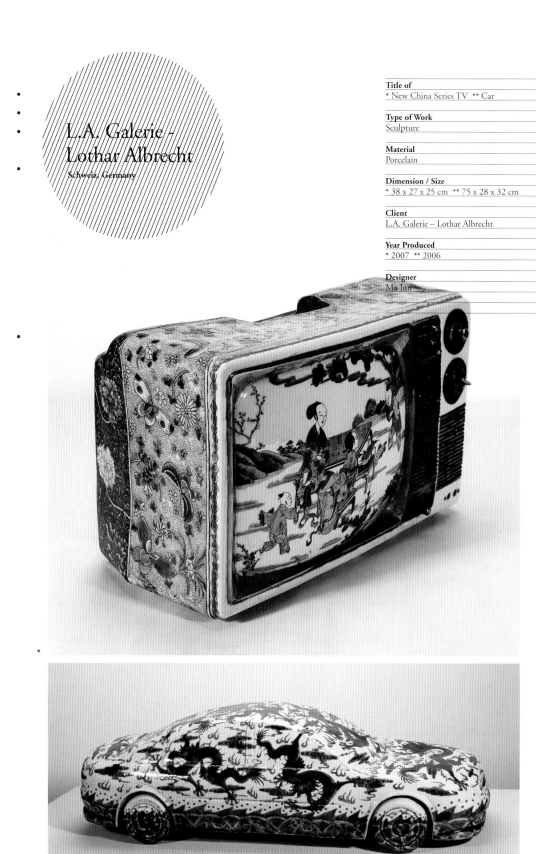

*

**

L.A. Galerie -
Lothar Albrecht
Schweiz, Germany

Title
Cola Bottles

Type of Work
Sculpture

Material
Porcelain, Wood

Dimension / Size
36.5 x 36.5 x 31 cm

Client
L.A. Galerie – Lothar Albrecht

Year Produced
2005

Designer
Ma Jun

Description
Ma Jun used the traditional Chinese porcelain-making technique for the smaller objects of his 'New China Series' (begun in 2005). The glazes in the traditional colours, the floral patterns, the folkloristic subjects and the characteristic surfaces that make the objects appear like very valuable arts and crafts. This combination of the shapes and forms of 'modern' Western products with traditional Chinese ways of production makes for hybrid objects. In an almost metaphorical way, the process of the models of industrial mass-production being fired and decorated in the traditional way exemplifies how a traditional pattern can cast over everything and turn it into something different. It also demonstrates, however, how arbitrarily these patterns can be utilized, as there no longer exists any meaningful interplay between object and decoration.

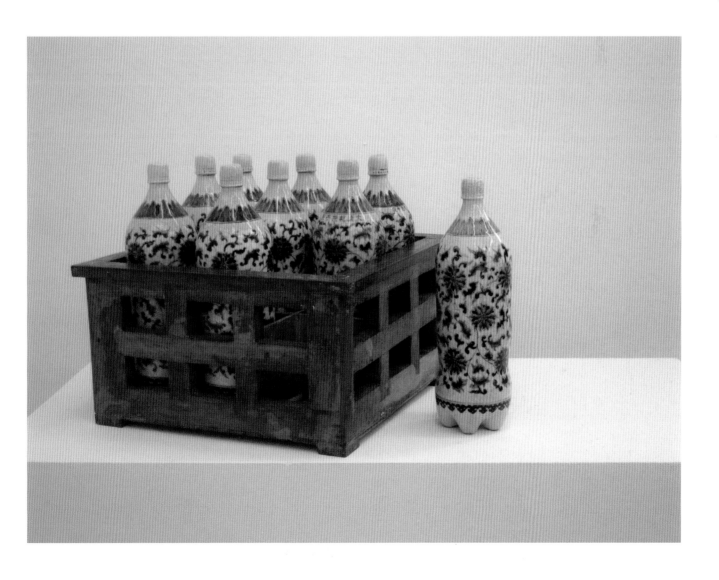

Estudio Campana
São Paulo, Brasil

Title
Vermelha Chair

Type of Work
Chair

Material
Stainless steel structure, Dyed cotton braided ropes

Dimension / Size
H 77 x W 86 x L 58 cm

Client
Edra, Italy

Year Produced
Designed in 1993 and produced since 1998 by Edra

Designer
Fernando and Humberto Campana

Description
Wrap-around armchair with steel frame painted with epoxy powders. Several days' manual work is required to build the seat, and together with high expertise for the weaving. The 500m of special rope with an acrylic core, covered in cotton are first woven onto the frame to create a structure and then plaited by consecutive overlapping. Leaving sufficient surplus to form a kind of random weave which creates an unusual padding.

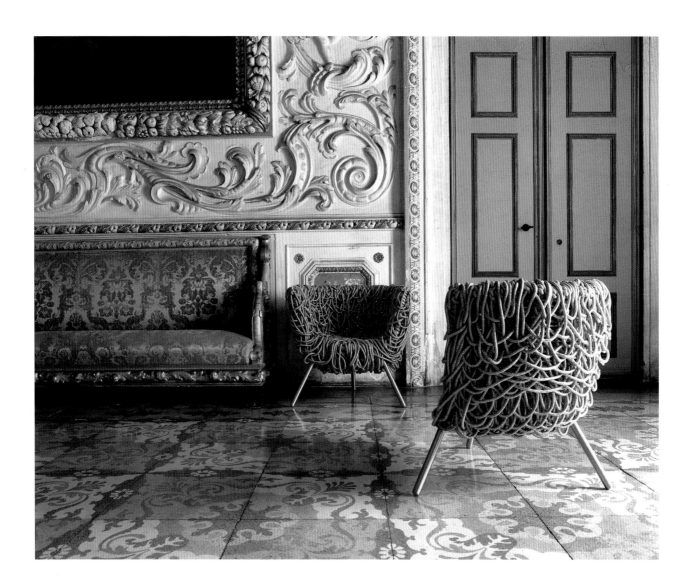

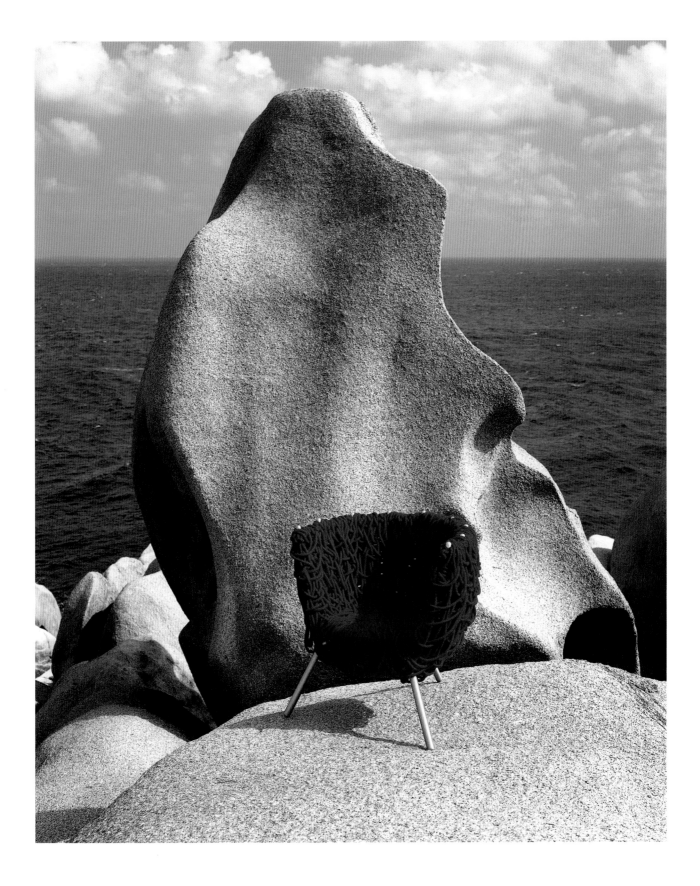

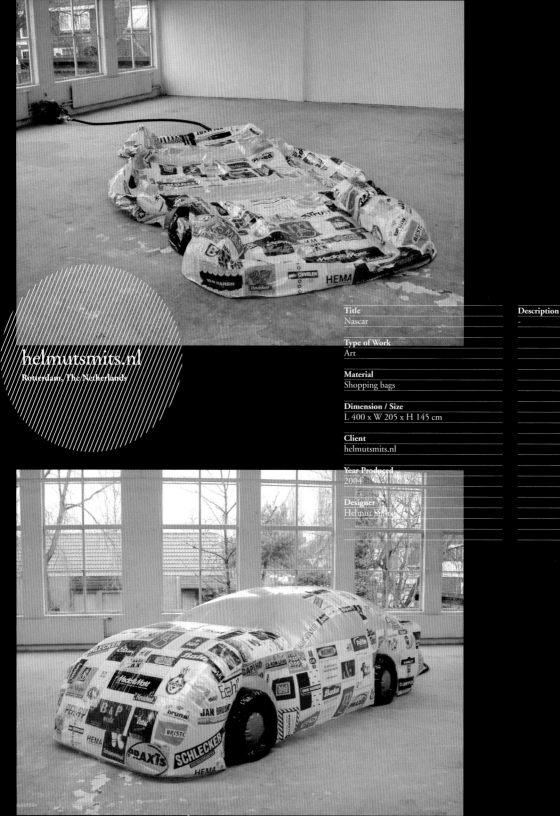

Title
Nascar

Type of Work
Art

Material
Shopping bags

Dimension / Size
L 400 x W 205 x H 145 cm

Client
helmutsmits.nl

Year Produced
2004

Designer
Helmut Smits

Description
-

helmutsmits.nl
Rotterdam, The Netherlands

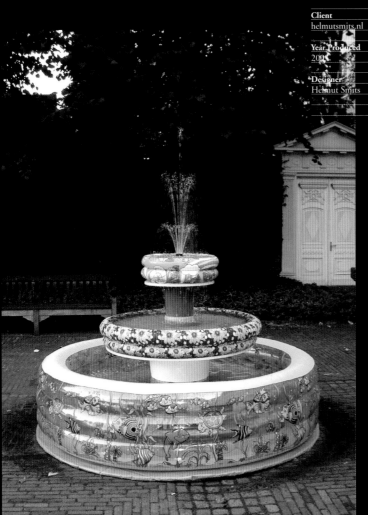

Title
Paddling Pool Fountain

Type of Work
Art

Material
Inflatable paddling pools

Dimension / Size
L 234 x W 234 x H 280 cm

Client
helmutsmits.nl

Year Produced
2008

Designer
Helmut Smits

Description
-

Estudio
Campana
São Paulo, Brasil

Title
* Dolphins and Sharks ** Alligator Chair
Chair *** Multidão Chair **** Banquete
Chair

Type of Work
Chair

Material
*, ** and **** Stuffed toys and animals
*** Brazilian hand made Esperança dolls

Dimension / Size
95 x 100 x 140 cm

Client
Estúdio Campana

Year Produced
*2002 ** 2002 **** 2002
*** 2004

Designer
Fernando and Humberto Campana

Description
All chairs were hand sewed on canvas cover
over a stainless steel structure.

*, ** and **** Designed in 2002, this chair
plays with the idea of new forms of uphol-
stery. It is an assemblage of stuffed animals
arranged according to different sizes, colours,
textures and heights in order to give balance
to the piece.

*** The Multidão chair was designed in
2004 and involves a very interesting project.
The dolls that upholster the chair are
handmade in the state of Paraiba, Northeast
of Brazil, in a town called Esperança – Hope
in Portuguese.

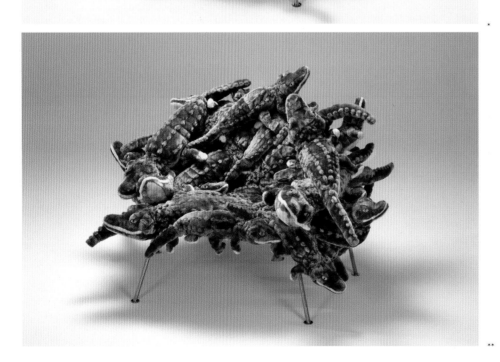

*

**

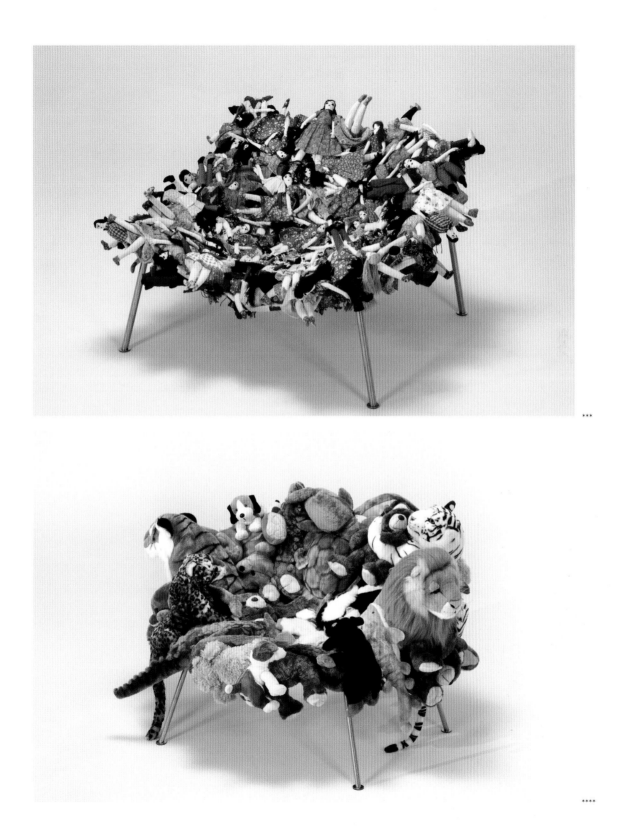

illusive
ilusorio
denkbeeldig
幻象
イリューシヴ
착각을

'Illusive' displayed designs that you may not only judge by its appearance, but also its content – the idea behind. It demonstrates how some concepts violate the reality and fill our mind with limitless creativity. This section reveals how illusive objects are made simply from imaginations and how it tricks our souls out of boredom.

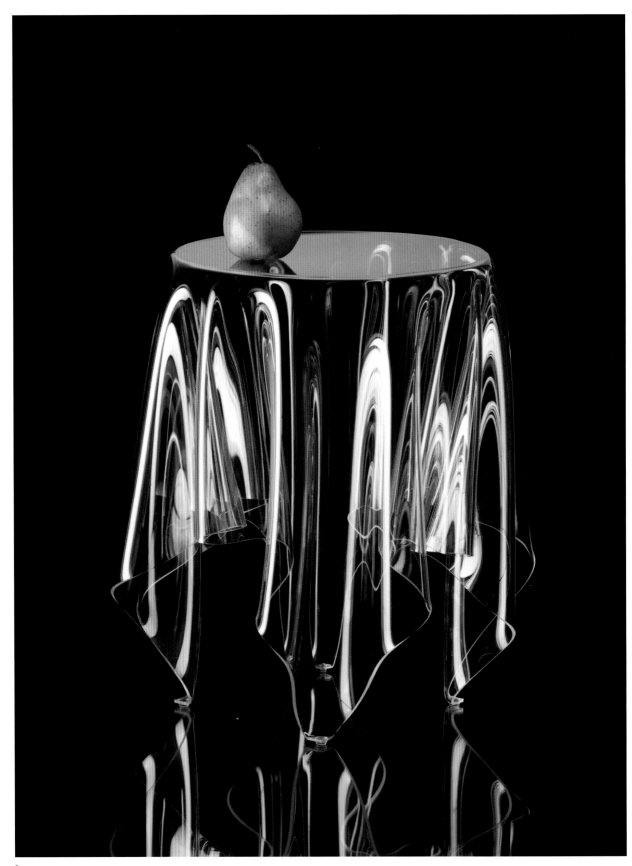

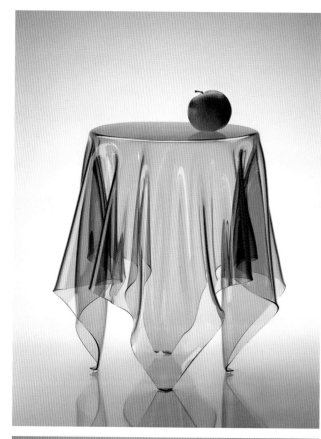

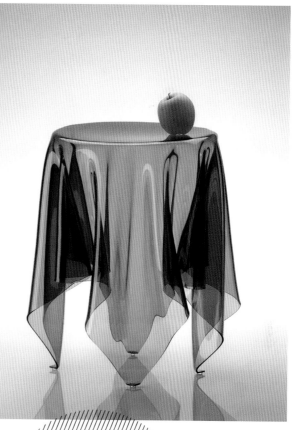

Essey ApS
Greve / Denmark

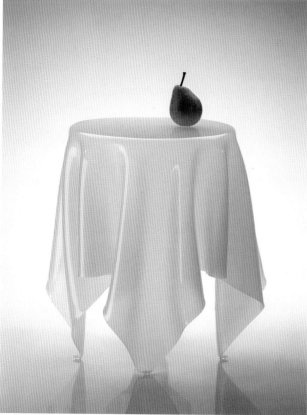

**

Title
* Grand Illusion ** Illusion

Type of Work
Side table

Material
PMMA (Acrylic)

Dimension / Size
* 500 x 550 mm ** 400 x 450 mm

Client
ESSEY ApS

Year Produced
2006

Designer
John Brauer

Description
John passed a Café in Copenhagen preparing for lunch. He saw a white square table cloth was placed on a round table and the corner touched the floor. John then thought 'What if i could freeze this form and eliminate the table?' So he used his mobile camera to take a photo and asked an acrylic workshop if it is possible to bend acrylic like this image. However the workshop said it was impossible. John then took a work cloth and went to work with them until the result of Illusion and the bigger Grand Illusion.

Essey ApS
Greve, Denmark

Title	**Description**
Bin Bin	John wanted to associate the crumbled paper with the paper bin using a non verbal communication. He wanted to create a form that reflects the identity of the product – making it speak for it selves. The result was created by making about 500 small bin made of paper, then crush them and unfolding them again. The model with a perfect balance of order and chaos was selected to be scanned in a 3D model before making the manufacturing equipment.
Type of Work	
Paper bin	
Material	
HDPE (High density polyethylene)	
Dimension / Size	
300 x 300 mm	
Client	
ESSEY ApS	
Year Produced	
2005	
Designer	
John Brauer	

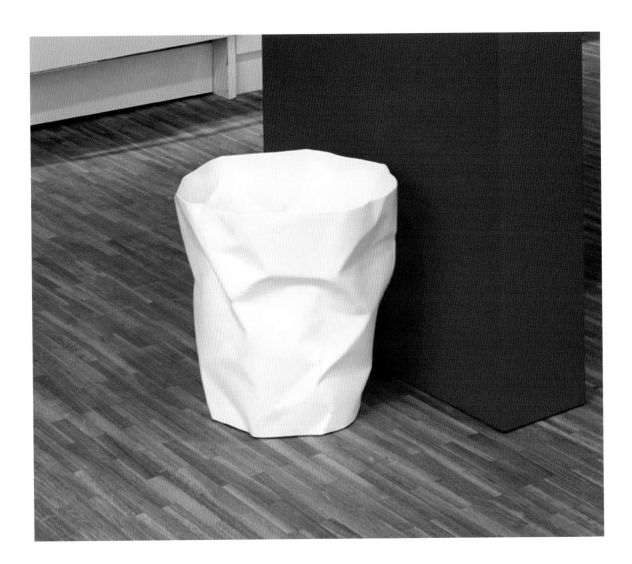

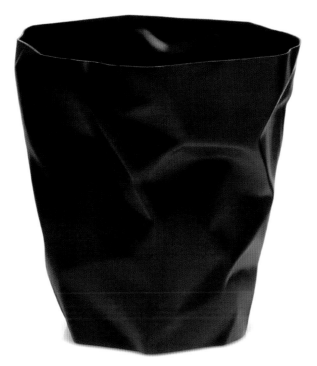

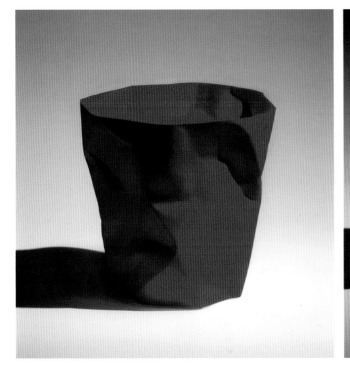
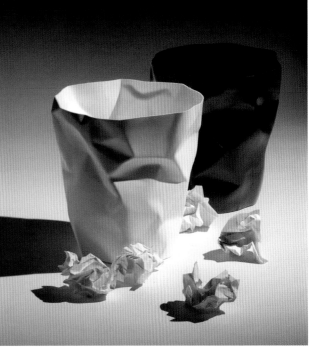

Maarten Baas
Eindhoven/Waalre, The Netherlands

Title
Clay armchair

Type of Work
Furniture

Material
Clay, Leather

Dimension / Size
W 60 x D 70 x H 65 cm

Client
-

Year Produced
2006

Designer
Maarten Baas

Photographer
Maarten van Houten

Description
Clay furniture is made of synthetic Clay, with a metal 'skeleton' inside, to reinforce the structure. All pieces are modeled by hand. No moulds are used in the production, which makes each piece unique.

Clay has been launched in Milan in 2006. The playful and spontaneous character became an immediate success. The first big exhibition was in the same year. In 2007, the Dutch Groninger Museum commissioned Baas for an installation of five ventilators.

The eight standard colours of the Clay series, are black, white, brown, red, yellow, blue, orange and green.

Maarten Baas
Eindhoven-Waalre, The Netherlands

Title
Clay fan

Type of Work
Furniture

Material
Clay

Dimension / Size
Small: 50 x 50 x 130 cm, Cage W 30, 40
Medium: 60 x 60 x 160 cm, Cage W 50, 55
Large: 70 x 70 x 200 cm, Cage W 70, 280

Client
Groninger Museum

Year Produced
2006

Designer
Maarten Baas

Photographer
Maarten van Houten

Description
Clay furniture is made of synthetic Clay, with a metal 'skeleton' inside, to reinforce the structure. All pieces are modeled by hand. No moulds are used in the production, which makes each piece unique.

Clay has been launched in Milan in 2006. The playful and spontaneous character became an immediate success. The first big exhibition was in the same year. In 2007, the Dutch Groninger Museum commissioned Baas for an installation of five ventilators.

The eight standard colours of the Clay series, are black, white, brown, red, yellow, blue, orange and green.

Studio
Bertjan Pot
BH Schiedam, The Netherlands

Title
Seamless Chair

Type of Work
Chair

Material
Aluminium, Wood, Foam, Felt

Dimension / Size
70 x 60 x 65 cm

Client
Produced by Bertjan Pot in cooperation with stichting sofa

Year Produced
2004

Designer
Bertjan Pot

Description
The seamless chair was made for a project organized by 'Stichting Sofa' and 'De Ploeg.' Sofa and De Ploeg asked a few designers to come up with new ideas for upholstered furniture. One of the fantasies Bertjan had about upholstering was, what if it could be done seamlessly. After a small quest the designer came to felt. TBertjan has seen several art projects where things were covered seamlessly in felt and since most felt is 100% wool and most upholstery.

In normal furniture upholstered with wool, after a few years, the fabric starts to peel and turns in to felt. Bertjan's hope is that it will also happen with this chair and therefore will only get nicer.

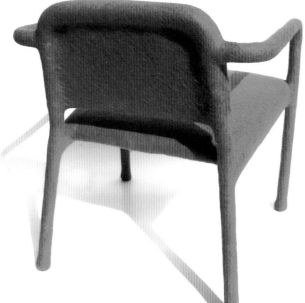

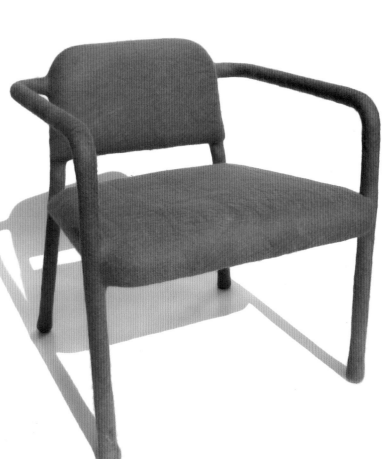

Valvomo
Architects
Helsinki, Finland

Title
Softbox

Type of Work
Storage system

Material
Needlepunched polyester felt, Vacuum
formed PET lid

Dimension / Size
670 x 420 x 180 mm

Client
www.softbox.se

Year Produced
2001

Designer
Markus Nevalainen, Kari Sivonen

Description
Softbox is an elegant and simple storage
system. The boxes can easily be combined,
stacked or moved to suit your needs. The
soft surface of the box also gives it a tactile
quality.

Tim Parsons
Manchester, UK

Title
Splash

Type of Work
Bowl

Material
Pewter

Dimension / Size
Approx. D 20 x H 6 cm

Client
A.R.Wentworth (Sheffield) Ltd.

Year Produced
2006

Designer
Tim Parsons

Description
The Splash bowl is created by a process the designer has christened drip-casting. Molten pewter is gathered in a ladle and dripped onto a steel tool; in this case an upturned bowl form. The pewter cools and solidifies as it hits the tool. More pewter is dripped until the desired surface is covered and thickness achieved. The cast is then removed from the tool and the tool reused.

As each drip of pewter fuses with the last, minute channels are created on the inside surface of the cast. These form a decorative snapshot of the production process, clearly showing the metal's once liquid state. By contrast, the outer surface of the cast is a solidified matte gloop. The inside surface of the bowl is buffed and polished to emphasize the liquid-like appearance of the pewter.

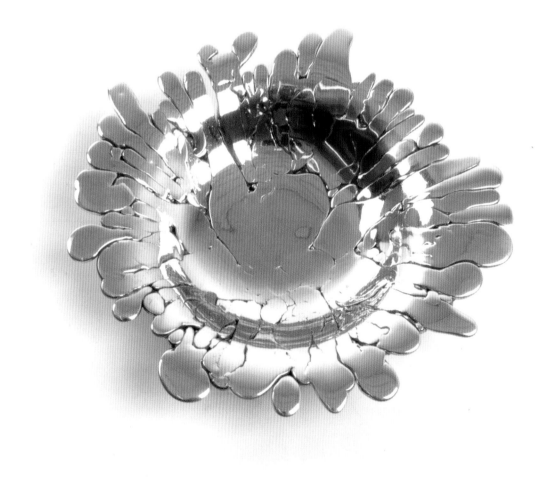

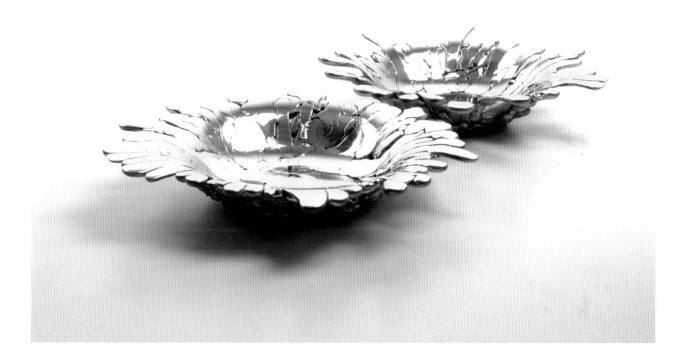

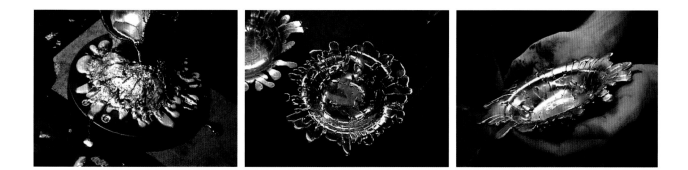

Chris Kabel
Designs
Rotterdam, The Netherlands

Title
* Copperlustre
** Black Money Vase (BMV)
*** Platinum Money Vase (PMV)

Type of Work
Product

Material
* Copper lustered porcelain ** Black porcelain *** Platinum lustered porcelain

Dimension / Size
D 22 x H 32 cm

Client
-

Year Produced
2005

Designer
Chris Kabel Studio

Photographer
Toolsgalerie

Description
Adorned with euro coins, these vases are a mild and very ornamental critique against design capitalism. Price has become decoration which adds value to the vase in turn.

Initally conceived at the EKWC.

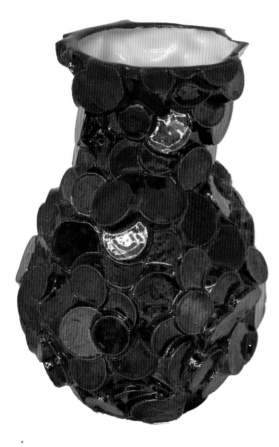

*

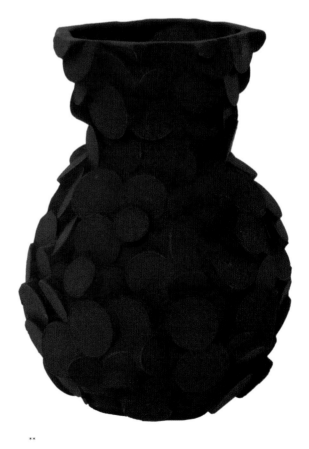

**

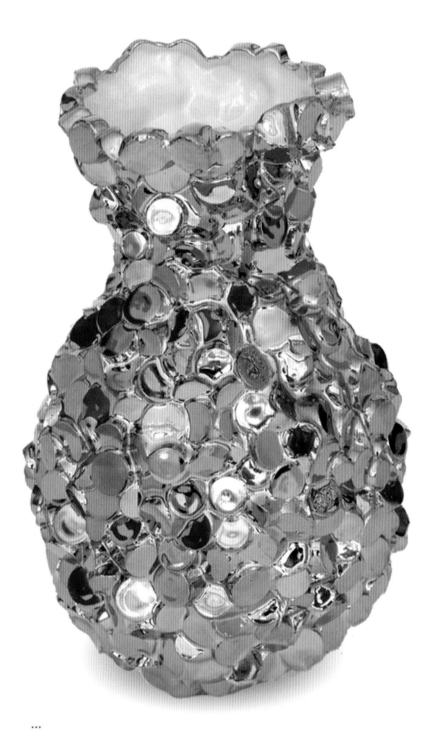

...

**Pd DESIGN
STUDIO**
Kyoto/ Japan

Title
Skin light • bulb

Type of Work
Light Bulb

Material
Silicon with special powder, LED light unit
(colour: milk white)

Dimension / Size
W 75 x D 75 x H 170 mm

Client
-

Year Produced
2005

Designer
Izumi Hamada, Hideo Hashimoto

Description
Skin is one kind of human behaviour mate-
rial. The designers want to create a soft skin
touch and try some material that is closer to
real skin touching. When they designed the
skin light series, they had been adviced about
'silicon' from the professional who is from
the special medical education goods maker.
Hamada and Hashimoto design lightings as
the humanity essence.

Buro Vormkrijgers
CB Eindhoven, The Netherlands

Title
Ceci ne'ast pas une lampe

Type of Work
Lighting

Material
Pyrex bulb, High power led, Transformer

Dimension / Size
110 x 60 mm

Client
Cultivate

Year Produced
2004

Designer
Sander Mulder, Dave Keune

Photographer
Sander Mulder

Description
A broken bulb can not function, or can it?
This lamp plays with the stereotypes of our
daily lives which are imprinted in our minds.

By the clever use of a high power led, lamp
becomes shade, and the impossible becomes
possible. The bulb is hand-blown from heat
resistant Pyrex glass, safe to the touch with
no sharp edges. Numbered and signed by the
designer, limited edition.

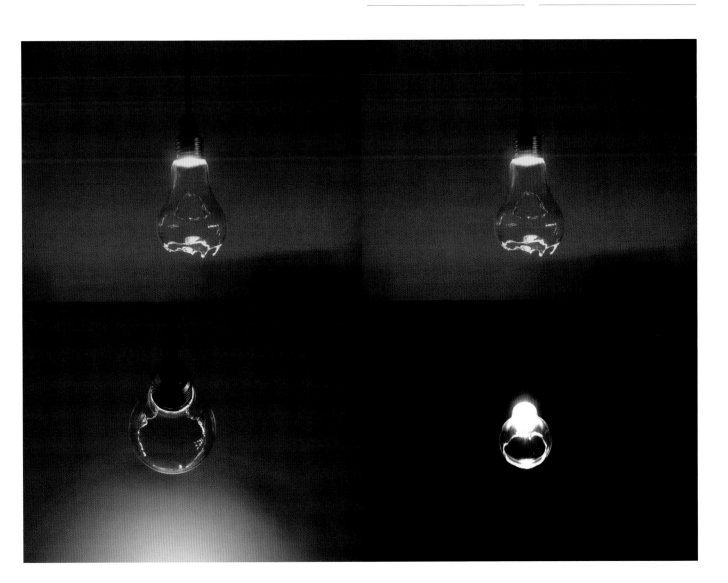

*

**

Big-game
Lausanne, Switzerland &
Brussels, Belgium

Title	Designer
NEW RICH Collection	Big-game
(* Price Tag	
** Bic Pen *** Apple Headphone	**Photographer**
**** Bic Lighter ***** Swatch Watch	//DIY
****** Push Pin)	

Type of Work
Craft

Description
This series of objects entitled 'NEW RICH' results from the confrontation between mass products and luxury. Designed for the Swiss brand +41, the objects question the meaning of accessories and offers new alternatives to jewellery.

Material
Solid gold

Dimension / Size
—

When gold replaces plastic, democratic and functional objects become exclusive in a subtle way. The designers have picked standard, universal products, and replaced a part of each object by an equivalent in gold. They love the shrewd blend between the down-to-earth functionalism of mass-products and the ultimate precious material: gold.

Client
+41

Year Produced
2006

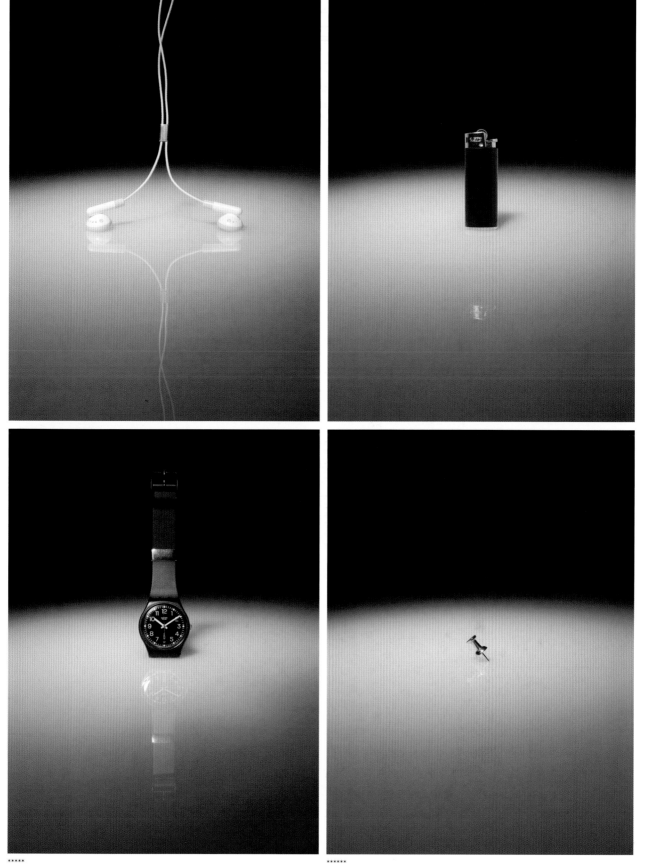

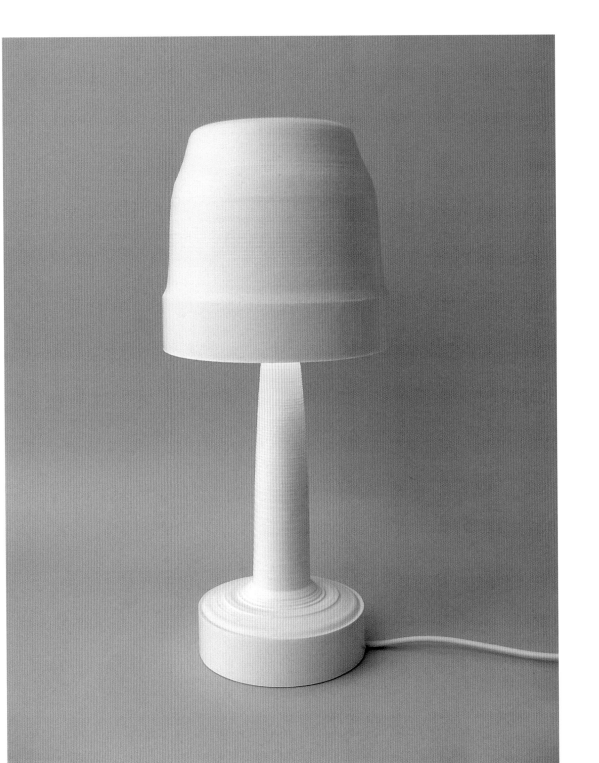

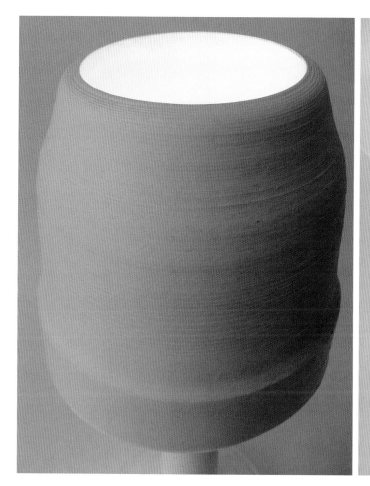

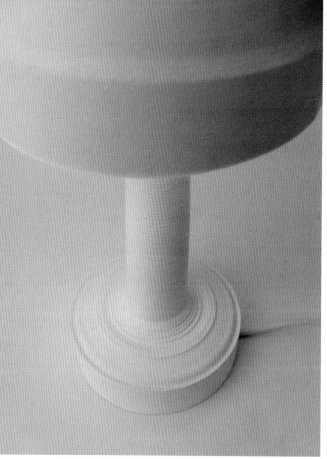

Eric
Klarenbeek
Zaandam, The Netherlands

Title
The Paperlamp Project

Type of Work
Lighting

Material
Paper, UV/PU protective coating

Dimension / Size
12.5 x 12.5 x 30 cm

Client
–

Year Produced
2005

Designer
Eric Klarenbeek

Description
This idea was born in a shop where the designer worked 5 years ago. The cash register always printed a paper-roll as backup, which is actually waste because the machine was clever enough to store the daily sale statistics.

Apparantly every shop worked according this same principle of useless printing 1000 meters of paper, thrown away day after day. The designer started collecting the paper-rolls and started playing with them. The extruded cash register rolls resulted in a limited collection of table and hanging lamps. The pink line indicates the ending of the paper-roll.

helmutsmits.nl
Rotterdam, The Netherlands

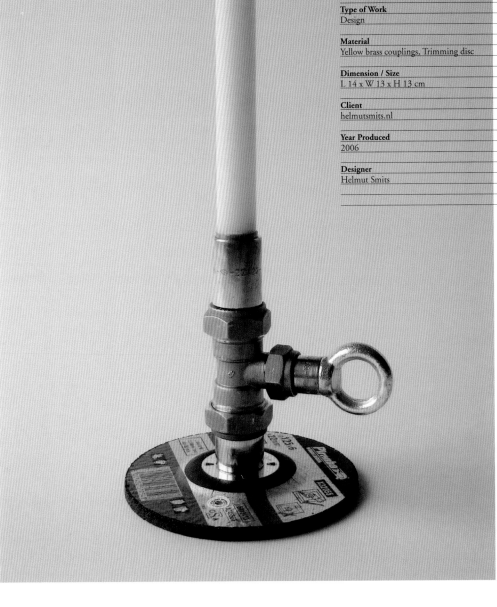

Title
Candlestick With Ring Bolt

Type of Work
Design

Material
Yellow brass couplings, Trimming disc

Dimension / Size
L 14 x W 13 x H 13 cm

Client
helmutsmits.nl

Year Produced
2006

Designer
Helmut Smits

Description
-

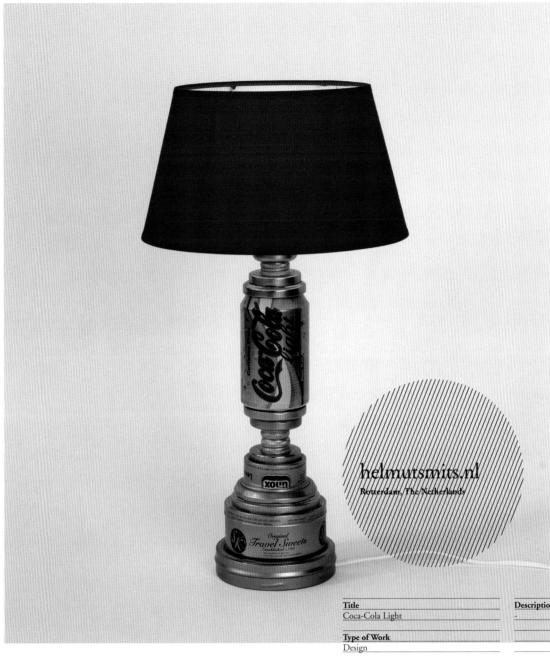

helmutsmits.nl
Rotterdam, The Netherlands

Title	**Description**
Coca-Cola Light	-
Type of Work	
Design	
Material	
Tins, Lids	
Dimension / Size	
L 28 x W 28 x H 45 cm	
Client	
helmutsmits.nl	
Year Produced	
2006	
Designer	
Helmut Smits	

Proef

Amsterdam, The Netherlands

Title
Sugar Crockery

Type of Work
Sugar spoons, cups, plates

Material
Sugar (isomalt)

Dimension / Size
–

Client
Proef

Year Produced
2005

Designer
Marije Vogelzang

Photographer
John Dummer

Description
The sugarspoons, cups, and plates are a range made inspired by the traditional craft of sugar-pulling and sugarmoulding. This craft uses the sugar merely for decorative purposes. Marije wanted to use the technique to make real usable products. Cups and plates can be used like porcelain but melt slowly. The spoon is perfectly in your tea to stir and sweeten. And it is edible!

*

**

Foldpaper
Zuerich / Switzerland

Title	**Year Produced**
* Feel safe, Alarm device ** Fumeur, ashtray *** The little friend, guinea pig **** Online, clothes-peg ***** Gourmet, carving board ****** The roll, sanitary paper ******* Spit and polish, cleaning sponge ******** Little green one, cactus	2000 – 2005
	Designer
	Samuel Perret
Type of Work	**Description**
Papermodels	The basic concept of the Foldpaper paper models is not very sophisticated indeed, but convincing at first view.
Material	
Paper	No astonishing mechanisms or incredible folding techniques are part of the models. In fact, the appeal of the models is produced by the surprising possibility to build common objects in original size. With the steadily growing collection of ordinary goods, every predilection, taste of humour or occasion is taken into account.
Dimension / Size	
Flat: A4	
Folded/built up: Vary	
Client	
Foldpaper	Don't just hold it, go on and fold it.

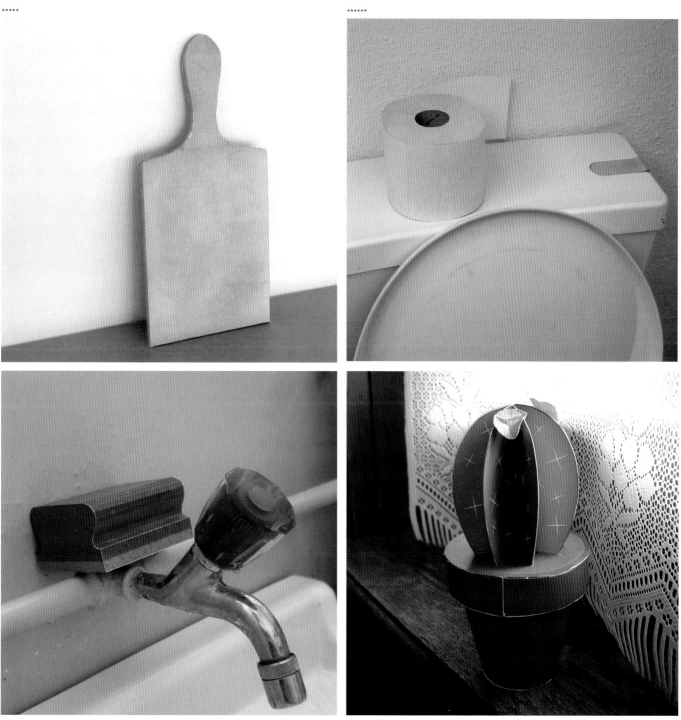

Big-game
Lausanne, Switzerland &
Brussels, Belgium

Title
BOX Stool

Type of Work
Furniture

Material
Powder coated aluminum

Dimension / Size
24 x 30 x H 40 cm

Client
Big-game

Year Produced
2006

Designer
Big-game

Photographer
Milo Keller

Description
The BOX stool was born from the transfer of cardboard folding techniques adapted to aluminum sheets. With its handle on the top, this piece of furniture refers to makeshift seats and can be stored in the same way as a cardboard box.

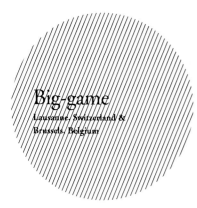

Big-game
Lausanne, Switzerland &
Brussels, Belgium

Title	**Photographer**
FLATPACK Rug	Milo Keller
Type of Work	**Description**
Textile	The FLATPACK rug refers to the most
	rudimentary way of protecting a floor
Material	(when doing a paintjob or break dancing for
Hand-tufted virgin wool	instance): a simple sheet of cardboard lain
	on the ground. In pure hand-tufted wool,
Dimension / Size	its shape reminds of a flattened package. Its
180 x 250 cm	straight cut structure and its beige colour are
	further reminders of the cardboard of which
Client	it exploits the graphic qualities.
Galerie Kreo, Paris	
Year Produced	
2006	
Designer	
Big-game	

BOEK
(PIET HEIN EEK)
Geldrop, The Netherlands

Title
Stamp Vase

Type of Work
Vase

Material
Brass, Copper / Stainless steel

Dimension / Size
27 x 27 x 27 cm

Client
-

Year Produced
1999

Designer
Piet Hein Eek

Description
The province of Noord-Brabant commissioned the production of a flower vase for us as a table centrepiece and gift for important clients. Considering the low budget and relatively small number required (700 in total), they had to come up with a cost-effective solution. The quantity needed was too high to be handmade but too low to justify investing in expensive moulds for serial production. The resulting 'Stamp Vase' was made from sheet metal manipulated into shape in a similar way to a napkin being pushed through a napkin ring. By pushing the metal into a constricted space, the sheet is forced to fold, creating the walls of the vase, each one ending up slightly different from the next, which was the designer's intention.

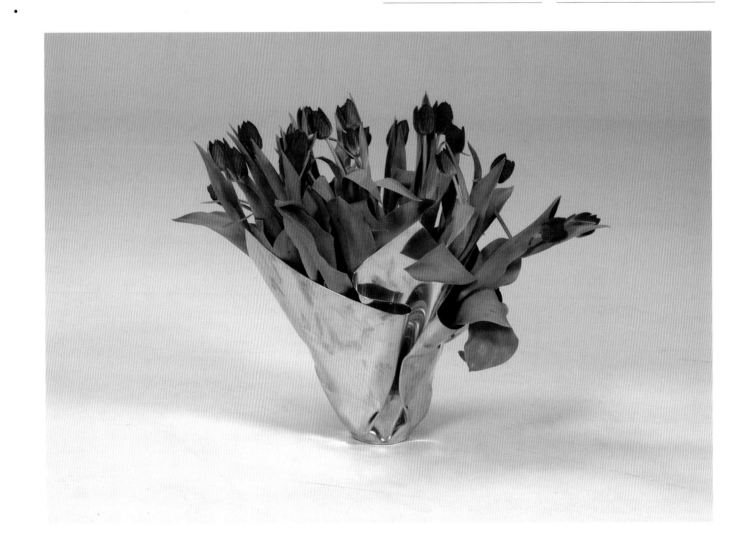

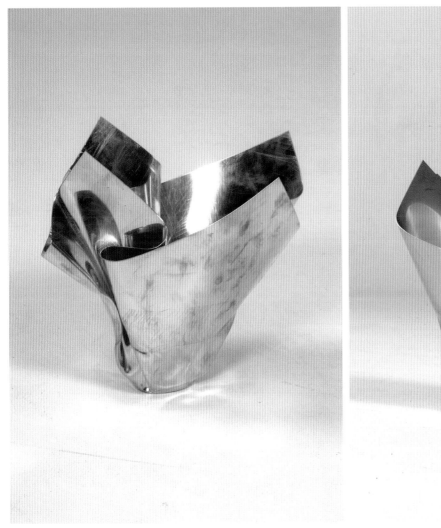 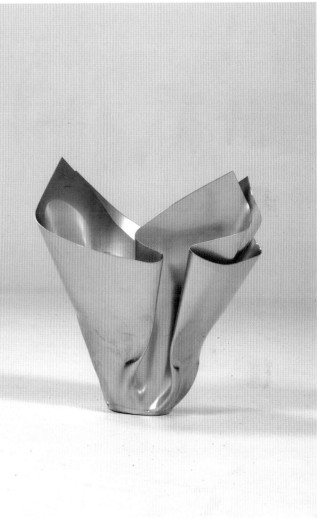

Lynn Kingelin
Design Studio
London, UK

Title
3/4 Iconic Dining Chair

Type of Work
Chair

Material
Steel frame, 3 1/2 shredded magazines

Dimension / Size
450 x 450 x H 450-850 mm

Client
Lynn Kingelin Design Studio

Year Produced
2005

Designer
Lynn Kingelin

Description
The eccentric, rebellious domestic environ-ment is filled with objects the designer finds an affinity for. 3/4 Iconic is a shredded paper chair with an external powder-coated steel frame.

Lightweight and durable, the design captures the energy and temporality of urban life. While the material can be moulded to form perfect edges, the design sought to express the extremes of the materials capabilities. The crumpled edges express the fragil-ity of the paper and blur the transition of the ephemeral into a lightweight, durable material.

Contents - Mostly Icon magazine.
Materials – steel frame & 3 1/2 shredded magazines.

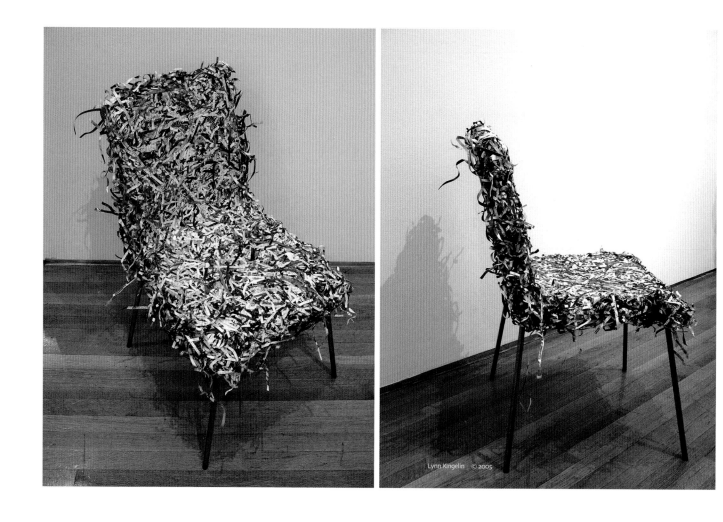

Lynn Kingelin © 2005

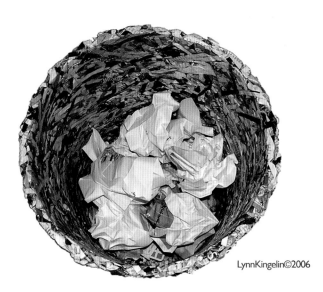

LynnKingelin©2006

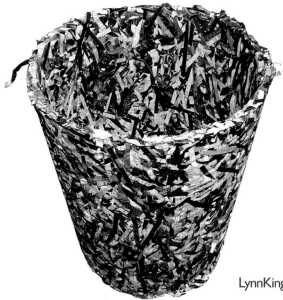

LynnKingelin©2006

Lynn Kingelin
Design Studio
London, UK

Title
Shredded Paper Recycling Bin

Type of Work
Paper category – Daily product

Material
Shredded Paper – New cellular material developed by Lynn Kingelin

Dimension / Size
Rim: H 35 x D 31 mm
Base: H 12 x D 240 mm

Client
Lynn Kingelin Design Studio

Year Produced
2005

Designer
Lynn Kingelin

Description
Visually bearing the message of its function, the Shredded Paper Recycling Bin is made from a new cellular material developed by Lynn Kingelin.

The design is lightweight, durable and retains the look and feel of paper. The material mixture is laid in a 3-part mould wet. The bin weighs approximately 1.7 kg as a finished product.

Each bin exhibits individual character and uses only 3/4 of a magazine. The product has a lifespan of 2+ years reflects the natural declension of the material through use. The Shredded Paper bin is not recyclable at end of life, but can be thrown away, if you can bear to part with it.

SHREDDED PAPER RECYCLING BIN DESIGN

The design started as a simple one day project I gave myself. It quickly became apparent I would have to develop shredded paper a durable, lightweight material if the recycling bin design was to become a successful manufacturable product instead of a wishful concept. Dozens of tests using different types of paper, binding agents, formulas and moulding techniques yeilded a great material I could manipulate.
It can be made so solid that is can be jumped on, or so it breaks down within 6 months of daily use.
The recycling bin design is made to last 2+ years.

-Lynn Kingelin

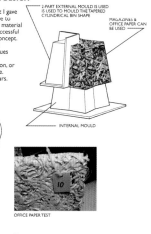

2-PART EXTERNAL MOULD IS USED
IS USED TO MOULD THE TAPERED
CYLINDRICAL BIN SHAPE

MAGAZINES &
OFFICE PAPER CAN
BE USED

INTERNAL MOULD

ARCHITYPAL BIN SHAPE USED TO
INTRODUCE SHREDDED PAPER
AS A NEW CELLULAR &
DURABLE MATERIAL

OFFICE PAPER TEST

PRODUCTDIMENSIONS
35 CM HEIGHT
31 CM RIM DIAMETER
24 CM BASE DIAMETER

SIMPLIFYING RE-USE
TM

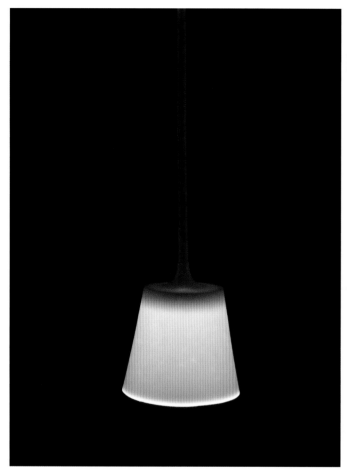

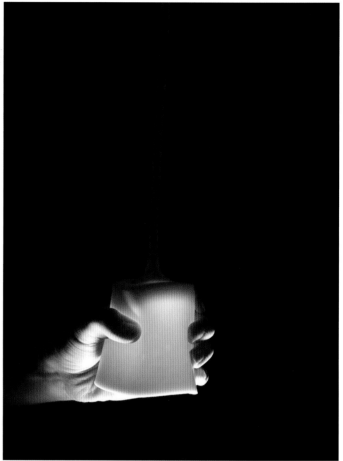

Big-game
Lausanne, Switzerland &
Brussels, Belgium

Title
SOFT Lamp

Type of Work
Lighting

Material
Silicone, L.E.D component

Dimension / Size
10 x 10 x H 10 cm

Client
MX Light

Year Produced
2004

Designer
Big-game

Photographer
Milo Keller

Description
The SOFT Lamp takes reference from the plastic cone usually used to conceal the cords between a pendant lamp and the electrical network in the ceiling. Instead of using rigid plastic, silicone is used to make a versatile soft lamp out of this shape.

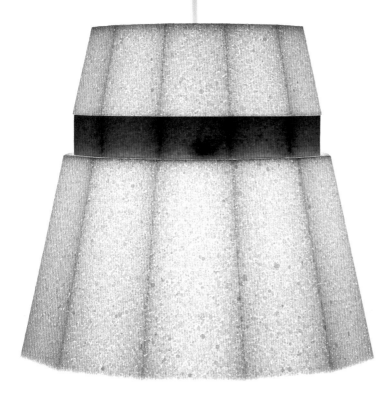

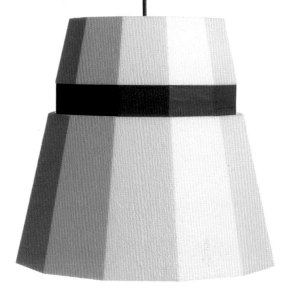

Big-game
Lausanne, Switzerland &
Brussels, Belgium

Title	**Photographer**
STYRENE Lamp	Milo Keller
Type of Work	**Description**
Lighting	The STYRENE lamp, made out of expanded polystyrene, exploits the diffusion and light transmission qualities of this material rarely used to create furniture. The fixation principle – 2 halves linked together by an adhesive tape – is inspired by industrial packaging systems and makes the installation of the lamp extremely easy.
Material	
EPS – Expanded polystyrene and industrial adhesive tape	
Dimension / Size	
25 x 25 x 50 cm	
Client	
Big-game	
Year Produced	
2006	
Designer	
Big-game	

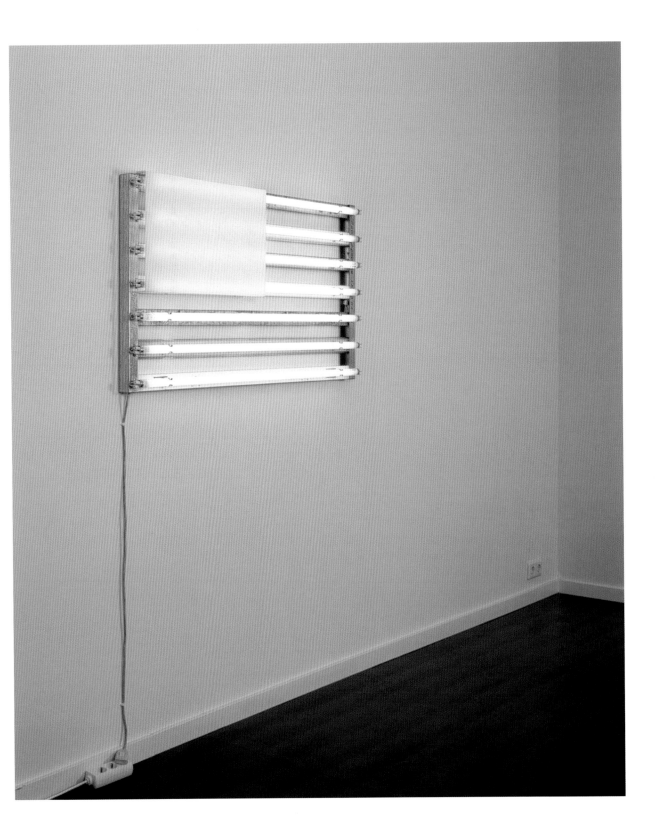

Title
Flag

Type of Work
Art

Material
Fluorescent lights

Dimension / Size
L 120 x W 7 x H 64 cm

Client
helmutsmits.nl

Year Produced
2005

Designer
Helmut Smits

Photographer
R.Messemaker

Description
-

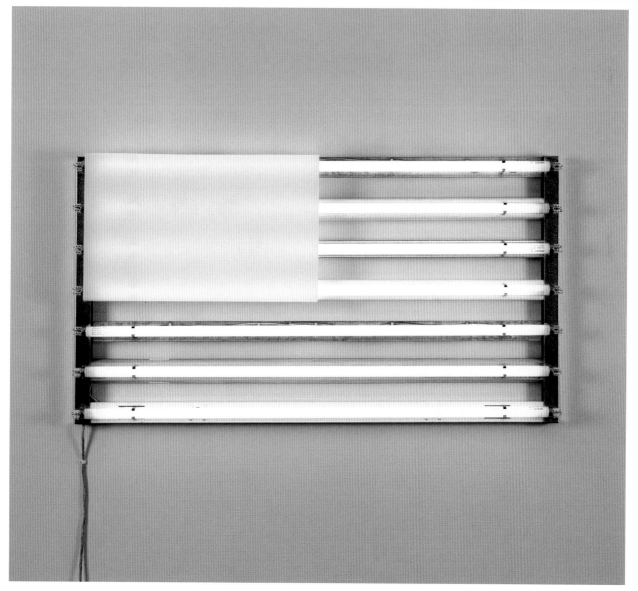

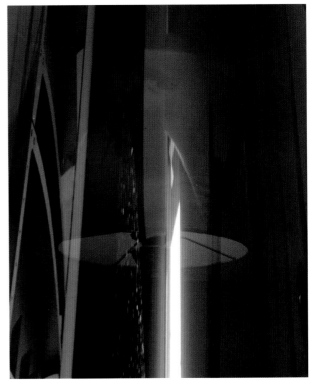

**

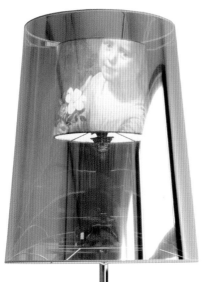

Studio
Makkink & Bey
Rotterdam, The Netherlands

*

Title	Designer
* Light Shade Shade Floorlamp	Jurgen Bey
** Light Shade Shade	

	Photographer
	Maarten van Houten

Type of Work	Description
Lighting	'Light Shade Shade' is a one way mirror that reflects its environment as well as concealing the chandelier within. When the light is turned on, the 'Light Shade Shade' reveals its unforeseen identity and projects the former beauty that lies within.

Material	
Semi-transparant mirror film, Old lamp	

Dimension / Size	
* H 190 x D 52 cm	
** Chandelier, shade: D 47 x 82 cm	This work is produced and collected by
5-armed chandelier, shade: D 70 x 75 cm	Moooi and under Droog Design's collection.
18-armed chandelier, shade: D 95 x 75 cm	

Client
-

Year Produced
* 2004
** 1999

**

Maarten Baas
Eindhoven-Waalre, The Netherlands

Title
Smoke

Type of Work
Furniture

Material
Wood

Dimension / Size
Vary

Client
-

Year Produced
2002

Designer
Maarten Baas

Photographer:
Maarten van Houten

Description
The Smoke series was the graduation project of Maarten Baas in 2002. Pieces of furniture are latterly burnt, after which they are preserved in a clear epoxy coating. Except three baroque products, which are reproduced by the Dutch label Moooi. After its very successful launch in Milan, in April 2003, Smoke has been playing an important role in the international contemporary design field. Since 2004 gallery Moss and Maarten Baas collaborate on the 'Where There's Smoke...' series: a Smoke collection of well known design classics of a.o. Rietveld, Eames and Gaudi. Besides this series, Baas has done commissions for collectors and museums from all over the world.

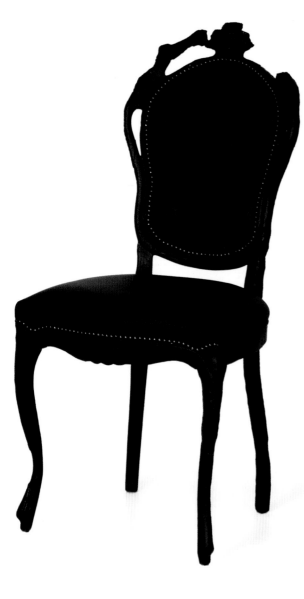

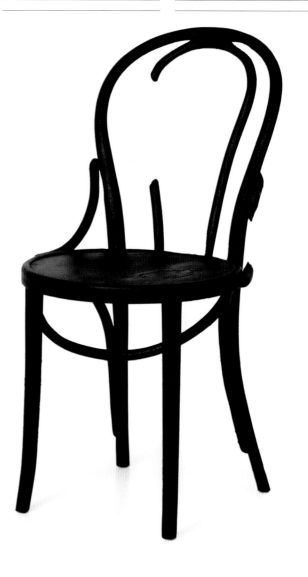

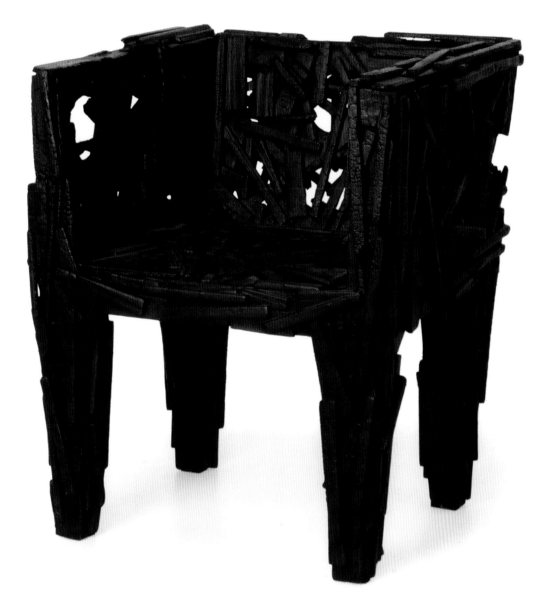

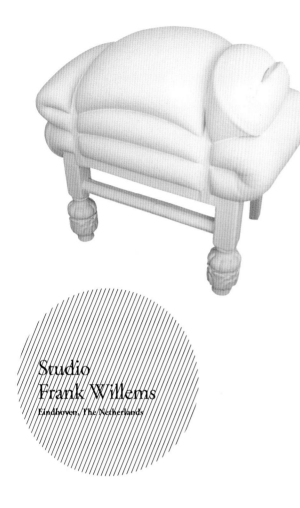

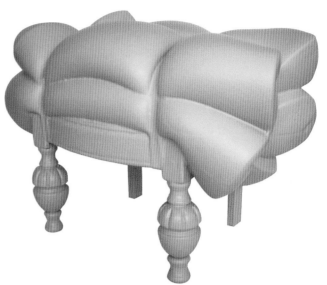

Studio
Frank Willems
Eindhoven, The Netherlands

Title
Madam Rubens

Type of Work
Stool

Material
Foam mattress, Wood, Polyurethane rubber

Dimension / Size
L 60 x H 55 cm

Client
-

Year Produced
2005

Designer
Frank Willems

Description
Madam Rubens is a mature and chubby lady after an extreme makeover.

During a visit to a waste processing facility while doing a research project for extending the life of various types of waste, almost all types of waste appeared to have a destination, except mattresses.

By folding disposed mattresses, a bulky, comfortable seat arises. The sexy legs are the result of dismantling a disposed stool. Folding the mattresses differently and using varying chair-legs, every single lady is unique, just like they ought to be.

After a full coating Madam Rubens is fresh, hygienic and totally rejuvenated.

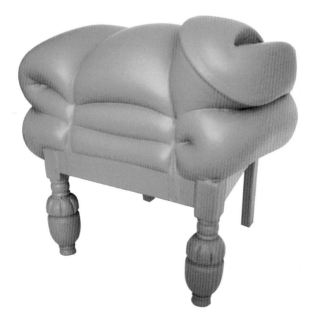

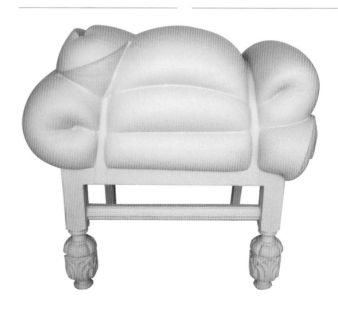

Studio
Frank Willems
Eindhoven, The Netherlands

Title
Goldilocks Collection

Type of Work
Stool

Material
Wood, Fabric, Cushions

Dimension / Size
34 x 94 x 45 cm

Client
-

Year Produced
2005

Designer
Frank Willems

Description
The 'Goldilocks Collection' is a furniture series inspired by the tale of Goldilocks and the 3 bears. The story is about making choices and ones personal preference. Someone can be very satisfied with something that someone else completely dislikes.

The 'Goldilocks Collection' translates this into a table and 3 chairs. The chairs don't have a fixed seat, so you have to create the seat you like by tying a pile of cushions to it. The number, the colour or the softness of the cushions is up to you. The table looks massive, but can be fully disassembled, when you remove the legs, the table can be stowed easily. Using different leg-sizes, gives you control of the height of the table.

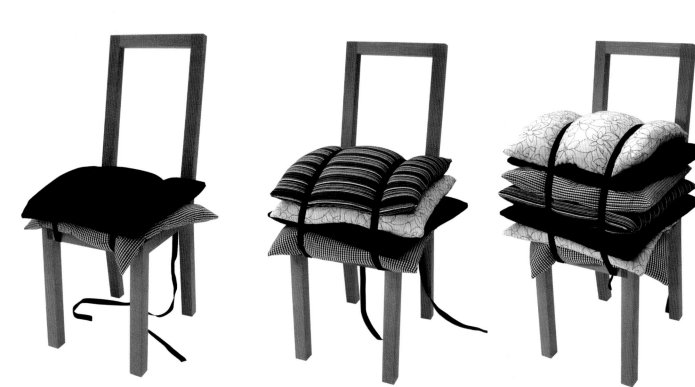

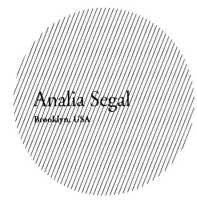

Analia Segal
Brooklyn, USA

Title	**Description**
Marti	Analia transforms the architectural space into a locus for exploration. The tiles lose their original function becoming a readable plane, which simultaneously reveals and conceals human existence holding the momentum when a sensation becomes a mark. The grid generated by the white squares is randomly distorted debilitating the notion of stability as an a priori condition of the rigid geometry.
Typ of Work	
Wall installation	
Material	
Ceramic tiles	
Dimension / Size	
Vary, Tiles: 6" x 6"	
Client	The designer believes desire gets in the way of our perception. She is interested in this work in revealing the psychological complexity of constructed space while appropriating architecture as a stage for latent, unconscious projections. Analia intends to produce a common point where the physical, psychological and spatial parameters of our experience collide.
-	
Year Produced	
2002	
Designer	
Analia Segal	

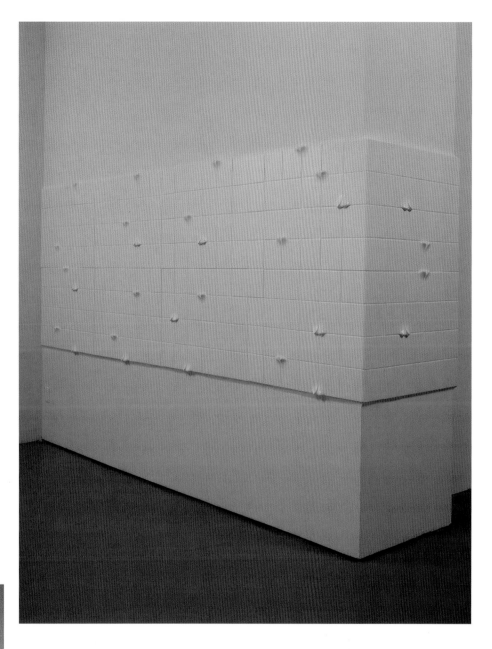

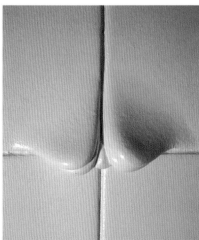

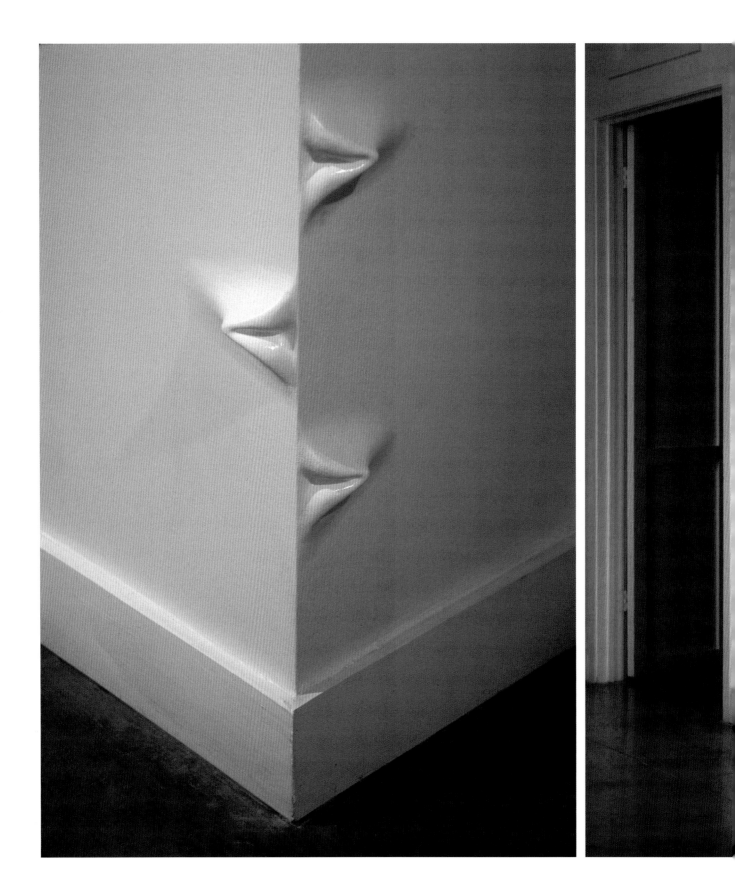

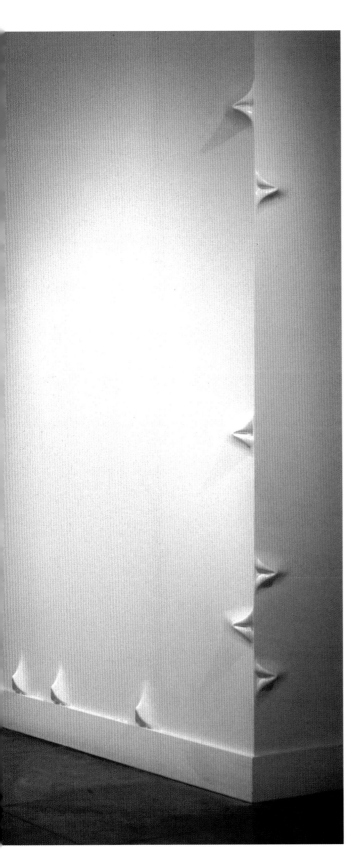

Analia Segal
Brooklyn, USA

Title
Montana

Type of Work
Wall installation

Material
Plaster

Dimension / Size
Vary, Detail: 4" x 32"

Client
-

Year Produced
2003

Designer
Analia Segal

Description
A wall is the place where the human body entwines with its habitat. It is the arena where sensuality and rationalism coexists. 'Montana' is a installation that examines the relationship between the body and one's immediate surroundings. Through inhabiting transcends the bounds of a geometrical space, Analia believes this process embodies an erotic connotation activating a dynamics of prohibition and transgression. By manipulating the surface of a wall, she transforms the architectural space into a locus for exploration. The embossed pieces, as traces, give the walls a fleshy quality. The result of the interaction between the body and the constructed space reinforces the contrast between the transience of the body and the endurance of architecture.

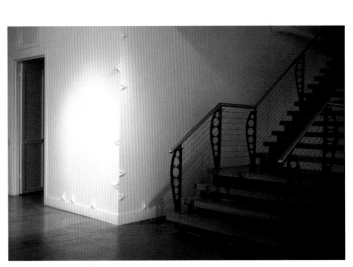

Analia Segal
Brooklyn, USA

Title
* Carl, blue ** Carl, brown

Type of Work
Floor installation

Material
Carpet tiles, Rubber

Dimension / Size
Vary, Square: 1' x 1'

Client
-

Year Produced
2006

Designer
Analia Segal

Description
Carl is a new body of work that invites viewers to occupy the work's space by walking on it while creating a spatial dialogue between them and the sculpture. Carpet tiles, a standard commercially available material, compose these floor installations. By consistently keeping up serial sequences.The undulating, warped, carnal qualities of the rubber pieces that appear behind the carpet bring out sensuality to an industrial material. These marks, or 3-dimensional canvases invite the viewer to comprehend the work in the process of experimenting it. They are the arena to examine the ambiguity and turning the anonymity generally associated with non-places such as waiting rooms, hallways, airport into places defined as relational concerned with identity.

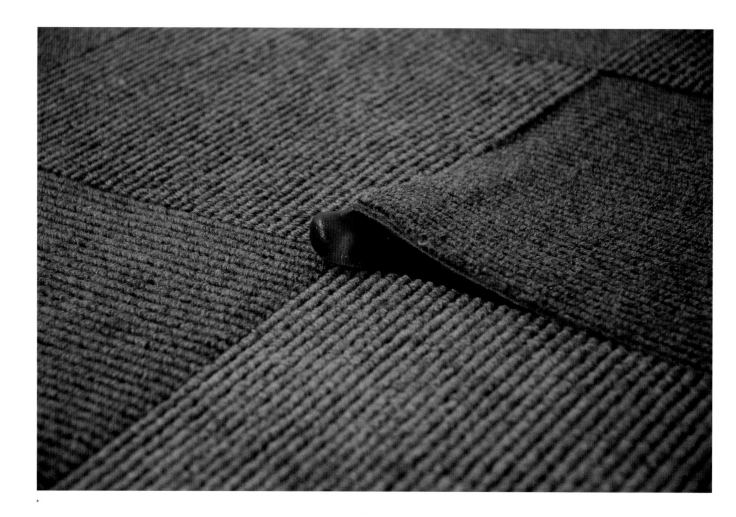

*

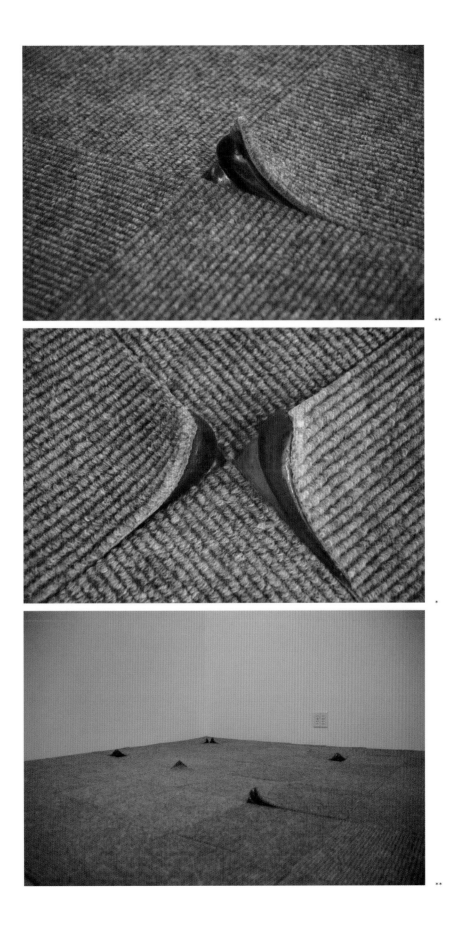

**

*

**

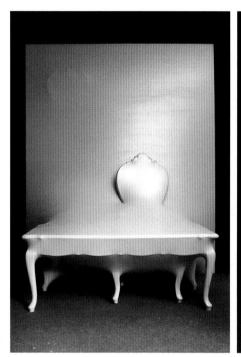 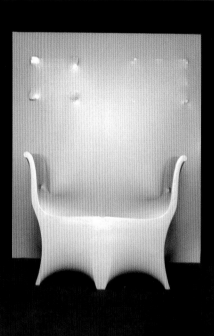 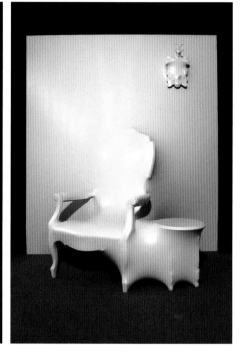

Studio
Makkink & Bey
Rotterdam, The Netherlands

Title
Kokon-Panelling / Parlour London

Type of Work
Artwork

Material
Kokon, Used furniture

Dimension / Size
Vary

Client
Parlour London

Year Produced
2002

Designer
Jurgen Bey

Description
These products have been rapped in an elastic synthetic fibre. The material shrinks around a skeleton and forms a smooth elastic skin. The 'skeleton' consists of existing furniture; the elastic skin gives it an entirely new appearance. By cross-breeding and grafting, products and functions of a different nature can merge and develop into new products.

Studio
Makkink & Bey
Rotterdam, The Netherlands

Title
Boombank (Tree trunk bench)

Type of Work
Artwork

Material
Tree, Brons

Dimension / Size
400 x 50 x 100 cm

Client
Droog Design for Oranienbaum

Year Produced
1999

Designer
Jurgen Bey

Photographer
Marcel Loermans

Description
The first benches are chairs-in-a-row. The woods of Oranienbaum are filled with felled trees scattered around which could serve as giant benches. By cross-breeding the trees with a number of different chairs new garden benches are made. An interaction between culture and nature. The tree trunk is the seat, bronze casts of existing backs transform the trunk into a proper piece of furniture.

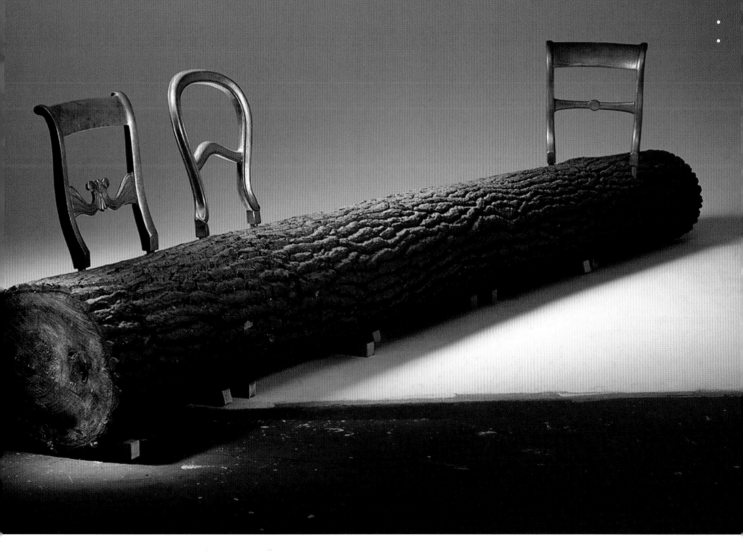

Studio
Makkink & Bey
Rotterdam, The Netherlands

Title
J.P. Gaulier

Type of Work
Catwalk

Material
Textile

Dimension / Size
Vary

Client
J.P.Gaultier

Year Produced
2003

Designer
Jurgen Bey

Description
Catwalk and backwall for the presentation of the women summer collection show 2004 by J.P. Gaulier in Paris.

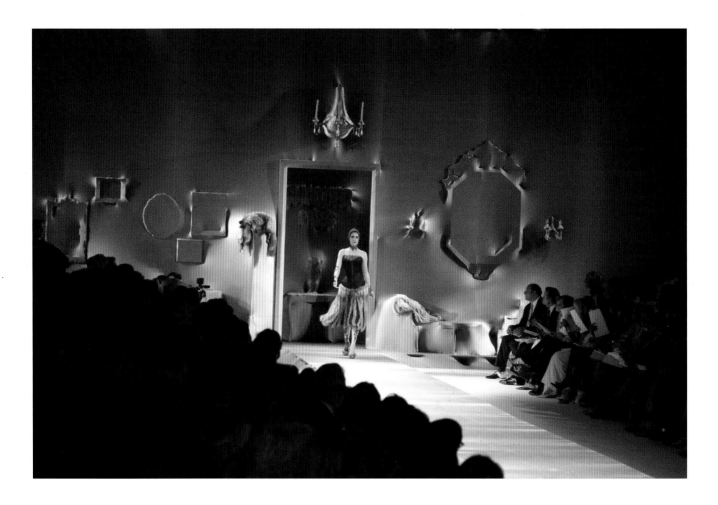

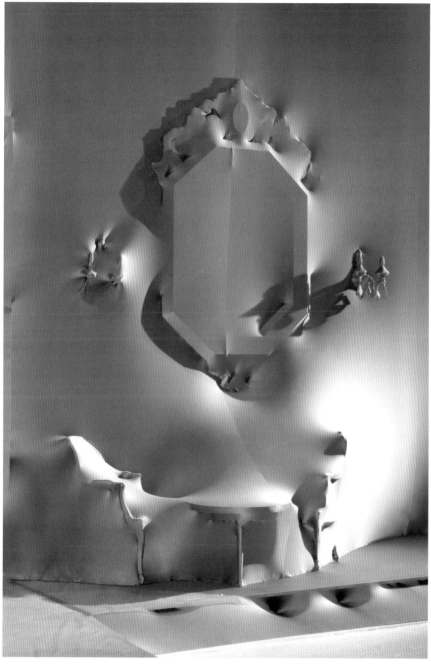

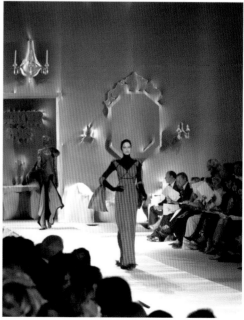

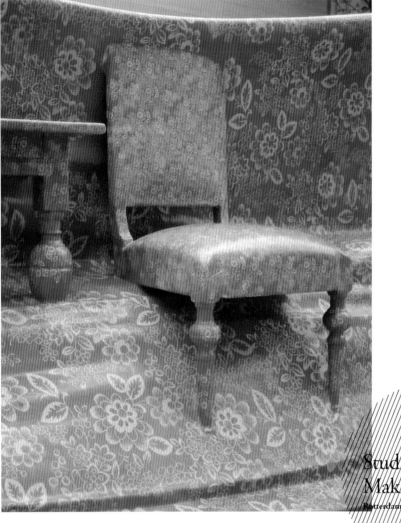

Studio
Makkink & Bey
Rotterdam, The Netherlands

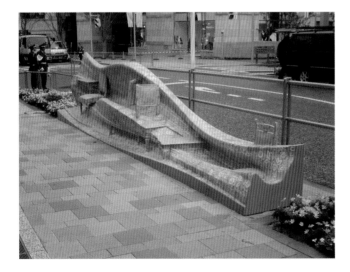

Title
Tokyo Day-tripper

Type of Work
Installation, Furniture

Material
Glassfiber, Polyester

Dimension / Size
7 m

Client
Droog Design

Year Produced
2002

Designer
Jurgen Bey, assisted by Silvijn v/d Velden,
Christiaan Oppewal

Description
Day-tripper is based on a study of the
different postures people assume on the
street during a day, while learning, sitting,
lounging, or squatting. Seven of these
postures have been fixed and have shaped the
wave-like form of this work. More formal
pieces of 'furniture' have been integrated in
this wave – like a dining table, a coffee table
or chairs. Working initially from an
appreciation of European scale and culture,
in this case the designers have chosen to
fabricate the works using a skin of fiberglass,
printed with a white flower decoration over
pink coloured polyester.

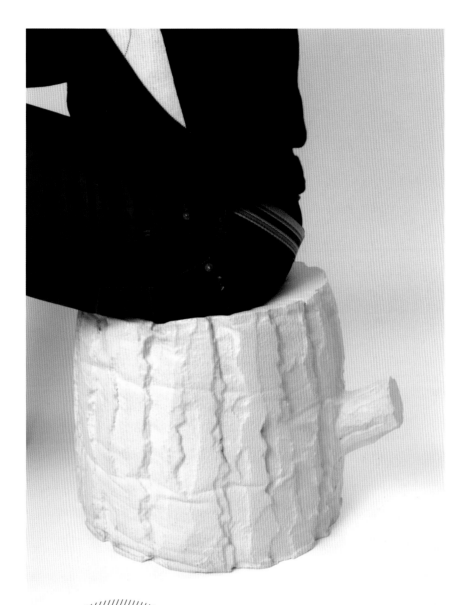

Title
Tree Trunk Stool

Type of Work
Furniture

Material
PU Foam coated with a polyurethane coating

Dimension / Size
D 36 x H 40 cm

Client
BY:AMT Inc, Ilona Huvenaars.com

Year Produced
2001

Designer
Alissia Melka-Teichroew, Ilona Huvenaars

Description
No trees were harmed in the making of this stool. It's made of soft foam, not wood, and it comes in some shades not found in nature. Each makes an eye-catching ottoman, extra seat, or side table. Group several together and transform a room from ordinary to enchanting. The stools are light, soft and waterproof so they can be dragged around, set outside and thrown around.

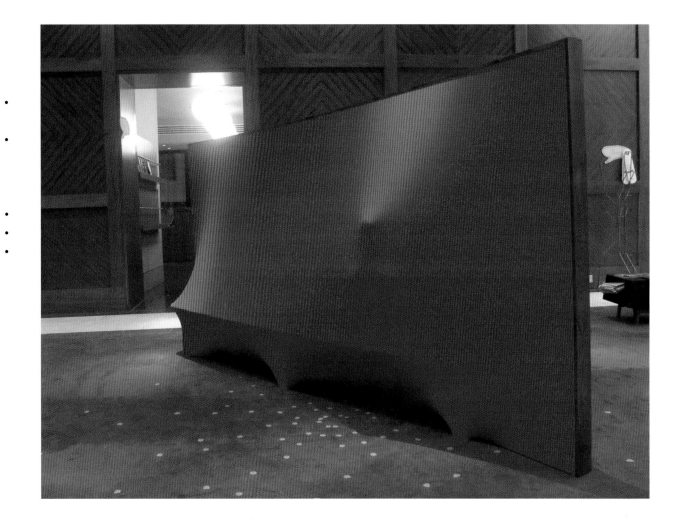

Jordi Canudas
London, UK

Title
Behind the Wall

Type of Work
Furniture

Material
–

Dimension / Size
L 3.8 x H 1.7 x W 1 m

Client
Jordi Canudas

Year Produced
2006

Designer
Jordi Canudas

Description
Wallfa is an intriguing two-sided piece of furniture that is both wall and sofa. It is a comfortable sitting area that becomes playful when different users interact between either sides of the wall. Movement, sound and touch insinuate a hidden scene happening on the other side.

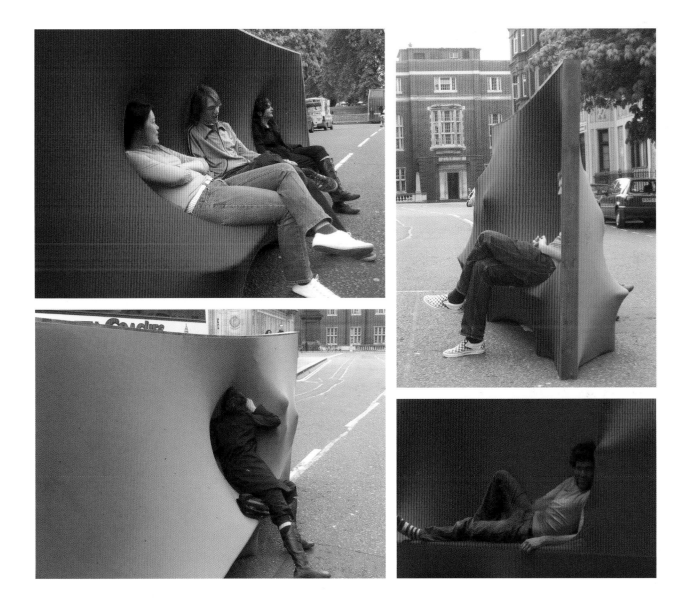

Florentijn
Hofman
Rotterdam, the Netherlands

Title
Konijntje Snoepfles

Type of Work
Outdoor display

Material
PVC with rubbercoating, Layer scaffold,
Wooden panels

Dimension / Size
6 x 4 x 12 m

Client
Sprookjesstad, CBK/BKOR

Year Produced
2005 – 2006

Designer
Florentijn Hofman

Description
This slightly plump rabbit was being on
display in the center of Rotterdam during
the festive season 2005. After that, it
travelled to various locations.

**Florentijn
Hofman**
Rotterdam, the Netherlands

Title
Max

Type of Work
Outdoor display

Material
Otatoe crates, Pallets, Wood, Straw, Rope,
Metal wire, Shrinking foil

Dimension / Size
12 x 8 x 25 m

Client
Mama, Brains unlimited, the Dutch
goverment

Year Produced
2003

Designer
Florentijn Hofman, Harmjan Timmerarends

Description
'Max' was an assignment by the Dutch
government and it was the first sculpture for
the 'Year of the Farm' project. In connection
with this project to promote the farm, each
of the Dutch provinces got its temporary
work of art. It started off at the village of
Leens in the province of Groningen. It took
2 months to build the huge Shepherd dog,
with assistance the local youth of this tiny
village. 'Max' is the watchdog which guards
the farm as a cultural heritage.

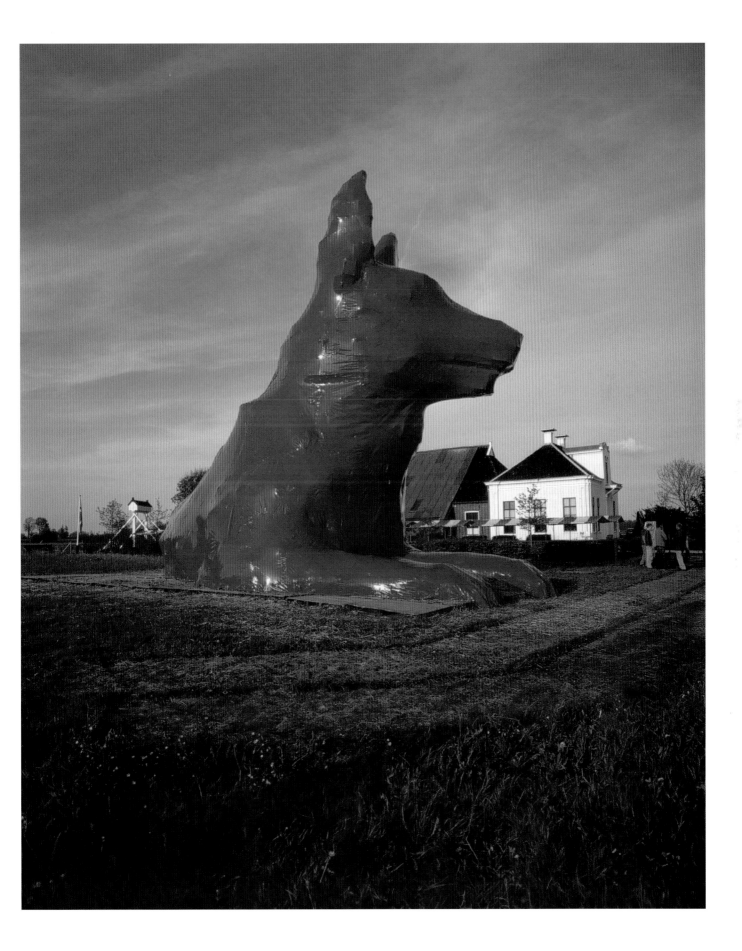

Florentijn Hofman
Rotterdam, the Netherlands

Title
Vlaardingse Reus

Type of Work
Outdoor display

Material
Salvaged wood, Nails, Screws, Rope

Dimension / Size
8 x 10.5 x 5.5 m

Client
MAMA Showroom for Media and Moving Art, Jeanne van Heeswijk

Year Produced
2002 – 2003

Designer
Florentijn Hofman, Harmjan Timmerarends

Description
In the scope of Jeanne van Heeswijk's social art project 'De Strip' in the city of Vlaardingen, Florentijn was assigned to make a sculpture out of salvaged wood. It took 3 months to build, with the assistance of local people. The sculpture is an assemblage, and although the quality of the wood was poor, it stood on 2 other locations after being shown for 2.5 hours on its primary location, the Westwijk in Vlaardingen. Rabbits never sit still for too long!

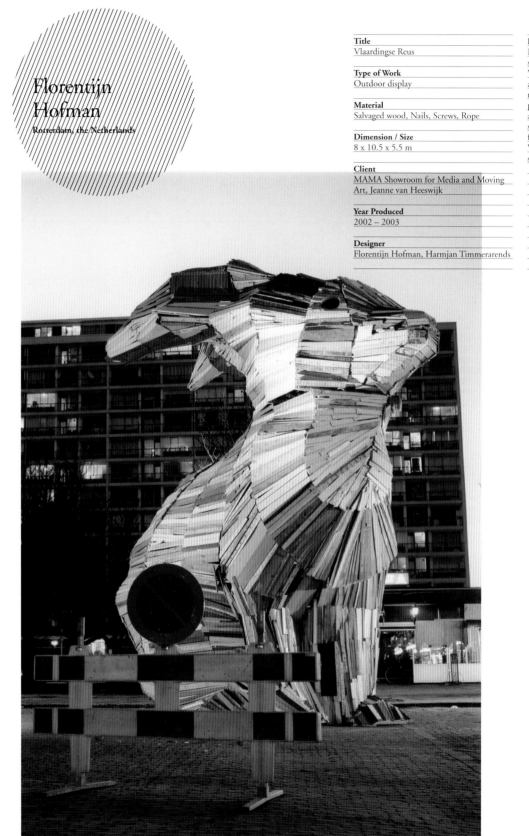

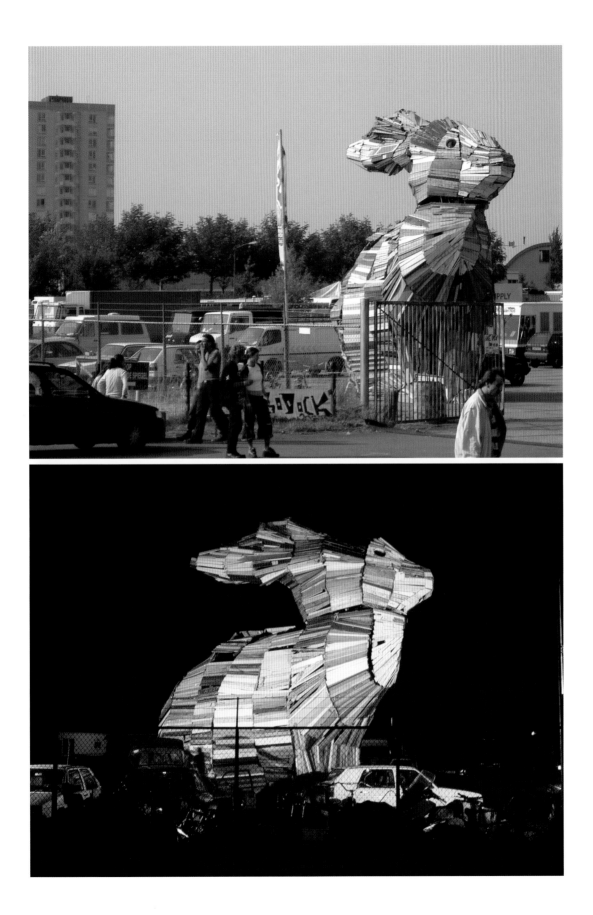

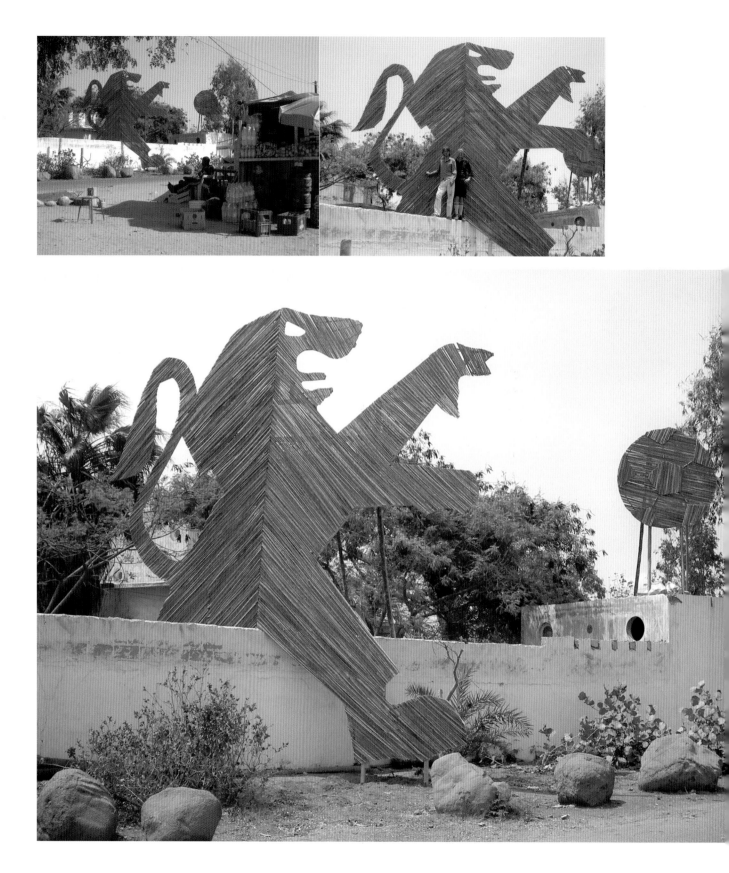

Florentijn Hofman
Rotterdam, the Netherlands

Title
Lion avec ballon

Type of Work
Outdoor display

Material
Samba wood, Palm branches, Palm beams

Dimension / Size
Lion: 8 x 4 m
Football: 4 x 2 m

Client
–

Year Produced
2006

Designer
Florentijn Hofman, Harm Jan
Timmerarends, the Senegalese equipe

Description
In cooperation with Harm Jan Timmerar-
ends and a group of Senegalese carpenters,
formed by Erik Pol, the designers made a
huge lion and a football. This resulted in a
very interesting cooperation and a sculpture
with a handshake (boumbaclaque). They
made a Senegalese as well as a Dutch lion.
The Dak'art Biënnale lasted untill the start
of the World Championship Football, and
therefor they could try to keep up the
honour of Senegal. Also, the lion refers to
the Peugeot logo, a car of which plenty of
redundant european specimens are still being
used in Senegal.

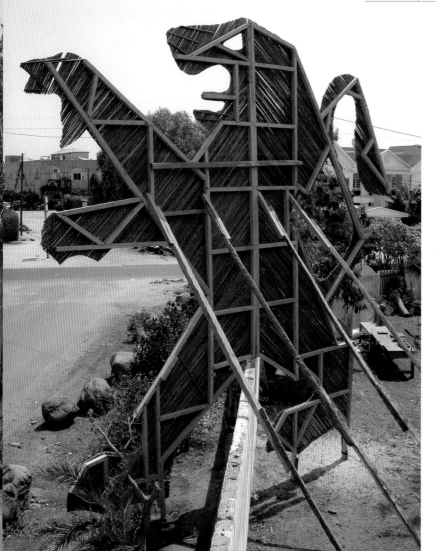

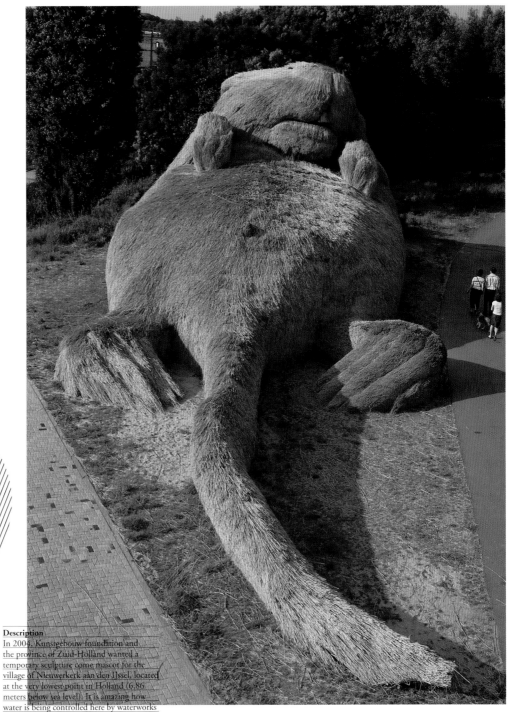

Florentijn
Hofman
Rotterdam, the Netherlands

Title
Musk Rat

Type of Work
Outdoor display

Material
Wood, Thatch, Metal wire

Dimension / Size
31.3 x 8 x 12 m

Client
Mama, Kunstgebouw Foundation and the
province of Zuid-holland

Year Produced
2004

Designer
Florentijn Hofman, Harmjan Timmerarends

Description
In 2004, Kunstgebouw foundation and
the province of Zuid-Holland wanted a
temporary sculpture come mascot for the
village of Nieuwerkerk aan den IJssel, located
at the very lowest point in Holland (6,86
meters below sea level)). It is amazing how
water is being controlled here by waterworks
and dykes, so this fact was taken as a starting
point. It resulted in a giant alter ego of the
musk rat, also to show the size of the prob-
lem the animal is said to cause.

The musk rat (ondatra zibethicus) suppos-
edly is the biggest threat to dykes because of
its digging into them and therefore the 'most
wanted' animal in The Netherlands.

contributors
contribuyentes
medewerkers
簡介
コントリビューター
기부자

ANALIA SEGAL

Analia Segal is an Argentine artist and designer. She has been living and working in New York since 1999. Graduated as a graphic designer from the University of Buenos Aires in 1985, and she got her masters degree in Art from New York University in 2001. At beginning of her career, she has been attracted to installation art. The 'multi-layered' practice that embodies the porosity of contemporary art and explore the blurry boundaries between art, design and architecture. She had many solo shows including Kobo Chika Gallery, Tokyo 2005; Museum of Modern Art in Buenos Aires, Argentina 2003; Plus Ultra Gallery-New York 2002; Centro Cultural Borges in Buenos Aires, Argentina -1998; Argentine Consulate in New York, 1996.
Page 242-247

AQUA CREATIONS LTD.

Aqua Creations, established in January of 1994. It features the innovative lighting and furniture creations from internationally acclaimed designer Ayala Serfaty. Her refined lighting and furniture designs are not only developed for individual consumers interested in adding quality and character to their homes, but also continue to be featured as the stylistic signature for a growing number of small and large scale architectural and interior design projects around the world. In addition to a beautiful array of now standard lighting and furniture products, Aqua Creations also engaged in the development of extraordinary projects and limited edition specialty designs.
www.aquagallery.com
Page 086, 088-089, 092-095

ASSA ASHUACH STUDIO

'It might be difficult to predict the future, but what seems clear is the fact that the pace of technological progress is increasing exponentially, and the evolution we can expect in the next two years, is likely to be no less significant than the progress we have seen in the last ten years.' said Assa Ashuach.
Page 029, 056-059, 110-111

AUTOBAN

Founded in 2003 by architect Seyhan Ozdemir and interior designer Sefer Caglar. Autoban is a combination of works on architecture, interior and product design. Every single Autoban product has a certain character, reflecting the designers' quirky approach to 'almost cliché' items. Starting point for each of these products is the material itself and its capabilities. As their names imply, the range consists of furniture and lighting units that are inspired by the nature and the rituals of daily life.
Page 044

BIG-GAME

Elric Petit, Augustin Scott de Martinville and Grégoire Jeanmonod met at ECAL, the University of Art and Design in Lausanne, Switzerland. Respectively Belgian, French and Swiss, they developed a common approach and soon they formed a close team. Big-Game was created in June 2004.

Big-Game – Beyond the fact that their ambition is to become 'big game', they also view the world of design as a huge playground. Their motto 'From confrontation comes Progress' means that in their view, creating a new object always implies some code and reference manipulations. Besides, they always take it very serious about the technical constraints linked to contemporary industrial production.
Page 216-217, 226-227, 232-233

BOEK (PIET HEIN EEK)
Page 020-021, 062-063, 228-229

BOOKHOU DESIGN

Based in Toronto, bookhou design was co-founded by John Booth and Arounna Khounnoraj to showcase their individual and collaborative works.

John booth received his arts education at Queens University. He also received a degree in architecture from the University of Toronto. He is currently investigating form and structure in both furniture and painting.

Arounna Khounnoraj received her education at the Ontario College of Art, a B.F.A. at the Nova Scotia College of Art and Design, and an M.F.A. at the University of Waterloo. She divides her time between her textile and home décor designs and her artwork where she explores sculpture, drawing and printmaking.

Together John and Arounna explore natural structures, forms and patterns both in objects and architectural installations.
Page 040-041, 096-097

BURO VORMKRIJGERS

Buro Vormkrijgers (Bvks) is a Dutch design studio founded by Sander Mulder (1978) and Dave Keune (1978), both graduated at the Design Academy in Eindhoven, the Netherlands. Over the years, Bvks has become an international operating studio which specializes in the field of professional furniture, lighting and interior design. It combines work for international business and private customers with concepts developed under their own management. The results have been published worldwide in leading magazines and TV programs, and have been purchased to leave their traces in homes, offices, galleries and museums all over the world.
Page 012-013, 148-155, 215

BY:AMT INC

Alissia Melka-Teichroew, founder and creative director of BY:AMT Inc, formerly known as Alissia MT Design, is a New World-Old World mash-up. The daughter of a French mother and U.S. father, she was born and raised in the Netherlands. She is a graduate of Design Academy Eindhoven, The Netherlands holds a Master of Industrial Design from the Rhode Island School of Design, USA. After stints in Paris, San Francisco and Boston, Alissia finally alighted in New York, her true home. She now lives and works in the Greenpoint neighborhood of Brooklyn.

ALISSIA Design came into business soon after Alissia's graduation from The Design Academy in 2000. The US version of ALISSIA Desgin, Alissia MT Design was launched in 2005 (now re-named as BY:AMT Inc). While developing her own original projects, she also served a seven-month design residency at the renowned design consultancy IDEO and also worked on staff at Puma International. In 2006, she decided to concentrate on AMT full time. Recent projects include a modular series of branching clothes hooks, Tree Hooked – a collaboration with Jan Habraken of WATdesign; and a new series of playful acrylic jewelry in stores.
Page 024-027, 253

CHRIS KABEL DESIGNS

Now based in Rotterdam, Chris Kabel has studied industrial design at the Design Academy of Eindhoven, where he was noticed by Droog Design. His diploma project Sticky Lamp was included in their catalogue in 2002, the beginning of an ongoing collaboration including commissions and exhibitions. Mooi and Royal VKB have followed, and some of his products have entered the collections of the Boijmans van Beuningen, the Stedelijk Museum Amsterdam and the FNAC. Nominated in 2003 for the Rotterdam Design Prize with his 1totree lamp, he has had a solo show in Paris in 2006, another sign of his recognition as a promising independent designer.
Page 212-213

CONTRAFORMA

Contraforma was officially established in 2000, but the core group of designers and managers has been working in the sphere of furniture and interior design since 1992. Under the philosophy that 'every thing can surprise you, every shape can be multifunctional, every solution can be unique,' it unites a new generation of young, creative and already experienced designers and architects.

Contraforma's aim is to develop visually aesthetic and highly functional design solutions analyzing and evaluating advanced materials and modern technologies. Seeking for new expressions in design, they create new environments that inspire unique atmospheres in their approach to interior design.
Page 190

DAVID TRUBRIDGE LTD

David Trubridge is in the unique position of being a designer of international repute whose skills are built on his earlier wealth of craft knowledge. He graduated as a Naval Architect from Newcastle University Britain, but since then he has worked as a furniture designer/maker and architect. He settled in New Zealand after sailing there on a yacht with his family. His design process combines innate craft knowledge,

sculptural abstraction and computer design technology, as it draws on his life's rich experiences. He is renowned as New Zealand's best known furniture designer and regularly exhibits overseas in Japan, North America and Europe.
Page 049

ERB
Ronan Bouroullec and Erwan Bouroullec were born in Quimper, respectively in 1971 and 1976. As soon as Ronan graduated from the Ecole Nationale des Arts Décoratifs, he began working alone, progressively assisted by Erwan, who was still a student at the Ecole des Beaux-Arts of Cergy Pontoise. They have worked together since 1999. Their collaboration is a constant dialogue, one that is fed by their separate identities but strives toward a common goal.

In 1997, they met Giulio Cappellini when their 'Disintegrated Kitchen' was on show at the Salon du Meuble in Paris. This was the starting point of a regular collaboration that has resulted in various projects since 1999. Today, Ronan and Erwan work with numerous well-known manufacturers such as Vitra, Cappellini, Ligne Roset, Habitat and the Kréo Gallery. In addition, they work on architectural projects like the Floating House and an artist's studio under construction. They were internationally awarded. In 2003, they were voted 'designer of the year' by Elle Decoration, Japan.
Page 077, 136-137

ERIC KLARENBEEK
'In our society, we're caught in a quest of determining and redefining our individual values. We search for new principles in objects, their interaction and emotions and give them new meaning. Beauty and function will become equals. For a world where human acts merge into our environment. Function and aesthetics are equals in a reality of new values.' said Eric Klarenbeek.
Page 102-103, 218-219

ERNST GAMPERL
Born in Munich, Germany in 1965, Ernst Gamperl became a furniture maker apprentice after graduating from high school. Upon the apprenticeship Ernst started - equipped with a book of woodturning - as a self-taught person. The fact that he had no previous knowledge when he began turning and taught himself everything, meant that he had a very unfettered approach to the trade. Three years later the Design School in Hildesheim offered him the possibility to become a Master Craftsman.

Ernst exhibits his work extensively throughout Europe and internationally, including North America, Asia and Australia. His objects have earned him numerous prices as well as prestigious museum honours, and form part of many private collections. Together with his wife Ulrike Spengler and their two children they are living and working in Italy, in particulary Lake Garda where he creates the amazing forms of his vases, sculptures and unoque collection pieces.
Page 104-105

ESSEY APS
ESSEY ApS is founded by John Brauer, an architect and designer and now the creative director, who has initiated the most successful products as well as overall the design direction. With a very distinguished design direction the company has, in this short time, positioned itself among the most promising design icons, winning 5 international awards for its outstanding design approach. Bin Bin, a paper bin, is the most well-known and successful product so far and is awarded 3 international design awards. Illusion is another symbolic product which was awarded the best new product in London 2006. ESSEY is now represented in 16 regions around the world and in many dedicated design shops, from MoMa, Museum of Modern Art, in New York to the local high end design and furniture shops.
Page 202-205

ESTUDIO CAMPANA
Since 1983, the brothers Fernando (1961) and Humberto (1953) Campana have been solidly building their career achieving both national and international recognition.

Based in Sao Paulo, Estudio Campana is constantly investigating new possibilities in furniture making. It creates bridges and dialogues where the exchange of information is also a source of inspiration. The work in partnership with communities, factories and industries keeps the freshness of Estudio Campana repertoire. Their work incorporates the idea of transformation and reinvention. Nowadays, their pieces integrate permanent collections of renowned cultural institutions in New York, and Germany.
Page 034-035, 120-121, 194-195, 198-199

EVA MENZ DESIGN LTD
Eva Menz, born and raised in Munich, Germany, trained in subjects of art and design attending Salzburg Academy with Marcello Morandini, Pena in Madrid and concluded graduating with a Honours degree from Central Saint Martins College in London.

Since then Eva's work has been exhibited in international shows in London, New York, Zurich, Frankfurt, Amsterdam, Bratislava and Prague. Critically acclaimed for both her conceptual work as well as her visual sensitivity she is increasingly well-known for her unique collection of chandeliers and installations. Fluent in several languages Eva leads a team at her studio Eva Menz Design Ltd in London, acting as art director, designer and facilitator for creative learning.
Page 164-165, 178-181

FEEK
A line of furniture and interior tools owes its unique design to the creative initiative FEEK, which was founded in 2004 by Frederik van Heereveld and Eltjo Klomp. The furniture exemplifies the company's spirit and philosophy – products with a fresh, youthful look with flexible techniques made out of future materials.
Page 032-033

FLORENTIJN HOFMAN
Dutch artist Florentijn Hofman (Delfzijl, 16 April 1977) lives and works in Rotterdam. In 2000, he got a diploma from Constantijn Huygens, Kampen and a master from Interdisiplinaire kunsten, Berlin- Weissensee in 2001.

Florentijn is known for his playful interaction with the public space. He frequently exceeds the borders of existing and explores any possible ways for people to experience the surroundings differently.
Page 256-265

FOLDPAPER
Foldpaper was founded in the year of 2000 in Zuerich, Switzerland. Since then, it is managed by Samuel Perret whom is the owner, director and designer.
www.foldpaper.ch
Page 224-225

FORM US WITH LOVE
FORM US WITH LOVE is a young and growing, global design company set up in Sweden in 2005. Their focus is on design within the segments of products and furniture. They work unconventionally and let every product develops according to its own specific background variables. They are inspired by the interaction between people and products, driven by the genuine love for design and creating every product through a unique design process. Their projects range from lighting design for Design House Stockholm, Uno design and Zero to furniture design for Materia, Mitab and Wilo, to watch and jewellery design for Axcent of Scandinavia.
Page 014-015

FUTUREFACTORIES
Lionel T Dean graduated from the Royal College of Art, London in 1987. He worked as an automotive designer for Pininfarina in Italy before launching his own studio in 1989. Lionel's work explores the boundaries between art and design. In 2002, as the Designer in Residence at the University of Huddersfield, Lionel began FutureFactories, a concept for designs that evolve and mutate to create a potentially infinite stream of one-off solutions. These designs would be produced using Rapid Prototyping techniques. Initially with Blue Skies research, the project has proved a huge success and has yielded a string of products ranging from gallery pieces to retail designs for well-known manufacturers. Today Lionel focuses exclusively on digital manufacturing. FutureFactories has been exhibited in London, Milan, and New York. In 2005 one of Lionel's pieces was acquired by MoMA, The Museum for Modern Art in New York, for its permanent design collection.
Page 072-073, 078-082

HAYON®STUDIO
Jaime Hayon was born in Madrid, Spain in 1974 and trained as an industrial designer in Madrid and Paris. Began working as a researcher in Fabrica, Italy in 1997.

He started his individual career in 2004 and has kept his hands full with eclectic projects from toys, to furniture and interior design as well as artistic installations. His boldness has been transcending the borders of the often-separated worlds of art and design, and merging his own style with ease between the two. With a new base in Barcelona, Jaime has been awarded by Wallpaper as one of the 10 breakthrough creators worldwide as well as the 2006 Elle Deco International Award and the Icon Magazine Best Show award for the 2006 London Design Week. Jaime's work has been featured in all major design publications and newspapers worldwide.
Page 186-187

HELMUTSMITS.NL
Helmut Smits (1974) is a multi-disciplinary visual artist based in Rotterdam, The Netherlands.
Page 196-197, 220-221, 234-235

HIROSHI TSUNODA DESIGN STUDIO
Born in Tokyo, 1974 and educated in the United States at the prestigious Rhode Island School of Design. Hiroshi Tsunoda is one of the most talented young emergent designers of the international panorama. From a young age, Hiroshi Tsunoda knew he wanted to work with his hands. When he was eight years old, a documentary about the futurist designs of Giorgetto Giugiaro for Maserati became a precendent for him. His passion for movies and the fascination of American culture took to him to Chicago, where he studied English. At Rhode Island, he discovered his talent and developed his technique and style: simple and minimal lines with a retro-futuristic twist and a delight in all that is artificial. His designs have been exposed in two occasions in the Salone Satellite of Milan. He currently has his own study of design that is located in Barcelona and leading the design brand DesignCode with Lincoln Robbin-Coker (from Sweden).
www.hiroshitsunoda.com / www.designcode.es
Page 010-011, 038-039

JORDI CANUDAS
Jordi Canudas was born in Barcelona in 1975 and graduated in Industrial design from Elisava Design School in 1999. As well as working in exhibition design and architectural studios for the following years. Jordi was involved in the design and artistic events that won several design awards. In 2004 Jordi moved to London to work in product and exhibition design studios before starting his master degree in Design Products at the Royal College of Art in 2005. He is currently studding his second year.
www.jordicanudas.com
Page 254-255

JULIA LOHMANN
Julia Lohmann was born in Hildesheim, Germany in 1977. She graduated from the Surrey Institute of Art and Design in 2001 with a first class degree in Graphic Design. In 2004,

Julia took a master degress in Design Products at the Royal College of Art, London. She was awarded the D&AD Student Award First Prize Product Development in 2001. Her work has been exhibited internationally including Germany, France, London, Sydney, Tokyo and Singapore.
Page 118-119

JULIAN MAYOR
Julian Mayor is an artist and designer based in East London. After graduating from the Royal College of Art in 2000 he worked in California as a designer for IDEO. On returning to London in 2002 Julian worked for Pentagram and other design studios while starting to exhibit his own work. He currently teaches 3D computer modelling at the London College of Communication while continuing his exploration of computers and sculptural form. He has recently completed a series of sculptural benches for a park behind the Tate Britain gallery in London and another called 'burnout' for a private client in East London.
www.julianmayor.com
Page 028, 050-052, 185

KARIM RASHID INC.
Karim Rashid is a leading figure in the fields of product and interior design, fashion, furniture, as well as lighting and art. Born in Cairo, half Egyptian half English, and raised in Canada, Karim now practices in New York. He is best known for bringing his democratic design sensibility to mass audiences. Working with an impressive array of clients, Karim is radically changing the aesthetics of product design, and the nature of the consumer culture. In addition Karim has successfully entered the realm of architecture and interiors.
Page 134-135

KARIN VAN LIESHOUT
As a product designer, Karin van Lieshout is not as focused on the technological progress as the meaning of things like their cultural and emotional value. Inspired by handcraft, combined with new materials and thoughts, her goal is to develop new products with a visual elegance.
Page 108-109

KENNETH COBONPUE
Kenneth Cobonpue is an international designer based in Cebu City, Philippines. He graduated with a degree in Industrial Design in New York, Working with natural materials, Kenneth is the leader of a modern design style using craft and technology that takes its inspiration from Asia. Continuing the legacy of his mother, Betty Cobonpue, an innovative designer who found new ways of working with rattan, Kenneth has won several awards including the Japan Good Design Award (7 times), the ICFF Craftmanship Award in NY, the grand prize at the 2004 Singapore International Furniture Design Competition, the 2005 Design for Asia Award, the 2004 Ten Outstanding Young Men of the Philippines and

a special citation by President Gloria Macapagal-Arroyo for embodying the ideals of Asian Design. His work has found itself in magazines including TIME and NEWSWEEK, newspapers like the Washington Post and International Herald Tribune, and books like the International Design Yearbook published in New York and London.
Page 068-069, 087

L.A. GALERIE – LOTHAR ALBRECHT
L.A. Galerie – Lothar Albrecht was found in 1990 and participated from the early 90s at Art Basel, Armory and other art-fairs. L.A. Galerie's understanding is to be a discovery gallery. They always have international programs with artists from Japan, Australia, Brazil and not to forget many European countries and the USA. After visiting many times in China, Lothar fell in love and opened a gallery in Beijing in 2004.
Page 192-193

LYNN KINGELIN / IKUINEN DESIGN
Designing timelessly exquisite retail spaces, objects and experiences at the front, innovative edge of contemporary culture. Lynn Kingelin seeks to create designs that are different in kind – Current, conceptual and feasible.
Page 230-231

MAARTEN BAAS
Dutch designer Maarten Baas was born in Arnsberg, Germany in 1978, grew up in Burgh-Haamstede and Hemmen in the south and centre part of the Netherlands. In 1996 he studied at the Design Academy while he created his first design - candleholder 'Knuckle,' was taken in production by bij Pol's Potten.

In 2005 Maarten started his collaboration with Bas den Herder to form, who became responsible for the production of all pieces. The foundation of studio Baas & den Herder made it possible to produce Maartens unique pieces on a larger scale, but yet all hand-made in Holland.
www.maartenbaas.com
Page 206-207, 238-239

MADELON GALLAND
Madelon Galland works in a variety of media including sculpture, site specific/installation art, photography and printmaking. The STUMP Project began on the streets of New York City as a gesture in unauthorized public art and developed into a thesis project and exhibition, as well as various site specific installations for outdoor exhibition. For the last few years, Madelon has spent the most of her time in India nursing animals in much the same vane as upholstering tree stumps in terms of demonstrating care in public for the most visibly diminished. There is the intention also to bring the courage to care about the pedestrian radar for thoughtful introspection and responsive action and dialogue.
Page 142-143

MARCEL WANDERS STUDIO
Marcel Wanders' fame started with his iconic Knotted Chair, which he produced for Droog Design in 1996. He is now ubiquitous, designing for the biggest European contemporary design manufacturers like B&B Italia, Bisazza, Poliform, Moroso, Flos, Boffi, Cappellini, Droog Design and Moooi of which he is also the art director and co-owner. Additionally, Marcel Wanders works on architectural and interior design projects and recently turned his attention to consumer home appliances. Various designs of Marcel Wanders have been selected for the most important design collections and exhibitions in the world, such as the Museum of Modern Art in New York and San Francisco; the V&A Museum in London; the Stedelijk Museum in Amsterdam; Museum Boijmans van Beuningen in Rotterdam; the Central Museum in Utrecht; Museum of Decorative Arts Copenhagen and various Droog Design exhibitions. Marcel Wanders has recently been elected Elle Decoration's International Designer of the Year.
Page 074-075, 183

OBJECT D'ART
Tom Abbott is a young product designer. He graduated from the University of Hertfordshire in 2006 with a first class Hons in Product Design. He won first prize in The Lighting Associations student design award 2006 which had a prize of £2000 and the Gretna Prize from The University of Hertfordshire, which is given to the student who has been the most successful. His work has been featured on the front cover of Lighting-design magazine and Audi magazine. He is currently working as a designer in London for a media company but would like to set up his own design consultancy in the near future. His work can be recognized by his use of organic form, sympathetic use of material and simplicity of idea.
Page 085

OBOILER
Karl Zahn graduated with a BFA from the Rhode Island School of Design, USA in 2003. He began working and experimenting on personal projects while living in San Francisco. His work deals with themes of over-consumption, dying technology and the societies disconnect with nature. He created www.oboiler.com, the website as a platform to display these ongoing projects and ideas. Karl currently lives in Brooklyn and work as a freelance designer.
Page 083

PD DESIGN STUDIO
Pd DESIGN STUDIO was founded by product designer Hideo Hashimoto (born in Kyoto-City, 1968) and Izumi Hamada (also born in Kobe-City, 1972). They specialise in furniture design, indusutrial design, graphic design etc. They aim to reconstruct the significance of existence of things from all viewpoints, and to make a new route into their design direction. They formed another design firm to carrying out expression dispatch between people.
Page 214

PETER CALLESEN
Peter Callesen lives and works in his native, Denmark. He studied at Goldsmith College, London and at The Art Academy of Jutland, Arhus, Denmark. He creates beautiful intricate paper sculptures from his studio in Copenhagen.

Along the side of his larger site-specific installations, Peter is perhaps best known for his signature A4 papercuts, which weave references to a myriad narrative sources - from Greek mythology, Danish fairytales and biblical stories to childhood memories. The austerity of subject matter and starkness of the pure white paper are humbled with a somewhat quirky attitude towards life and death. The apparent fragility of his creations which is the core of his work, and may be interpreted as a poetic gesture to the transience and impermanence of beauty. He is collected internationally and represented by Emily Tsingou Gallery, London.
Page 176-177

PHILIPS DESIGN
Philips Design is one of the largest and longest-established design organization of its kind in the world. A part of Royal Philips Electronics, it is headquartered in Eindhoven, the Netherlands, with branch studios in Europe, the USA and Asia Pacific.

Its creative force of some 450 professionals contains more than 30 different nationalities. Embracing disciplines as diverse as psychology, cultural sociology, anthropology and trend research in addition to the more 'conventional' design-related skills. The mission of these professionals is to create a harmonious relationship between people, objects and the natural/man-made environment.
Page 114-117

PROEF
Back in November 2004, Proef started in Rotterdam. Marije Vogelzang collaborated with De Bakkerswinkel and Onno Donkers Design to open a restaurant for breakfast, lunch and tea-time. In the incorporated shop, people could buy original trade food and slow-food products, while in the kitchen the on-the-spot assignments were prepared. It soon became clear that the establishment in Rotterdam was not big enough for all the activities to take place, therefore it was decided to move the design studio and offices in Cultural Park Westergasfabriek in Amsterdam. Proef in Rotterdam subsists as the unique eating-place it has always been.

The idea behind Proef originates from a liking for; small-scale, craft, joy and surprise. Proef is a place with honest products together with special furnishing, measured dinner-sets and an enthousiastic staff where everyone can feel like home.
Page 222-223

RADU COMSA
Radu Comsa is the winner of 100% Folding Chair Competition organised by Designboom.
www.raducomsa.ro
Page 132-133

REDDISH
Reddish was founded in 2002 by industrial designers Naama Steinbock and Idan Friedman. Both born in 1975, graduated with distinction from the Holon Academic Institute of Technology, Israel. Reddish studio focuses on keeping its designs clear and intriguing, and spends most of the time helping objects feel better about themselves. During the last year, Reddish studio won the first prize of the inspired by Cologne 06 — Interior Innovation Award Imm Cologne, and exhibited at the V&A museum in London.
Page 042-043, 100-101, 172-173

RONEN KADUSHIN
Ronen Kadushin (b.1964, Israel) is a designer and a design educator currently living and working in Berlin. Open Design is an alternative design and development method that frees a designer to pursue creative expressions. To realise the items as industrially repeatable products and have the ability to distribute design globally.
Page 016-019, 022-023

SAM BUXTON
Sam Buxton lives and works in London. His work is dominated by his experiments with advanced materials and technologies crossing the boundaries between art, science and design. His passion is for making new objects, searching for new ideas that respond to the modern moment, and reinterpreting objects to make them new and engaging.

Since graduating from the Royal College of Art in 1999, Sam has become the most well known for his MIKRO series of fold-up sculptures, that began as his business card, and his 'Surface Intelligent' electroluminesent tables and clocks. His current projects include investigations into the relationship of the human body to objects and surfaces and explore the growing role that information and data storage plays in our daily lives. He was one of the four designers shortlisted for the Design Museum's Designer of the Year award in 2004.
www.mikroworld.com
Page 156-161

SAND & BIRCH DESIGN
Sand & Birch Design Studio was founded in 2003 when Andrea Fino and Samanta Snidaro decided to join their different cultural backgrounds and experiences together for a unique project: to re-interpret the concept of furnishing and to bring other meanings, other senses and other lives to objects.

Andrea Fino has studied law and at the moment works in the field of communication for Government Institutions, and has gained experience in visual communication in the realisation

of social events. Samanta Snidaro has studied architecture in Italy and Spain, and has made various experiences in the field of photography and graphics.
Page 030-031

SEBASTIAAN STRAATSMA
Sebastiaan M.G. Straatsma was born on 12th March 1972 in Dokkum, The Netherlands. He graduated from The Design Academy Eindhoven (Men and Living) in 1999 and opened the studio in 2000.

The studio that he established deals with reinterpreting ordinary products and works with new material and techniques. He plays with product function, decoration and appearance; as well as placing products in a different context and changing the meaning of the products.
Page 191

SONIA CHOW STUDIO
Sonia Chow was born in Ottawa, Japan. She graduated in Communication Design from Nova Scotia College of Art & Design, Canada and moved to Tokyo in 2003.

Her poster was collected by the National Gallery of Canada. Throughout the years, she won 19 awards for graphic design and furniture and 13 National Competition for Home Furnishings and Consumer Products. Sonia was also the Winner in Home Furnishings category in 2001 and awarded by Honourable Mention for Concepts from ID Magazine's 50th Annual Design Review in 2004.
Page 122-123

STERNFORM PRODUKTGESTALTUNG
Sternform Produktgestaltung by Andrea Grossfuss and Olaf Kiessling, is a young office for product design. They specialise in furniture, accessories and all kind of products surrounding and concerning people. They try to walk through life open-eyed and to react adequately. Additionally, they do not want to think of the functions of things only, but also care about life being as pleasant as possible with them – good handling, a smile, an insight, amazement, a pleasant movement, a lightening.
Page 053

STEW DESIGN WORKSHOP
Both architects, brothers Jon and Kevin Racek head Stew Design Workshop. With a strong foundation in technology, Stew seeks to infuse their work with creativity, economy, and wit. In addition to their line of sculptural plywood furniture, past projects include an architectural installation in an abandoned staircase, a DIY homeless shelter constructed from a shopping cart, and a medical clinic housed in a recycled oil tanker.
www.stewdesignworkshop.com
Page 066-067

STUDIO BERTJAN POT
A flirt with computer esthetics and industrial production methods, Bertjan Pot works without a computer. Almost all designs come from experiments in materials, old and new. He believes the way a product feels is just as important as how it looks. Only recently Bertjan was reflecting on his work and he found out that a lot of projects could be described as structural and non structural skins.

As in the Knitted lamp where Bertjan froze a soft textile around a cluster of balloons and where the resin drained textile becomes the hard structure. It is similar to the Carbon Chair, the Random Light and the Random Chair where a skin becomes a product.
Page 048, 112-113, 124-127, 208

STUDIO FRANK WILLEMS
Frank Willems is a young Dutch designer with a passion for adventure. A graphic designer by training with a degree in advertising and presentation techniques, and a specialization from the Design Academy in Eindhoven, Frank has already made a great start. At first glance, his designs definitely flirt with environmentally friendly materials and production. The hand-made Madam Rubens is but one piece in his collection which brings ordinary unrelated objects together in the harmony of a distinguished final piece.
Page 240-241

STUDIO JOB
Studio Job designs projects in arts, design, architecture and fashion. Based in Belgium and The Netherlands, Studio Job works with international companies like Bulgari, Bisazza, Swarovski and design labels like Viktor & Rolf and so on. Objects and products of Studio Job are being sold at Moss in New York, Dilmos in Milan, Cibone in Tokyo, etc.
Page 064-065, 076, 130-131

STUDIO MAKKINK & BEY
Started from 2007, Studio Makkink & Bey designed for public spaces, interiors and applied art. Analyzing the contents, searching for the relation of the things and its users. A supporting story and the things having an interaction with its users are starting points for their projects.

As a designer, Jurgen Bey feels like an explorer travelling the world out of curiosity, or being sent with a mission to investigate, ask questions and make connections. To come back with stories, his stories are told with design because that is his language. Since 2006, Jurgen has also became the Art Director of PROOFF.
Page 060-061, 236-237, 248-252

STUDIO RAINER MUTSCH
Born in 1977 Austria, Rainer Mutsch graduated from the University for Applied Arts, Vienna. He found Studio Rainer Mutsch in 2004, which it focuses on industrial de-
sign, interior design, conceptual design and set design. He works for international clients like Swarovski, BMW/Mini and several furniture companies. He received international awards including the Young Creatives Award for Design (1st prize), Eisenstadt, Austria and Spin-off Design-Newcomers, and Furniture Fair Cologne, Germany. His work is mainly exhibited in Europe include Austria, Italy, Sweden, Germany and Spain.
Page 036-037

STUDIO VAN EIJK & VAN DER LUBBE
Both graduated at the Design Academy and the post graduate programme of the Sandberg Institute in Amsterdam, Niels van Eijk and Miriam van der Lubbe started their design studio in 1998, where they worked individually but share one studio. They often collaborate on projects, where they focus on product, interior and exhibition design. Their work has been exhibited worldwide and purchased by many museums such as Museum Boymans van Beuningen Rotterdam, Centraal Museum Utrecht, Museum voor Moderne Kunst Arnhem, The Dutch Textile Museum Tilburg, Manchester City Art Gallery, WOCEF Korea, Museum FIT New York and Stedelijk Museum Amsterdam.
Page 188-189

STUDIOBILITY
Gudrun Lilja Gunnlaugsdottir graduated from Akureyri school of art in 2002. Since 2004, Gudrun worked as a part time teacher at The Icelandic Academy of the Arts, where she also worked with Jurgen Bey on a 4 weeks course. In that same year, she worked at Studio Jurgen Bey, Rotterdam, and Holland for about 3 months. In 2005, she started her own studio, Studiobility.
Page 182, 184

SUZUKIKE
SUZUKIKE is a design group founded by the Suzuki brothers, Yohei and Kohei. Yohei and Kohei are 4 ages different and reside from Sendai. Upon college graduation, the two had separate ways. However, in September of 2005, the Suzuki brothers have awaken to their senses of being a 'Suzuki' and determined to find a design group 'SUZUKIKE.' 'SUZUKIKE' means 'Suzuki Family.' Within the environment such as interior, furniture and graphic that surrounds us, SUZUKIKE designs a sensation that is joyful. As designer and brothers, they must feel excitement, enjoyment, and fortune. To feel excitement, enjoyment, and fortune and to bring forward those ideas through various medium, is significant and the reasons for SUZUKIKE designs.
Page 138-141

SYLVAIN WILLENZ DESIGN STUDIO
Born in Brussels in 1978, Sylvain Willenz studied 3D design in the UK and product design at the Royal College of Art in London, and graduated in 2003. Sylvain now works in Brussels on various projects, from product and exhibition design to interior installations. Works are char-

acterized by an eclectic use of materials and processes as well as they are concerned with their relevance in design culture.
Page 084

T.N.A. DESIGN STUDIO
In 1989 Tomoko Azumi (born in Hiroshima, 1966) graduated in Environmental Design at Kyoto City University of Arts, Japan. In 1995 she opened a design studio, AZUMI, in London with Shin Azumi, and took a master course in Furniture Design at the Royal College of Art, UK. During their partnership, they won numberous awards such as 2000 'Product of the Year' FX International Design Award and 2003 'Best Contribution' 100% Design Blueprint Award, UK. In 2005, Azumi opened, t.n.a., design studio independently. Recently, she has been tutoring staff at Royal College of Art and doing research at the London Metropolitan University.
Page 046-047

TIM PARSONS
Tim Parsons was raised in Wiltshire, and studied industrial design at Royal College of Art in London from 1998 to 2000. Upon completion of his studies he began selling his own products to London retailers and undertook a research project from the Helen Hamlyn Research Centre at the Royal College of Art. In 2002, Tim moved to Manchester where he now combines teaching design at Manchester Metropolitan University with running a small studio. Mixing influences from craft and industrial design, his approach examines notions of familiarity, functionality and the quality of materials and processes, producing simple and durable objects.
Page 210-211

TJEP.
Frank Tjepkema and Janneke Hooymans met at the Design Academy Eindhoven in the 90's. In 2001 they officially joined forces as Tjep. In a common adventure aimed at adding quality, energy and amazement to the world.

In every project Tjepkema's objective is to combine conceptual innovative ideas with functional intelligence and visual elegance. His way of working attracted clients such as the notorious advertisement agency KesselsKramer.

Janneke Hooymans is bringing expertise in the field of architectural design, interior design and styling. In 2004 Tjep. won the Dutch Design Awards in the categories interior and fashion design.
Page 090-091, 106-107, 145-147, 162-163, 174-175

TOSHIYUKI TANI
Toshiyuki Tani's studio was established in 1999, adopted the traditional craft skill and technique of Japan. It is the human privilege to use 'Fire,' it has grasped the night time and produced the shadow with light. Using its

characteristic that cannot be separated to display on the works continuously. April of 2006 Renamed 'Illumination maker Toshiyuki Tani.'
Page 045, 170-171

TYSON BOLES
Tyson Boles was born as a sculptor and trained in industrial design. His love for the nature and humour helped him make his decisions.
Page 98-99, 166-167

VALVOMO ARCHITECTS
Valvomo, a design studio founded in 1993 has gained international recognition as a creative think-tank of eight designers and architects. In addition to furniture and lighting design the studio works on interior, exhibition and architecture projects.
Page 209

WOKMEDIA
Julie Mathias and Wolfgang Kaeppner together established WOKmedia, which they prefer to be described as design collective where each contributes of his talent and ability for all the studio's projects. Since 2004, they worked on joint projects with Michael Cross.

Their preferred creative condition is the stage between the conceptual progress of a piece and its stasis as a product. The piece could become a product, but they prefer to see it as an installation. WOKmedia's work has been shown in various international group shows and solo exhibitions including the the Design Museum London and the Museum of Contemporary Art in Taipei.
Page 128-129, 168-169

WOOD LONDON
WOOD london is set up by a young British designer named Bethan Laura Wood. By re-contextualising elements from existing, everyday objects, Bethan creates new products that explore how different attributes and aspects of 'the mundane' can be celebrated and rediscovered.

Bethan is interested in detail and process, she explores the patterning, and decoration that are both the making processes and the use of an object can leave behind.
Page 054-055

Acknowledgements

We would like to thank all the designers and companies who made
significant contribution to the compilation of this book. Without them
this project would not been able to accomplished. We would also like
to thank all the producers for their invaluable assistance throughout this
entire proposal. The successful completion also owes a great deal to many
professionals in the creative industry who have given us precious insights
and comments. We are also very grateful to many other people whose
names did not appear on the credits but have made specific input and
continuous support the whole time.

Viction:ary

Future Editions

If you would like to contribute to the next edition of Victionary, please
email us your details to submit@victionary.com